10 things you need to know before you see the doctor

A Physician's Advice
from More than 40 Years
of Practicing Medicine

Silver Lake Publishing
Los Angeles, California

10 Things You Need to Know Before You See the Doctor

A Physician's Advice from More than 40 Years of Practicing Medicine

First edition, 2004
Copyright © 2004 Sheldon Lipshutz, M.D.

Silver Lake Publishing
3501 W. Sunset Blvd.
Los Angeles, California 90026

For a list of other publications or for more information from Silver Lake Publishing, please call 1.888.663.3091.

Library of Congress Catalog Number: Pending

Sheldon Lipshutz, M.D.
10 Things You Need to Know Before You See the Doctor
A Physician's Advice from More than 40 Years of Practicing Medicine

Includes index.
Pages: 286

ISBN: 1-56343-781-3
Printed in the United States of America.

To my wife Rita, my love and my best friend always without whose help this book could never have been written.

And to my children—Laurie, Mark and Keri, and their spouses Ronald, Amy and Howard, and my nine grandchildren Jason, Danny, Josh, Noah, Max, Michayla, Lexie, Jack and Sammy, whom I dedicate this book.

A special thanks to editor Kristin Loberg and publisher James Walsh of Silver Lake Publishing for bringing this book to fruition.

Table of Contents

INTRODUCTION: *"HELP, I NEED A DOCTOR!"* 7

ONE: BEING A PATIENT IS SOMETHING YOU LEARN 11

TWO: THE DOCTOR *ISN'T* ALWAYS RIGHT 33

THREE: PAIN IS A SIGNAL FOR YOU TO TAKE INVENTORY 53

FOUR: SURGERY IS ALWAYS SCARY BUT PREPARING IS EASIER THAN YOU THINK 77

FIVE: HEALTH PLANS AND DOCTORS ARE CHOICES YOU MAKE 109

SIX: DIAGNOSING REQUIRES TEAMWORK— YOU AND YOUR DOCTOR 141

SEVEN: EVERY PILL, EVERY SWALLOW COUNTS 157

EIGHT: WOMEN HAVE A LOT TO WORRY ABOUT 175

NINE: CHILDREN AND ELDERLY NEED EXTRA ATTENTION 191

TEN: KNOW YOURSELF AND YOUR BODY 211

CONCLUSION: "DOCTOR, BEFORE WE BEGIN..." 229

APPENDIX A 241

APPENDIX B 247

APPENDIX C 267

APPENDIX D 275

APPENDIX E 279

INDEX 281

"Help, I Need a Doctor!"

I've been a physician for more than 44 years. During that time, I've seen many changes occur in the practice of medicine—most of them for the good. But I've also seen some things that have frightened me both as a doctor and a patient. In sharing with you my experiences, I don't intend to frighten, but rather to tell the truth. If you understand the truth about what goes on in medicine, you'll put yourself first and get the proper medical care you deserve. You'll be able to find the right doctor and ask the right questions...and you won't be so intimidated by visiting the doctor and managing the course of your health care. No matter what you do for a living or how much biology you *don't* know—whether you're a lawyer, accountant or stay-at-home parent—you can and must play an important part in your health care.

Malpractice and Legal Issues

Throughout this book, I will use the term *malpractice*. Sometimes I mean this in the legal sense (and I'll point those times out); more often, I'll mean this in the broader, professional sense. We live in very turbulent times with a great deal of litigation. Because

of this, many physicians fear the possibility of someone filing a lawsuit against them.

Rising malpractice insurance has also made it difficult for doctors to rest easy when it comes to legal matters. But malpractice isn't always what you think it means; it's not only about lawsuits and seeking monetary rewards for medical procedures gone wrong. To the contrary, it encompasses a broader range of issues, much of it not legal. This book will lay out the meaning of *malpractice* and show how its prevalence affects the quality of treatment you receive. When I talk about malpractice, I am talking about *any* kind of bad treatment you might receive—regardless of the legal implications.

It's important to realize that medicine is *not* an exact science. It is an art that draws from science. Every human body is different. To learn, doctors make mistakes and learn from them. Discussing these mistakes at conferences often leads to litigation. If the story gets out today, an attorney will be consulted tomorrow. For this very reason, autopsies are way down—again, for the fear that something found will lead to litigation.

The use of autopsy has declined steeply over the past 50 years. Currently, autopsies are performed in only about 6 percent of non-forensic hospital deaths, and even less among deaths in the community. However, discrepancies between clinical diagnosis in the living and true cause of death or postmortem diagnosis exist in as many as 30 percent of cases. Thus, the autopsy remains unique and valuable as a tool for establishing the cause of death.

Because of this, the American Medical Association continues to urge the federal government to provide for payment, under its programs, for autopsies as a valuable element in determining the quality of medical care and enhancing the quality of medical education.

In the following chapters I will explain the various things you can do to keep from falling victim to what I call *the cover-up*. This cover-up refers to all that goes on behind the scenes in doctors' offices, hospitals and laboratories to cover up mistakes. Cover-ups occur because medicine has become such a fragile and expensive component to our society. So much is at stake—from the business end to the consumer end.

This is not a criticism of your physician or medical provider; it's simply a statement of fact. You should have respect for the advice and decisions of physicians. However, you must be certain that these are the proper decisions and proper avenues of treatment. I hope that this book will give you some insight into the problems that are facing medicine today.

When I was a medical student, two things made an impression on me. The first was a quote from one of my teachers:

Don't forget that you will always be a student. You must keep up with your reading because medicine is an always-changing field. The notes you take today will be completely worthless in a few years because new methods will be devised to take their place. You are always going to be a student.

The medical community must keep up with the changes occurring in medicine. Unfortunately, not everyone does. That's part of the cover-up. Laws have been passed in an attempt to force

professionals to keep up with the quickly changing field of medicine. But it doesn't always work. It's up to you to realize this and to direct your care to the right physicians who can treat your ailments and keep you healthy.

Another thing I learned in medical school: to do the best I can and have faith in my treatment. Hippocrates said, "Physician, do no harm."

Unfortunately, in some instances, the physician *does* do harm. A doctor might remove the wrong breast or leg after an x-ray gets read backwards. Or unnecessary delays might occur that can cause serious harm. Tumors can grow with delays. So do other problems.

In the chapters to follow, I will outline—through various examples—what you can do to direct your medical treatment and diagnoses to maximize quality of care and prevent mistakes from happening. There's a vast—and growing—pool of knowledge out there; it's up to you to find the people who have the answer to your problems.

Changing the way you approach your own health care will ultimately have an impact on the state of public health care in general. As more people take charge of their health and learn how to make well-informed decisions, more medical dollars will be saved and more people will be satisfied with their care.

There's a complex interplay between the hard economics of modern health care and the altruism that lies at the core of the medical profession. Informed consumers of medical services are the best hope for any kind of reform—whether radical or gradual. So, change begins with you.

1.
Being a Patient Is
Something You Learn

It's 7 A.M. You've arrived at a hospital, been checked in and are lying on a gurney ready for the operating room. You haven't received any drugs yet to anesthetize your mind, so you're thinking fast: *Did I make the right decision? Do I trust the second opinion...or should I have gotten a third? Am I doing the right thing? How will it all turn out?*

These questions—and many others—are racing through your mind:

Is the procedure being done just for the money?

Is this procedure well documented—has it been done many times before?

Am I a guinea pig?

Is this an experimental procedure?

What will the consequences be?

How much pain will I have? How much disability?

Will everything return to normal?

Will my insurance cover everything?

Then the anesthesiologist arrives with the IV. He injects the solution into your arm and asks you to count backwards from 10. You finally start to relax when you say "eight." It's too late for

your questions. Your head starts to spin and you lose sensation in your body. You're sure all will be well—but in the back of your mind you're still wondering, *will it?* Then you say "four" and don't remember the rest.

If you've ever gone through this, you're not alone. Even in carefully planned procedures, where you set a date to have surgery and haven't landed yourself in the ER with an unexpected procedure ahead of you, you probably worry about a dozen different things right up to the moment you fall asleep. If there was a way to minimize all the possibilities of things going wrong, you would.

If you could rest assured that you won't be a victim of bad medicine, you'd be able to get through the surgery more easily and recover more quickly. The key is finding the answers to your questions before donning a surgical gown. And you do this by talking with your doctor well before you're in the operating room.

Imagine a scarier situation. You're in an ambulance and on your way to the nearest hospital. The last thing you accurately remember is that you were in your car and heard a loud bang. Now you're on a gurney, covered with dressing and a blanket, rocking side to side with the quick movements of the vehicle as strangers—EMTs—look down at you with concern in their eyes. There's an IV bag hanging over you and a line running into your right hand. You wonder, *Am I going to a good hospital? Will the doctor know what to do? Is the doctor well qualified? Do they know who I am? Will my family be notified? Will I live? Will I need surgery? Will I have scars? What will the outcome of this be?*

Even though you're nervous about being on the bed, you don't have to feel so vulnerable or worry about being a victim to bad medicine. If you've had all of your questions answered and you feel comfortable with those answers, you'll have faith in the surgery and not question the outcome. This will lessen any feelings of vulnerability. It will give you knowledge—and some control of the situation.

Being an Informed Patient

Near the end of my working days, I realized that many of my patients had no idea how to direct my attention to their medical problem. They were in the dark when it came to assisting with their medical care. They had no comprehension of what was going to occur or how the care would be delivered. They didn't want to know what was wrong with them, opting instead to leave their health care and well being in the hands of me or whoever else was treating them.

In most cases, patients don't know anything about the treatments they are going to receive and are incapable of making their own decisions. A typical example of this is the discovery of a lump in a woman's breast. The patient is frightened, apprehensive and worried. However, several options can be followed and, while all of them are somewhat correct, the final decision has to be made by the patient. In the past, decisions about therapy were left to the physician, but now, for the most part, they are left up to the patient. In the case of the breast lump, the treatment can be mammography and observation of the lump.

The lump can be removed and examined, or it can be biopsied, in which case a proper course of treatment would depend on the results of that biopsy. In some instances, a given therapy is determined by the expertise and experience of the physician—and there are not many options. But keep in mind that the physician is there to guide the patient to the ultimate decision, which should be up to the *patient*. You can always say no.

We've all heard of patients who opt not to undergo treatment for life-threatening illnesses. They'd rather live the remainder of their lives out in peace, without invasive surgeries and taking sickening medications. If you're given six months to live after you're diagnosed with stage four bone cancer, or eight months to a year with radiation and chemotherapy, you might opt to decline the treatment and live as long as the cancer will let you.

People's reasons for leaving things up to their physicians are two-fold: They either don't know how to participate in their own medical care; or they just don't want to learn how because they are intimidated by the whole experience of seeing doctors and being examined. Many take the easy route by relying solely on the doctor. From my experience, if people had the opportunity to participate, they would. Leaving everything to a caretaker—a doctor, nurse, lab tech, etc.—is not the way to ensure quality care, yet this is how most people go about their medical needs. Even today, when we live in an age of information and have things like WebMD and CNN\Health a double-click away, much of the care provided by the medical profession is going unquestioned by the general

public. It shouldn't be like this. You must take an interest in your health care and especially in the treatment you get.

A New Pact

As a patient and consumer, you must take responsibility and an active participation in your health. As I'll repeat throughout this book, you can't be a passive recipient of medical care; you must be a part of your health journey and view your doctor as a partner in maintaining or restoring your health. No matter how much you try to fight it, certain things have changed the way patients and physicians interact. It's becoming easier to take an active role...and it's becoming more necessary.

Several things have contributed to the changing roles of patient and physician. First, people question everything these days and, in particular, those who have some authority over them. Second, the Internet provides volumes of information previous accessible only to physicians. So when you get diagnosed with Crohn's Disease, you don't have to rely solely on your doctor for information...and you shouldn't. You can enter "Crohn's" into an Internet search engine and access hundreds—maybe thousands— of sources with more information on treatment, experts in the field and typical prognoses. Third, in addition to living in an age of information, we live in an age of chronic diseases. Why? The population is living longer and, some argue, people are less healthy.

> **In 2000, 125 million Americans, or 45 percent of Americans, were living with chronic conditions. Of those living with a chronic condition, 56 percent had one chronic condition and 44 percent had two or more.**

When you have 55 million Americans living with two or more chronic conditions (e.g., diabetes, arthritis, asthma) in a country that's ranked 15th by the World Health Organization for health care, many are going beyond the scope of their primary care physician. Many are searching for alternative therapies, as 60 percent of all Americans used some form of alternative medicine in 2000.

> **People are realizing that there is no one person who has all the answers. People must adopt a new set of management skills for managing their own health care. You know yourself best—your history, your hereditary health conditions, your propensity for risky behaviors like smoking, excessive drinking, etc.—so only you can ultimately determine what's best for you.**

As a medical student, I was taught that one of the most important parts of medicine is compiling a good history of the patient and the complaint. Health care providers are increasingly

torn between spending time with patients and seeing more patients. One of the most common complaints voiced by patients is that not enough time is spent with them; they feel like a number in a long line of patients. A better way to have more time with your physician is for you to give him or her the information needed without your doctor having to extract it from you like pulling teeth. Later in this book, I'll outline some techniques for talking with your doctor and give you some things to know before you go and see your doctor.

Getting the Best Treatment

It's often said that those in the medical profession receive the best medical care. This is true in part because those in the field know what type of information to give to physicians. When doctors become patients, they know what questions to ask and how to ask them. They know what to expect. They know something of the type and quality of care that is expected and they take charge in directing this care. This kind of interaction doesn't have to happen only among doctors. In this book, I'll show you what to expect of medical care.

Everyone has a right—and should have a desire—to take charge in directing his or her medical care. I don't mean you should self-diagnose or tell the professional with a medical degree what to do. Rather, taking charge of your health care means doing the things that will allow your doctor to provide you with the best care.

As you'll see later in this book, these things include knowing about your family's medical history and giving the correct information about yourself so he or she can arrive at the proper diagnosis. I've seen too many patients who complain of a problem but only tell me of their immediate symptoms—and even then leave out some of the important information.

Take, for example, a woman complaining of pain. Her immediate symptom and reason for visiting the doctor is, well, *pain*. We all know that pain is the body's way of telling us that something is wrong. However, the real problem is not the pain but, rather, an underlying cause, such as a trauma. Let's say you fall down and hit your head quite severely. The pain in your head persists for several days but you don't seek medical aid. Finally, the pain becomes so severe that you must see a physician. You tell your doctor about the severe pain—a headache—but say nothing about the fall—the trauma. Without knowing about the trauma, the physician may overlook a severe injury to the brain. He may even overlook a subdural hemorrhage, which is bleeding in the brain and requires immediate surgery.

This happened to a patient of mine once. He'd fallen while taking a short cut, running through a golf course to attend a meeting. On his run, he fell and hit his head on a sprinkler. After having headaches for three weeks he finally saw his physician—who treated him for the headache. But he never said anything about the fall. After three more weeks he was seen again complaining of dizziness and light-headedness. Further examination revealed blood in his brain, causing pressure on the brain and irreversible brain damage. This patient eventually lost a good part of his brain function.

The point: you must tell your physician all of the important information regarding your symptoms and any relevant information as to how they could have occurred.

Among the misconceptions in medicine is the belief that physicians should determine the symptoms from patients by serial questioning rather than listening to patients freely deliver their symptoms. To illustrate what this means, think of your car. If you were to take your car to the mechanics, say that *something* is wrong, and then leave your car, you may not get your car back with the problem resolved. You can help by telling the mechanic what you think the problem is—steering, brakes, transmission, etc.

Car repair is only a little different than medicine. Patients can alert a physician to the wrong area of symptoms so that the investigation begins in the wrong area. A good example of this is a patient who has a scar on his abdomen. Typically, when asked what type of surgery a patient has had, very often the answer is *none* or *I don't know.*

Patients have a hard time recalling procedures and surgeries performed long ago—or while they were children. Long and complicated names of procedures can also make it difficult to remember. And, some are never completely informed of what they've been through. So they notice the scar but don't recall what was done exactly.

In some instances, the scar is from an injury and not from surgery at all. It's very important to know what a patient has had and helpful to know by whom. Remember: a scar on the right side of the abdomen does not necessarily refer to surgery to remove the appendix. In some rare cases, the appendix is removed from the left side. Knowledge of previous procedures is helpful and absolutely necessary in the proper treatment of an impending condition. It's also important to alert doctors to what medications you are taking, if any. Sometimes, the cost of a diagnostic test can be avoided if the proper information is conveyed to your physician.

> **Everyone knows when a new transmission was installed in his car but, when it comes to medical treatment received, people often draw a blank.**

The Importance of Medical Records

Because people move around so much these days, they never think to take medical records with them. They don't keep a record of where they received certain treatments, who were their doctors and what hospital those doctors were affiliated with. Records can always be transferred, but many don't think to do so. For your own safety, you should make copies of your records and keep them safe. Don't expect records to remain in a doctor's office for an indefinite number of years, either. If your file remains inactive for a long time, chances are your doctor will retire your records to an archive elsewhere, and it will be very difficult to retrieve them.

There's nothing wrong with requesting a record and copying the vital information for yourself. That way, if you move or switch doctors suddenly, you won't have to worry about conjuring up your medical history.

Isn't your health more important than your car? It's good to understand simple terms regarding your health. Most don't know what saturated fat is, what blood pressure means (and what theirs is) or what a colonoscopy does. Later chapters will give you a working knowledge of important terms, as well as equip you with the information you'll need the next time you visit a doctor. Because it's so important to keep a good record of your history and health care, I'll give you ways to start or add to an existing record. Having a good idea of your family's health history can be the most vital tool for managing your health.

Mistakes Still Happen

Technology has made more things available to us. Ten years ago, most people didn't carry cell phones, have access to the Internet or the opportunity to fix their eyesight with a laser in an outpatient doctor's office. Diabetics, for example, can now monitor their own blood-glucose levels and use insulin pumps to deliver medication when they need to—without having to rely on a doctor to manage their diabetes on a daily basis. A catheter is placed into a subcutaneous space of the abdomen or buttocks and

connected to the pump that can be worn in the manner of a small pager. This not only cuts out the need for constant and costly medical attention, but it improves the quality of life for the diabetic. The patient feels more in control of him or herself, and autonomy alone can have a big affect on the psyche.

Today's machines can detect much more than ever before. MRIs (magnetic resonance imaging), CT (computed tomography) scans and PET (positron emission tomography) scans are all examples of techniques used to detect and diagnose illnesses or impending disease. Although the machines used are high-tech and require skillful technicians to work and adept doctors who can translate results, these scanning methods have made indentifying medical problems faster and more accurate.

But they can complicate things. Healthy people ask for "body scans" to look for potential illnesses and end up focusing on insignificant abnormalities.

And old-fashioned mistakes still do occur. X-ray films (or scans) can be misread or read backwards. Cultures can be mislabeled. Surgical instruments can be miscounted after closing up a patient. This should not be the case.

Part of this is our medical community's fault. But part of the problem lies with patients who don't take charge of their health care and learn how to be a patient. If you don't give all the necessary information to your doctor, how can you expect him or her to provide the best care? You can't.

Communicating Clearly

I recall a great day in medical school when we were challenged to interview patients without touching them. In other words, we could ask any questions we wanted to regarding the patients' symptoms, complaints, etc., but we couldn't use our hands to examine them. Our entire diagnosis had to come from our conversation with the patients. Instead of touching and asking if it hurt, we had to revert to their answers to: *Where is your pain?*; *How bad is your pain on a scale of one to 10?*; and *Can you describe your pain in words?*

We all learned a lot that day and the experience remains with me. It reminds me to regard the questions I ask and the answers I get from patients as the most valuable tools in practicing medicine. I think that physicians should remember days such as this so they can come to proper conclusions from listening. Unfortunately, some doctors don't make the time or effort necessary to listen to their patients. They funnel you in and out as fast as possible. This is another reason for becoming a more informed and attentive patient: It will minimize the chance of mistakes.

Rx Overload

The number and volume of drugs available today is mind-boggling. There is such an array of antibiotics available that most physicians find it challenging to even remember 20 percent of those on the market. New ones come out every day. Not only must doctors remember the trade name of a drug—which are the names you see on TV like Allegra, Viagra and Celebrex—but they

also have to remember their generic names (fexofenadine, sildenafil citrate and celecoxib). Drugs can sound alike so it's easy to make mistakes.[1]

With the vast number of drugs available on the market today, the wrong antibiotic can be prescribed if a physician is not aware that the drug ordered does not effectively work on you or your ailment. As a patient, you must give some attention to this fact and do your own research, too.

The drug companies know that it's hard for doctors to keep abreast of every new development in pharmaceuticals. It's one of the reasons they pay to put ads on TV and in magazines. The drug companies want *you* to remind your doctor.

Chances are you've seen the various ads showing someone sneezing and then suggesting that you contact your physician for this drug (e.g., Allegra, Zyrtec, Clarinex, Flonase, Nasonex, etc.). Most of these drugs are relatively new. Your physician may not even know about some of them.

At the same time, the medication may not be what you need. Pharmaceuticals is the fasting growing health care expense, and will continue to be a seriously debated topic. From promotional spending on prescription drugs to the glut of pills and potions for this and that, you need to know a few things about drugs and how to make good decisions about the prescriptions you choose.

[1] Chapter 7 is dedicated to discussing the subject of pharmaceuticals in great detail. I'll cite true examples of how mistakes in medication take place.

Medicine and Money

How health care providers—and the financiers around them—get paid says a lot about the culture and society that they serve. How certain drugs and therapies get regulatory approval while others languish in a limbo of endless tests and research says a lot about how our government works. And how insurance companies decided what to cover—and not cover—says a lot about the business environment.

The trillion dollar health care industry is the largest industry in the U.S., employing more people than any other. The annual budget and expenditures for health care in the U.S. exceed any other industry. Just think of the number of people it takes to deliver the health care you receive. Think of the number of meals served daily in medical complexes and hospitals. Add to this the salaries of all the workers in the medical field—nurses, nurses aids, cleaning help, maintenance, gardeners, painters, electricians, carpenters or the pharmacists, physicians, office managers, file clerks, etc. These numbers are astronomical. And these numbers don't include the gas, electricity, telephones, faxes, linens, drugs, bandages, etc.

Our health system's reliance on managed care has changed everything, which is why I've dedicated a chapter to health insurance (Chapter 5). It's hard to put "effortless" and "health coverage" into the same sentence, but it's worth familiarizing yourself with how to buy the right medical insurance—and pray that it comes to your rescue when you need it most. When it comes to peace of

mind in the medical arena, insurance is part of the package. And taking charge of your health care begins with a good medical plan.

> **You, as part of the general public receiving medical care, need to have some knowledge of what is going on and take some responsibility for your own care. If you don't want to be a victim of the system, you must have some knowledge and an understanding of what will occur and how to direct the care you receive. The pool of knowledge has gotten so vast that there are specialists in every little field.**

Remember: the only reason for specialization is that there is too much to know—and one person can't know it all. You must be sure that the doctor you choose is really a specialist in that particular field.

When I was a medical student, I was sent on an externship. I went to a small town to observe how medicine was practiced there.

At that time there were only a handful of specialties in that town: general practitioners (or family doctors), surgeons (and all sub specialists), internal medicine (including cardiologists, gastro-enterologists, pediatricians, etc.), dermatologists, EENT (ear, eye, nose and throat) and orthopedists (bone doctors). Many doctors had not taken the extra time to study various fields so they just called themselves "specialists." (A medical license does not specify whether or not one is a specialist.)

I was sent to work with a highly respected internal medicine specialist. As soon as I arrived, we began a major surgery. The procedure the doctor was performing was a gastrectomy—removal of the stomach for cancer. After we all scrubbed for the surgery, an old wooden music stand was brought into the room and covered with a sterile drape.

Next, the sterilizer was opened and a sterilized book of anatomy was placed on the music stand to refer to throughout the procedure. I was horrified. The doctors and even the nurses assisting the procedure knew that the physician didn't know the anatomy well enough and had to be guided through it. Would you want to be the patient in this situation? Do you think that the patient was a victim? I do.

I still don't understand how that physician could practice medicine with so little knowledge. While at medical school I saw several surgical procedures and *never* noticed a reference book used during procedures. Needless to say, I was shocked and stunned by what I had seen during my externship. The book was referenced many times during the procedure. At the end of the procedure—which lasted eight hours—everyone was relieved that it went well.

The memory of that open book on the music stand is one of the main reasons I wrote this book.

Don't Be a Victim

This book is not a guide on how to sue your physician or be a problematic patient. Nor is it intended to guide you in degrading your physician. I've been a physician (with a specialty in surgery)

for over 40 years and have the utmost respect for my profession. I want you to be knowledgeable in the treatment you receive and to know that things can and do go wrong; further, I want to show you how to prevent errors from occurring and to be wary of the credentials that your physician does or does not have.

> **Medicine is complex and consists of an enormous volume of knowledge. To understand what is happening you must have an understanding of this complexity. This book will give you some insight into the problems that occur, the way diagnoses are made and can go astray...and how you can take charge and achieve the proper treatment for your condition.**

This book is based on true accounts. I have traveled extensively and have witnessed medicine in many parts of the world. I hope that after reading this book you become more aware of the problems occurring in medicine and of how you can help by taking charge of your health in an effort to receive the best care available. It's in your hands. You must take an interest in your care and, in some instances, help to direct the course of events that take place. You can and must do it.

Today, there are many more options than ever before. Conventional therapy changes all the time. It's up to physicians to keep abreast of the changes that happen and adjust their practice

to offer the best care available. A few years ago ulcer disease was very common. People had ulcers that were treated with special diets, antacids and in some instances, surgery. Now we know that bacteria cause many cases of ulcer. Peptic ulcers, for example, are blamed on Helicobacter Pylori (or H. Pylori). The ensuing infection is best treated with antibiotics that rid the bacteria as you would other types of bacterial infections. This is a big change from the old treatments.

For nearly a century, stress and dietary factors were believed to cause peptic ulcers. Hospitalization, bed rest and a bland diet were routinely prescribed to treat the disorder. Later in the 20th century, researchers attributed peptic ulcer disease to an imbalance of digestive fluids—hydrochloric acid and pepsin—and the stomach's ability to defend itself against the injurious effects of these powerful substances. So, antacids became the treatment of choice.

Since the 1970s, a number of potent anti-ulcer drugs have been introduced that are highly effective in enhancing the stomach's defense. But not until the discovery of H. Pylori did a new way to treat peptic ulcers emerge.

Scientists now believe that bacteria may contribute to heart disease, a discovery that may be more important than understanding the effects of cholesterol on the arteries. Thus, treatments and approaches to illnesses are constantly changing. Alternative medicine has become popular, but these methods have yet to be proven effective. In some cases, they are worth a try. There's scream

therapy (laughing), herbs, manipulation, etc. They all must be considered by the patient.

> **Don't be a victim. Consider the treatment possibilities and then decide. You can get advice from experts but ultimately, you make the decision. Ask your physician what he or she would do if in your position. Then make the decision. Often, mistakes are made because you, the patient, are not involved in the decision-making. Get involved. After all, it's your life. But, before you can make a decision, you must have the facts. For this reason, you rely on the expertise of the physician to help you with your decision. You work together. As you'll see in Chapter 6, you and your physician form a pact.**

What a Difference a Decade Makes

The world of the 21st Century is already completely different world from the world of the late 20th Century.

With advancing technology in all fields, most industries are immensely different than they were two decades ago. Medicine has led the way. Laparoscopy (direct visualization of the internal organs with a telescope-like instrument and a fiber optic system for light) and laser have become common methods of surgery. New antibiotics come out every year.

And—partly in response to those developments—new types of health care delivery systems have evolved. Chief among these: the health maintenance organization or HMO. HMOs have been criticized, but not all of the changes that come with HMOs are bad. The first thing most people say when someone mentions *HMOs* is that they are terrible. Everyone has a horror story to tell. So, you'd assume that the quality of health care would be the major motivating factor behind the choice of a health plan—but it's not. Price drives consumers...and HMOs are cheap.

But they can be effective—if you use them well.

A few years ago, my wife suddenly became ill from what I thought was food poisoning. The next day, her symptoms worsened. She had diarrhea, severe nausea, some abdominal pain and problems with her eyes. One eye pointed downward while the other pointed upward. I gave her some antibiotics immediately but by the next day her symptoms had worsened and I thought we needed to consult a doctor who specialized in these matters. We belonged to an HMO so we went to see our primary physician.

Upon arrival, we were immediately sent to a neurologist (to rule out a brain tumor, etc.), an ENT specialist (to rule out severe sinusitis or severe abnormalities of the sinus such as a tumor), and an infectious disease specialist. My wife was then given an MRI. Within two hours, all the tests had come back and we were informed that my wife had a mild case of botulism.

Without an HMO membership, this kind of emergency may have taken days—not hours—to perform. My wife was able to see several specialists, all within the same building, in order to get

to the bottom of her ailment. With private insurance, we would have had to travel around to the various specialists and testing centers. And, when it comes to certain situations, time is of the essence.

Conclusion

This chapter opened the conversation up to a variety of issues that will be discussed in further detail throughout this book. Your goal is to become an aggressive, smart consumer of medicine...and not resort to the old way of being a passive patient. At the beginning of this chapter, you pictured yourself lying on an operating room table awaiting surgery and asking yourself a lot of questions. You were a passive patient. Once you learn how to be a patient prior to landing in the ER or operating room, you won't have to worry so much about the kind of treatment you'll receive and what will happen when you wake up. You will have become an *active* patient.

Taking charge of your health care today means understanding what has happened to medicine in recent years, and where it's going. Responsibilities have changed, roles have changed. Doctors and their patients are having to embrace new realities that alter the way they interact and manage medicine together.

In the next chapter, I'll discuss medicine's past and show you current trends that continue to have an impact on how you deal with your own health now and in the future.

2. The Doctor *Isn't* Always Right

Medicine is very different today than it was just a few decades ago. This is true for both doctors and patients. The surge in recent medical developments, including pharmaceuticals, has put more pressure on patients to care for themselves...and has made malpractice a more hotly-contested issue. Moreover, events in recent history—from the sexual revolution to court cases and the development of the health maintenance organization—also have made an impact. The resulting change is not only a shift in management, but a shift in where the responsibility lies when it comes to medicine.

Changes propelled by new ideas and technology happen every day. Most people born in the 1970s and after don't know a world without television. Some have never seen an alarm clock with hands on it. They don't even know what an LP record is—or looks like. They are familiar with a world of computers, X-boxes or Playstations, DVDs and cell phones. Because most people use some form of modern technology every day, they are continually tuned into the evolution of those advancements. You know, for

example, when there's a new way to watch movies at home, hence the sudden conversion of people's entertainments systems to DVD over the old VHS.

You may not, however, be as equally aware of changes that take place in other fields. Medicine, for example, is not a subject typically followed closely by the average person unless the subject (e.g., the 2003 SARS outbreak) lands on the front page of the paper or you get sick and suddenly need to update your working knowledge of it. Only then do you realize the extent of the changes that have taken place in medicine.

As medicine progresses in technique, treatment and pharmaceuticals, our knowledge of disease, germs and anatomy changes little. True, there are new types of germs...and new diseases. But most ordinary people have not kept up with the changes in medicine and, in particular, in the way medicine is delivered to the public. Ordinary people must begin to take the responsibility for their own health decisions and know that no health provider, be it a private physician or HMO, should make all the decisions.

> **You must be at the helm of your own ship. To receive the best medical care and avoid costly mistakes, you must give up being the passive recipient of care and instead, become a partner with your clinicians.**

After more than 40 years of practicing medicine, I began to realize more and more that the public needs some hand holding,

guidance and a little education to gain the confidence they need to help them make the right decisions. This book is *not* intended as a guide on how to sue the medical community. It's intended to show you what goes on behind closed doors—in your doctor's office, hospital, etc., so you can become an informed patient.

A Mystical Profession

In ancient times, the practice of medicine was associated with mysticism, and the body was revered as something sacred. Some argue that it still is. As long as unknowns exist, people will have fears and superstitions about medicine and its practice. Voodoo, for example, sprung from fear and awe of the human form. Various types of care evolved within cultures based on how people regarded the human body. And those who took care of the body were highly revered.

Some religions hold that the human body, having been created by God, belongs to God and we merely reside in it; our duty is to take care of our body and not abuse it. If we fail to do this, we've committed a sin.

Other cultures, notably the various tribes in Africa that believe in a "Shaman" or witch doctor who can perform magic, hold that altering the body—such as making large lips or ears or perforating the nose—is actually enhancing its beauty. Then there's the notion that if you commit a sin, you are punished—and in some instances you get a devastating disease. This idea evolved into the idea of curses, which get cast upon you. Thus, if you're "bad," you're cursed to be deformed or have evil bestowed upon you.

This, in turn, led to the concept of witches and devils. The idea of the Devil actually getting inside a human body and residing therein was believed for a long time and could only be cured by exorcism. The movie *The Exorcist* dealt with this issue, and those who remember that movie won't forget it.

In medieval times the physician was the healer, often called upon to heal the king. If he failed to do so, he was ridiculed, punished or beheaded. If he succeeded, he was revered throughout society as a healer.

In Native American cultures, the medicine man could cure disease. And, in as late as the 1930s some cultures believed that taking blood from the mother and injecting it into the child could prevent polio. Other superstitions included walking babies over a bridge or river; if you did this, you protected a baby from polio. People in the U.S. heeded this advice during the epidemic.

So, while the human form stirred various practices and superstitions, people's perspective of the physician revolved around the human form, too. The doctor was revered because he could treat the ills of the body. The doctor could make people better. As a result of this demigod status, many believed the physician was untouchable, a leader of sorts. Doctors had the answers and everything they said was to be followed.

When I was a child growing up in a small Midwestern town, the physician was revered. He was the final world—the law. Doctors amassed enough power to sway anybody. From this status came clinics named after the healers: The Mayo Clinic in Minnesota, The Leahy and Cushing Clinics in Massachusetts, etc. Those

associated with these esteemed clinics were considered the last word in medicine.

Because the belief that physicians had all the answers—and were close to God in a sense—pervaded for so long, it's no wonder that some of today's medical practices are rooted loosely in this idea. For example, prescriptions are still written in Latin. Why aren't they in plain and simple English? *II tabs. tid.* means take two tablets three times a day. Medicine's Latin history with regard to its language isn't an easy thing to change, but it automatically creates a barrier between laypeople who never learned Latin and doctors who must pick up this old language in their medical education.

To some extent, medical jargon becomes a secret language or code that distances physicians from the public. Only they can decipher their language. But it's also true that medicine's language has crept into the public arena with the spread of public health and today's aggressive pharmaceutical campaigns that target consumers. Social changes have also played a part of taking the mystery out of medicine.

The sexual revolution of the 1960s and beyond changed a lot in the way information about the human body got disseminated. Terms of the human body's sexual organs filtered into people's everyday language, making everyone aware of his or her own

anatomy and certain functions of the body. Because of this and the promotion of health and the human body in the public education system, the younger generation now has a better understanding of its physical being. Some of the mystery is gone.

Of course, there's nothing wrong with knowing the various organ functions in your body. You should all know the functions of all parts to your body. Of course, you won't know the functions in as much detail as your physician, but you can learn the basics of anatomy and physiology. This should not be a secret.

The Role of Autopsies

Autopsies determine the causes of death when it's unknown or unnatural; they also help define causes of disease. Forty years ago, autopsies were performed on a regular basis. In about half of all in-hospital deaths, most clinicians requested autopsies and most pathologists performed them without hesitation. Back then, the value of autopsies was widely recognized, the list of diseases discovered or clarified by autopsies lengthened dramatically and scientific technology advanced greatly. In recent years, there has been a large decline in the number of autopsies performed—especially at private hospitals.

It's generally accepted that four reasons—all of which revolve around money—explain the decrease in autopsies:
- lack of direct reimbursement;
- lack of defined minimum rate standards;
- fear of malpractice litigation; and
- the belief that technological advances have replaced autopsies.

In my opinion, the third reason—a doctor's worry that an autopsy will reveal some mistake on the part of the hospital and its staff—is the most common. Consider this: Premortem (before death) diagnostic errors are still found in approximately 40 percent of all patients autopsied. When an autopsy uncovers an underlying problem not previously diagnosed when the patient was alive, the doctor(s) and hospital become vulnerable to malpractice lawsuits.

A look back at 2001 illustrates the value—and importance—of autopsy results when it comes to understanding how we die and what others can do to prolong their own lives.

In 2001, the sudden cardiac deaths of young athletes made the headlines when a few football players collapsed and never played again. Florida State linebacker Devaughn Darling died in February 2001, most likely from cardiac arrhythmia; Florida fullback Eraste Autin died of a heart attack on July 25; Minnesota Vikings offensive tackle Korey Stringer, 27, died of heatstroke following a workout on July 31; Northwestern safety Rashidi Wheeler died of asthma complications on August 3. In 2002, many learned about St. Louis Cardinal pitcher Darryl Kile's fate after he died in his sleep at the age of 33—because two of the three blood vessels leading to his heart were almost completely blocked.

> **While nontraumatic sudden death in relatively young people who participate in athletic activities is not common, tragedies do occur. They gather high public attention and generate considerable concern because they are supposed to be "young"; "healthy" and "active."**

While the families of Darling, Wheeler and Stringer accuse the teams and their medical staffs of various degrees of negligence, the public is left to wonder: who's responsible and how can we prevent this in the future?

The training programs automatically come under fierce scrutiny, but the most powerful way to prevent these tragic events from happening is by detecting cardiovascular abnormalities (various unsuspected congenital cardiovascular diseases are usually responsible) before disaster strikes. This means empowering people to know about their own health risks and history. A young body that suddenly gives out points to there having been a growing problem that went unnoticed and undetected.

> **You can't rely on other people to detect those problems and predict your life expectancy unless you first pay attention to what your body tells you. If you do rely on others to manage your health risks, you're ultimately relying on other people to determine your cause of death after you've collapsed and succumbed.**

All of the sports players mentioned above had some telltale signals leading to their sudden deaths. Darryl Kile's father, for example, had heart disease in his family. If his dad had died of a heart attack in his early 40s, Kile should have known to undergo special tests (e.g., electrocardiogram, stress test or angiogram) to

check his own heart. In Stringer's widow's wrongful death lawsuit against the Vikings and its doctors for $100 million, the court will have to decide: To what extent can individuals hold the medical community liable for their health risks? There is no easy answer. One can argue that a level of personal negligence played a part in these dead athletes' lives.

As you move farther into this age of information, where you have more access to data and an enormous amount of research at your fingertips, you must become more knowledgeable of common ailments, symptoms and problems regarding your body. You can't keep blaming the system or your doctor for your own negligence. If your mom had a heart attack when she was 45, and if your father died of cancer when he was 55, this means you need to take certain precautions when it comes to your health. Don't expect your doctor to predict your risk for these illnesses without telling him or her about your parents' early death. Later in this book I'll give you a sample family pedigree from which you can construct your own and share with your doctor.

The following is a short list[1] of some of the things you should know when it comes to your body:

- blood type;

- blood pressure (whether it's high, low or normal);

- cholesterol level;

- weight; and

- family history of heart disease, stroke, cancer, diabetes, Alzheimer's or other disease.

[1]In Chapter 10, I'll review this list above and give you a more detailed list of things you should know.

Throughout this book, I'll also give you some key tips to understanding basic symptoms, what they can mean and how you can help your physician in his or her diagnosis and treatment of your problem. If you knew, for example, that shoulder and neck pain can be an indication of a heart attack, you might be more inclined to see your doctor before the actual, fatal attack happens. Or, if you knew the difference between the common cold and the onset of influenza, you'd be better able to decide whether or not you really need to go visit the doctor and beg for antibiotics.

Think about this: If you make an appointment with your doctor and tell him or her how and when you first noted a variety of symptoms, describing when and how they became more severe and what you think might be wrong, your doctor will be able to diagnose the problem and offer a solution more quickly. Just by you being aware of your symptoms and being open to talking about them saves time and money. Your physician would still make the final diagnosis, but a lot quicker with your participation.

The key is not to play dumb when you're with your doctor and expect your doctor to provide all the answers to your possible ailments. Some people play dumb out of fear for the doctor and what he or she might have to say; it's time to get over the fear and face the facts.

Traditional Medicine Gets Managed

By pointing your doctor to the specific area of your pain, you aid in the steps to your diagnosis. Or, you can be even more specific by saying, "I have pain in my upper right quadrant" (i.e., pain over the liver or gall bladder area). Your doctor will be able to start testing those organs without having to run through a gamut of other tests.

In traditional medicine—medicine before the arrival of managed care—most of people's health needs were left to the physician. People weren't supposed to concern themselves with health problems. If you felt ill, you saw your doctor. If your stomach ached, you asked your doctor to fix it. It was up to your doctor to arrive at a proper diagnosis and prescribe a course of treatment without much input from you—the supplicating patient.

Besides the impact the sexual revolution had on teaching people about health-related issues, managed care has also come to play a big role in how people approach their health care. In many ways, managed care forces people to take better charge of their health care. It does this in the way it attempts to minimize runaway costs: by calling for second opinions before lengthy or invasive treatments and for people to decide whether or not to continue or discontinue their care.

When a series of "right to die" cases were made public in the 1970s and 80s, patients and their families won more power when it came to making critical life decisions. You might recall Karen Ann Quinlan's story and her family's plight: after falling into a persistent vegetative state following two 15-minute periods dur-

ing which she ceased breathing, Quinlan lingered for 10 years in a nursing home before dying in 1985. When her family realized (early on) that their daughter would never wake up, they begged the hospital to remove the life support and let her die in peace. It took a long battle before the New Jersey Supreme Court eventually gave those rights over to the family instead of leaving the decision to the hospital, which refused to end her life. The family then alleged that nuns in the hospital secretly weaned Karen off the respirator so she managed to survive without it...and take 10 long years to die.

The U.S. Supreme Court didn't recognize a "right to die" until June of 1990 when it issued a decision that acknowledged its existence, but qualified that finding by arguing that it was entirely appropriate for the states to set "reasonable" standards to guide the exercise of that right. (Most states, however, do not categorize feeding and hydration tubes as extraordinary medical measures, so "pulling the plug" often cannot include switching off these life-saving machines.) Terms to right to die situations and others that can be categorized under "euthanasia" (i.e., the act of terminating a person's life because he or she is hopelessly sick or injured) are hazy and will continue to be challenged in the courts for years to come. Oregon is the only jurisdiction in the United States where assisted suicide is legally sanctioned.

Empowering people with the right to make clear-cut decisions about the course of their treatment, including extraor-

dinary medical procedures, has the subtle effect of getting people to learn more about health issues before making major decisions.

Without a medical degree or a course in biology you've probably absorbed a lot of medical terms and phrases. Names of obscure medications have become part of your everyday language: ibuprophen, acetaminophen, clotrimazole and pseudoephedrine. Initials and names of diseases and syndromes are things you read about in your daily papers: TB (tuberculosis), HIV/AIDS (human immunodeficiency virus/acquired immunodeficiency syndrome), mad cow and ebola.

A whole new approach to educating laypeople about medicine has emerged—particularly among young people. Nowadays, teenagers are more likely to know what the effects of alcohol are and how HIV is transmitted. Adults are asking their doctors about medicines they hear about on the radio or TV, and they know what Viagra is all about. You can't watch a sitcom without getting bombarded by drug ads, and you can't be a regular watcher of *Dateline*, *60 Minutes* or even the nightly news without seeing coverage of a medically-related piece at some point.

Despite the volume of information out there, there are still missing pieces to the puzzle in American health. People don't necessarily know what to do with all that informa-

tion; many don't know how to process it, ask for more, decipher the good from the bad and use the helpful points to best manage their own health. By the end of this book, you'll know what to do with the information...and you'll understand what kind of standard of care you should expect from your health practitioner.

Standard of Care

As new ideas and technologies change the course of medicine, standards of care change. In simple terms, a *standard of care* refers to a certain way that has been established by the majority of practicing physicians for the care and treatment of most diseases. This doesn't mean there cannot be deviations from that standard but, for the most part, there is a set way to arrive at diagnoses and a standard way of treating most of the known ailments.

Given the accepted standards of practice, *medical malpractice* results if a doctor injures a patient by using skill or rendering care that is less than that what could be expected from a reasonably competent doctor in diagnosing or treating the same condition.

When I first went into medicine in the late 1950s, the average price of medical malpractice insurance was $35 a year. Today, if you're an obstetrician in Miami, you could pay more than $200,000 a year in insurance. In most malpractice cases, a plaintiff must present expert testimony on what the standard of care is and the manner in which the defendant departed from that standard. Medical

malpractice lawsuits often become battles in which each side has expert witnesses declaring different acceptable medical standards.

As standards of care have become more established and people have begun to question the skills of doctors, lawsuits have become more prevalent. When I entered medicine, standards weren't so clear, physicians' diagnoses and skills weren't challenged and they were rarely sued for malpractice.

Times have changed. As a patient, you can't rely on your doctor to supply all the answers all the time...and you can't rely on your doctor to be the decision maker in all scenarios. Let's look at an experience I had early on in my medical career.

It was 1961. One of my first cases was that of a 36-year-old woman with a lump in her breast. In 1961, the accepted standard of medical care and practice was to first remove the lump (mammography had not been invented then) and give the specimen to the pathologist. After a careful examination of a frozen section of the lump, the pathologist would then tell the surgeon what to do—either make sure the whole lump was removed, if the diagnosis was benign (non-cancerous), or remove the entire breast, all of the muscles below the breast and the lymph nodes of the axilla (the armpit) if the diagnosis was cancer.

Things were tense in the operating room that day. The future of a 36-year-old woman rested in my hands. I carefully removed the lump and handed it to the pathologist. I then waited with the patient, still under anesthesia, for the pathologist's result. After 30 minutes, I decided to go to the lab myself. I told everyone that I was going to the lab, asked them to watch the patient carefully, and said that I'd be right back. When I got to the lab, I found the pathologist sipping a cup of coffee.

"Would you like some coffee?" he asked.

"No." I wanted to get back to the patient who was still under anesthesia. "What's the result? Is it cancer or not?"

His answer struck me like a bolt of lightning. "I'm not sure," he said, then added, "take off the breast and I'll make the pathology fit the case."

At first I didn't know what to say. *Take off a breast when we weren't sure of the diagnosis? How could he not be sure? Was I some type of new maverick? How many other times had he done this to other physicians? How many women had lost their breasts or other organs to the callousness or egotistical behavior of pathologists or other doctors?*

I was stunned. After a long pause I finally spoke. "If you're not sure, I'd rather wait for another opinion and close this case than remove a breast. Please send the specimen out for two or three other opinions."

The pathologist agreed. When I returned to the operating room, I left the breast intact.

Seven days later, the pathologist told me that he had the reports back from three different pathologists who all agreed that

the specimen was benign—non-cancerous. I was delighted. My patient did not have cancer and still had her breast.

I don't want you to think that everything that occurs in the practice of medicine is culpable for lawsuits. I will, however, discuss how much *malpractice,* meaning *bad practice regardless of legal implications,* does occur. I will tell you some tales that occurred in the physicians' locker room. I will tell you of tales that occur behind closed doors. I will tell you of some things to look out for and also many positive things that do occur. I hope to present a useful guide for you to follow in discovering some of the pitfalls that occur and how to prevent them.

Let me give you an example of what I am talking about.

Very few of you would undertake a major overhaul of your car without at least some knowledge of the mechanic, the shop or the problem that exists with the car. You would probably have talked to friends or others and gotten referrals to the best mechanic, the best garage or the best shop to repair the problem that exists. You would want to know exactly what is wrong, what is to be done to correct the problem, when it will be ready, how long it will take, how much it will cost and for how long the repair will be guaranteed.

However, when it comes to the most important thing that you have—your health—you don't usually ask these types of questions often enough. You accept at face value what your physician says—regardless of whether he or she is right or wrong.

> **It is only recently with the advent of the second opinion that questions have begun to be raised. However, you must**

> **remember that the idea of a second opinion was brought about by the company paying the bill for the service—often insurance companies or HMOs—and not by the public.**

In today's medical environment, everyone must learn to question providers about health—to ask questions and keep records about what's been done and what is being proposed.

It may be hard to believe, but many times in my office I'd see patients who had scars that they couldn't explain. Medicine is not a mystery. There are answers. Informed consumers need to know them.

Medical Malpractice

There is a difference between litigated medical malpractice and the kind of malpractice I talk about in this book. Generally speaking, medical malpractice refers to bad medical practice. The word *mal* in Latin means bad or, as interpreted, inappropriate. *Any* practice performed incorrectly or not within the standard of practice is considered malpractice. You don't have to have an ensuing lawsuit for a bad practice to be malpractice. When I talk about malpractice in this book, I am referring to any practice committed by a doctor that is bad, whether it has legal implications or not.

I'm not implying that much of medicine is bad medicine. That is not true. But malpractice occurs more often than one would

expect. For this reason I decided to write this book from the perspective of an insider to tell the public what I believe to be true: that the most missed diagnosis is that of malpractice.

When most people hear the word "malpractice," they think about the legal definition of the word. According to Black's Law Dictionary,[2] in medical malpractice litigation, negligence is the predominant theory of liability. And, in order to recover for negligent malpractice, a plaintiff must establish the following elements:

1) the existence of the physician's duty to the plaintiff, usually based upon the existence of the physician-patient relationship;

2) the applicable standard of care and its violation;

3) a compensable injury; and

4) a causal connection between the violation of the standard of care and the harm complained of.

A discussion about malpractice does not need to reflect the legal aspects, however. Malpractice happens every day and often goes undetected by the patient. One must also remember that what lawyers interpret as malpractice is harm. As in basketball—no harm, no foul. This means that, according to lawyers, if no harm has been committed there is no reason for malpractice. Medically, this is not true. Malpractice doesn't necessarily mean a doctor is willfully and grossly careless. It can simply refer to improper or unskillful treatment, which results either from negligence or neglect.

[2]Black's Law Dictionary, 6th Ed., p. 959

Conclusion

In considering malpractice, I fully realize that medicine is still a practice, and that doctors are human, too. However, some standards have risen and certain standards are the norm in practice and should be followed. This book demonstrates where the norm and standard have been broken and not followed. Through my stories, I'll show you exactly what I mean.

Legally speaking, malpractice has been focused to a smaller range of issues and disputes. Why? Economic changes have put more responsibility on patients, shifting the role that the law can take on cases dealing with medical malpractice. For the purposes of this book, I will not delve into the complex legal aspects of malpractice. On the contrary, I will focus on the non-legal elements of malpractice, which become increasingly critical the more people accept responsibility for their health care.

CHAPTER

3.

Pain Is a Signal for You
to Take Inventory

Pain is everyone's first clue that something is wrong. There are many kinds of pain, and it can be subjective or objective. What you feel as severe pain might be just an ache to other people. Pain can be so devastating as to cause disability. It can cause you to lose all of your rational behavior, spend an exorbitant amount of money and go to all lengths to stop or lessen the pain.

On the other hand, you might have thick skin, ignore the pain and continue on your way.

Pain and its management have come a long way in medicine. A defined body of knowledge and scope of practice have emerged, and today, pain medicine is recognized as a discrete specialty by the American Medical Association (AMA). When it comes to the impact of pain, the Nuprin Pain Report[1] specifically notes that four billion work days are lost each year that result in a financial loss to the economy in the amount of $79 billion per year.

Pain relievers—like aspirin, Tylenol, ibuprophen and Aleve—are among the most common over-the-counter drugs. Between

[1] Source: R. Sternbach, Survey of pain in the US: The Nuprin Report, Clinical Journal of Pain, 2:4, 1986.

1996 and 2000, the prescription pain medication market tripled to $1.8 billion...and will probably continue to rise as Americans grow older and have to deal with chronic pain.

Some of the common disorders that result in or are caused by acute or chronic pain are: head pain, joint pain, back pain, neck pain, burning arm or leg pain, nerve pain, chest pain, abdominal pain, cancer pain and burn pain.

In this chapter, we'll study the most common types of pain and give you some tools for knowing when the pain is something to pay attention to. You'll learn that you should not concern yourself with the pain per se, but rather the *underlying cause of the pain.*

Pain in the Chest

The first thing that a physician might think of when you complain of pain in the chest is a heart attack or an impending heart attack. However, after tests have been done and the most urgent risks have been ruled out (using a cardiogram and lab tests, for example), other things come to mind. To rule out those other things often requires expensive testing. In addition to the clues your doctor gets from the symptoms you describe, he or she will get closer to a diagnosis with your history, a physical examination, special x-rays, laboratory tests, special tests and tissue and fluid examina-

tions. By combining these results with his or her own knowledge, expertise, experience and sometimes an educated guess, he or she will come up with a correct diagnosis.

If your doctor can't find a reason to say you have heart disease, you might get sent home with the diagnosis of a pulled muscle or simply indigestion.

It's important to know that diseases of the stomach can cause pain in the chest. It's well known in medical circles that disease of the G-I (gastrointestinal) tract such as ulcer, gall bladder disease, pancreatitis, etc., can cause pain in the chest. This is called *referred* pain.

Referred pain often mimics heart pain, and can be trickier to diagnose. I believe that if a doctor doesn't have the know-how to investigate the possibility of referred pain, then he or she is committing a malpractice. Most would say that if someone has a G-I disease eclipsed by pain in the chest with no signs of heart trouble, that person is being misdiagnosed. But, if the correct diagnosis were made in the beginning, the disease process and the symptoms of pain could be treated properly. This early detection would avoid unnecessary pain and discomfort and probably unnecessary surgery. So, while there's a level of malpractice in this scenario, there's no *legal* malpractice.

Let's look at an example. Assume that a 45-year-old man is on his morning run when he suddenly experiences severe chest pain. His running partner takes him to the emergency room and upon arrival at the hospital the doctors note that both his blood pressure and an electrocardiogram are normal. Additional laboratory tests also show normal results.

Even though the pain subsides, the man is kept in intensive care for observation overnight. Upon discharge from the hospital he learns that all of the tests are normal and he did not have a heart attack.

What's the problem with this situation? The man was given the wrong diagnosis. No effort was made to rule out other possibilities causing the pain; thus, no effort was made to arrive at the correct diagnosis.

Don't ever accept a diagnosis that negates a hunch—even your own hunch. In other words, if you think you're having a heart attack and learn that you're not...it doesn't mean that there's not something else wrong with you. A diagnosis should make sense out of symptoms.

You are entitled to know what caused the pain or at least what the possibilities are. If the doctors are not supplying you with this information, then you need to ask.

To illustrate this again, let's take the opposite scenario. Assume you're playing tennis and you suddenly experience severe

pain in the hip area. You stop your tennis match and go immediately to see your doctor. An x-ray of the hip area shows nothing abnormal, and you go home with a diagnosis of pulled muscle or something similar. You might even learn a fancy medical name to call your pulled muscle: myofascitis.

Many things, however, could have happened to cause this severe pain. *Did you rupture a small tendon in the area? Did you tear some muscle fibers? Is there something wrong elsewhere that's causing pain to be referred to the hip area?* Remember, pain from somewhere else can be referred elsewhere. A typical example of this is pain in the jaw or shoulders, which can indicate an impending heart attack, among other less common symptoms. You must be aware of these things in order to get the correct diagnosis—and not get a diagnosis of malpractice.

Pain in the Groin

Groin pain is often diagnosed as a hernia. First, you must understand what a hernia or rupture is and how it causes pain. A hernia is really a hole in the muscle coverings of the body, mainly the intestinal wall. When the bowel gets caught in the hole and gets pinched, pain occurs. But, you could have a simple muscle pull or strain that causes the same type of pain.

Throughout my career I've seen several cases of misdiagnosed hernias. Many times a weakness in the lower intestines was misdiagnosed as a hernia when there was no hernia there at all. In some instances, muscle pulls were diagnosed as a hernia. If these cases

were taken to surgery, by the time you recovered from surgery, the pain from the muscle pull would have subsided and you'd be left with a whopping medical bill for an unnecessary procedure.

I've witnessed coffee-break conversations where surgeons confess that they've operated on people with no hernias. It can be hard to prove the existence of a hernia without making a cut, so any doctor can report one and say that he closed the hole. You are relying on the integrity and honesty of the physician; in the days when doctors can be sued for making honest mistakes, it's easier to say that he repaired a hernia than to admit he made an honest error and no hernia was present.

Unlike other repair workers, surgeons aren't always given parts to put into patients. Auto mechanics work with parts— so there's often proof when an error occurs.

Patients who undergo unnecessary hernia operations often have other problems that go undetected as a result of being overlooked for a hernia. What your doctor might diagnose as a hernia could actually be metastatic cancer or a severe back problem that presents itself as pain in the groin.

You have to rely on the honesty of your doctor, which is what makes choosing your physician so critical. Breaches in honesty happen in medicine, but you can minimize this possibility by choosing a doctor you can trust (see Chapter 5). Always seek an inde-

pendent second opinion to confirm the findings and use good common sense.

Common Sense

This can't be reiterated enough: You have to be your own boss when it comes to your health. And, being your own boss means you'll have to rely on a great deal of common sense to know when things are wrong, when the pain is so severe as to require a doctor's visit and when you know that something isn't right and you need to seek more attentive care.

Common sense is frequently forgotten amid the fury of modern life. People get so busy with day-to-day activities and chores that they forget to use common sense when it comes to the most important things in life. There's a common sense to medicine that this book aims to convey. First, if something is found wrong with you, ask your doctor: "If you had this, what would *you* do?" "How would *you* handle it?" or "Who is the best physician to treat this condition?" "Who would *you* go to?"

The point is to avoid bad practice—malpractice. Today's technologies limit the amount of malpractice, but you must press for utilizing those technologies to get to the bottom of some tricky

problems. Honest mistakes will happen; misdiagnoses will happen. You may be sent home with a note that says to take two gulps of Pepto Bismol for your stomachache and later suffer a ruptured appendix.

I don't want you to think that an honest mistake means that a gross malpractice has been committed. My point: If an error is made and no follow up corrects it, then you have a case of gross malpractice.

Pain Plus More

Everyone is in a hurry. As a patient, you're probably in a hurry and don't always give your doctor all of your symptoms. You probably forget a few or worse, miss out on remembering the moment when the pain began and the events surrounding that moment.

> **Pain is usually only one in a series of symptoms offered by the patient. If the other symptoms are understood and combined with the symptom of pain, a correct and more accurate diagnosis can be made.**

Have you ever made a list of things to say before getting to your doctor's office? When making that appointment to complain about an ache or severe pain, have you ever stopped to sit down and think about how the pain started and what the possibilities

are? Have you ever called your mom and dad and asked them if they've ever suffered a similar pain?

Things change the moment you enter a doctor's office. Most people are a bit nervous about the whole process of visiting a doctor. You have to wait and perhaps deal with medical papers. You might have to do some simple, initial tests like urinate in a cup. Your doctor won't have the time to wait for you to think of all the events that surrounded the onset of your pain. You'll be whisked in and out quickly.

In all likelihood, your doctor will do his or her best to draw the answers out of you, but you'll forget to mention a symptom or two and you'll hesitate to add more to your story. And, while your doctor mills though your records to find a reason in your history for this pain, you wait and wait for the doctor to come up with the answer—without a clear sense of the whole story.

For example, let's say you're a woman who's been having a series of severe headaches. Because you suffer from migraines, your doctor assumes that stress and changes in your menstrual cycle have triggered more migraines. Yet you fail to mention your chronic dizziness or the time your vision blurred for a few minutes. In reality, it's worse than a migraine and your doctor doesn't know to test for other things like a cancerous growth in your brain or an aneurysm.

I've seen many misdiagnosed patients who suffered from diabetes or other types of diseases who weren't originally diagnosed with these diseases. A typical example of this would be a patient complaining of pain in the foot. His physician takes a history but

only examines the foot area. Because of noted trauma to the foot, the doctor prescribes a treatment for this and sends the patient on his way. The doctor fails to look for and elicit other symptoms that would lead to other underlying problems. Diabetes, for example, could be overlooked in this case, so the doctor should have asked about excessive fluid intake, thirst, excessive urination, weakness, etc. By just looking at and treating one area of pain, the doctor misses a more serious diagnosis.

As a patient, you must take the time to remember all of your symptoms, relate them all to your doctor and be sure that your doctor listens and records the information. For this reason, it's a good idea to make a list to take with you so that you do not forget anything. Then the chances are much better that the correct diagnosis will be made and no malpractice will be committed.

I've seen misdiagnosed heart attacks because the symptoms of pain overshadowed other, more serious symptoms. Every bit of information obtained in a history from a patient is very important in arriving at the correct diagnosis. Pain is important, but other symptoms could be equally—if not more—important. It's essential that you tell your physician all of your symptoms, no matter how minuscule you think they are.

There's an old story about pain: A man injures himself and can't remember if he should use a hot or cold compress, so he calls his wife. She also can't remember for sure whether to use hot or cold applications so she asks her maid, thinking that if the maid knows all about cleaning, she probably knows about pain, too. The maid says, "Use cold first and if it does no good then use hot."

This is how many people deal with pain: they try one thing and if it doesn't work they try the opposite. Does this make sense? If you pulled a muscle in your leg while you were running, and resting it didn't seem to help make it heal, would you go out and try running on it again to loosen it up? Running with a pulled muscle would be the exact opposite of resting a pulled muscle for a few days.

You try both ways (hot and cold, running and resting) because you get frustrated with the results and you don't remember what you should do. You also don't know the exact treatment for the problems. If you had more knowledge about the workings of your body, you could prevent some of these things from happening.

So, to understand pain you must first try to understand what pain is.

The Definition of Pain

Twenty years ago, if you had a headache, you downed some aspirin. This was before the days of Advil and other NSAIDS (non-steroidal anti-inflammatory drugs) besides aspirin. Did you

know, however, that doctors gained an understanding of how these medications work only in the past 20 years? Three men in 1982 shared the Nobel Prize in medicine for discovering *prostaglandins*—hormone-like substances in the body that are the source of pain and inflammation. And when the mechanics of the prostaglandins were finally understood, we finally knew how aspirin and ibuprophen actually worked.

For years, we had treated one of the most common causes of pain—headaches—not knowing how the medications worked in the body. This new body of knowledge surrounding painkillers and how they function in the body has changed the way doctors manage pain and dispense drugs.

Painkillers like aspirin, Advil, Aleve, Excedrin and Motrin are designed to block the body's production of prostaglandins.

Pain is the body's way of sending a warning to your brain from the nerve endings throughout the structure of the body. When your body is injured, these nerve fibers send messages into your spinal cord and then up to your brain where it registers as pain. Chemicals are simultaneously released to cause redness and swelling around the injury.

Basically, pain is caused by either swelling on a nerve ending or fiber—as in the case of injury or blockage—or by changes that occur in a blood vessel. Changes can include vessel blockage or

narrowing, thus not allowing enough blood to get to the tissues. So, if your vessel spasms, narrows or clots, your tissues become deprived of vital oxygen and they begin to die, which is what happens when you have a heart attack. The result is pain.

If you understand this, you can better appreciate the cause and effect of pain and know how to best describe the pain to your physician. You can also appreciate how many times the diagnosis of pain can be missed and mistaken for something else.

If you can spot trouble when it's just beginning, you can prevent it from worsening and reaching a new plateau. You should have an understanding for the mistakes that may occur and be aware that an error is about to take place. This is not like the stock market—there are no ups or downs. There are no bears or bulls. There are only mistakes, and if left to continue or go untreated, fatal results can and do occur. I have been in medicine long enough to know that mistakes and cover-ups happen. After all, it would be foolish of the physician *not* to try to cover up his or her mistakes. One common way to do this is to try to gain your confidence and be extra courteous and attentive so that you won't notice that a mistake has occurred.

Let's assume that your doctor has made a mistake (a mistake not discovered until four or five days later). It's not life-threatening, but it has caused you some discomfort and increased disability. You have to stay in the hospital longer and you experience more pain; it takes you longer to recover. One way to cover this up is for the physician to be extra attentive. He or she will say something like, "Isn't it wonderful that I found the trouble and

was able to treat it before anything serious resulted?" Or the doctor will make rounds to see you three to four times a day and say, "You're getting much better. I'm so glad that we found the trouble before it got out of hand." I've seen this happen so many times. It's human nature to try to rationalize mistakes.

During my surgical residency a very prestigious surgeon removed a patient's breast for cancer. After the surgeon removed the breast and handed it to the pathologist, he suddenly realized that he had removed the healthy breast. He then proceeded to remove the patient's other breast. I wondered how he would rationalize this to the patient and the family. Here was his response:

> Honey, I took off the bad breast. We got all of the cancer. You should do very well. By the way, I knew that you would feel lopsided so I went right ahead and took off the other breast, too. Now you'll have nothing to worry about. Isn't that good? And by the way, if you want you can always have plastic surgery and two implants put in. But you won't have to worry about cancer now.

I was amazed by the response from the family: "Doctor, you are a genius—a God—you saved my life."

The above scenario happened decades ago, and probably wouldn't play out like that in today's litigious world. But, if you consider what happened at Duke University's hospital in February 2003, when a teenage transplant patient received a heart that didn't match her blood type, you can see how there are modern versions of equally devastating mishaps. Technology and a more litigious society won't ever rid malpractice.

> **In the case of the double mastectomy, if the patient had known more about her procedure and the (low) risk of leaving a healthy breast intact, she might not have praised him so kindly afterward. She would have known there was a mistake. Instead, the doctor accepted praise and didn't suffer any consequences for his outrageous error.**

This is another example of a patient placing too much faith and importance on the role of the doctor. In a better world, she would have included herself in that equation and prevented (or exposed) the cover-up. Cover-ups occur daily in the medical profession and only by awareness can you prevent such disasters from happening.

Pain Is Difficult to Measure

Pain is very subjective. To some, pain is a hurt. To others, pain is an intolerable agony. Pain may be barely felt by one person while it's severe to another, even when two people are exposed to the same source of pain.

Pain can be the worst thing a person can experience. Because of this fact, many forms of torture use pain as a vehicle to attempt to extract information from people. We've all heard of the old torture methods, various types of injections, removal of body parts, etc., to achieve the desired effects. All of these methods revolve around pain.

> **Most human beings have a limit to their tolerance of pain. If they experience pain above this limit, they will give in and submit to anything just to get rid of the pain.**

Pain can be blocked in a number of ways. It can be blocked by drugs, by the mind, by hypnosis, by acupuncture and by blockage of the nerve going to the area causing the pain.

If pain is so subjective, then why does pain become a malpractice when treated or when not treated?

Most of the time pain is treated. What I mean by this is that the *symptom* (i.e., pain) is what's treated and not the *cause* of the pain. Treating pain masks the pain, or the pain seems to go away. When you use aspirin or Advil, you're treating the pain—and not necessarily the underlying problem causing the pain.

Human beings don't like pain. And yet, pain is there to point us to something. Pain in the chest usually means something is going on or going to happen if we don't treat the pain. Likewise, pain in the abdomen points to there being something wrong. Pain is only a symptom, a warning signal you should pay attention to. It is your body's way of telling you that something is wrong. And, the more severe the pain...the more severe the problem.

> **Pain tells you that something is wrong and that you should stop now and take care of it. When it comes to modern machinery, if something stops working, you fix it quickly and get on with life. The same holds true when it comes to**

your body's machine. If you experience severe pain, you should seek the source of the pain rather than just treat the pain with painkillers.

Too much time is spent masking pain. Very few medications actually make the pain disappear; they only mask the pain so you don't feel it. Your body will then attempt to heal the cause of the pain by itself.

The human body really wants to be pain free and healthy. It wants to be well. Therefore, you must take notice of pain. To illustrate this in the simplest terms, think of falling and hurting yourself. Most of the time the first thing that you feel is pain. The pain is telling you that you are injured. You may not be severely injured, but you're nonetheless injured. Your body is telling you to take notice that something has occurred and you should respond. It's up to you to respond to this symptom of pain.

Sometimes there is pain that you won't notice because the body can't tell you that something is wrong. Such is the case in some neurological disorders where the body won't notice the pain. This doesn't mean there is nothing to treat. If you have a neurological disorder and sustain some type of an injury that you cannot feel, you may not even know that you're injured. Your body isn't equipped to tell you that you're injured. But, the injury should certainly be treated.

So, when is the treatment of pain bad practice?

Assume you have arthritis. You visit your doctor and he prescribes a pain medication. You start taking the pain medication and it gives you relief. No effort is made to be sure that the pain was really due to the arthritis and not to something else. Nonetheless, you keep taking the prescribed pain medication. You eventually run out of the medication and call for a refill.

This continues month after month, year after year. Your medicine chest is full of medications that have been refilled many times at many different pharmacies. You keep taking the medication, mixing it with other pain drugs. Sometimes you may even take two pain medications at the same time—both doing the same thing.

Sometimes different medications work against each other. Other times the medications work with each other, increasing the total effect. You may even become addicted to the medication.

I've seen many patients who have been seen by other doctors for other complaints and when I ask them to bring in their medications, they bring in a sack full of various pain medications. This, in my opinion, is malpractice. As a patient, it's your responsibility to show each of your physicians every medication that you are taking and have been prescribed.

Too Many Painkillers

Many people argue that too many painkillers are prescribed today, and that many people take painkillers for non-medical purposes. They get used to popping a painkiller when they really do need it, and continue to do so after there's nothing left to treat anymore. I've said how there's a multitude of different kinds and degrees of pain; how much you can withstand depends on your tolerance. Don't forget about mental pain and the pain from stress. I believe that is one of the reasons why people sometimes turn to drugs.

More and more people are asking for pain medication and more and more doctors are happy to write the prescriptions. They do so because they are too busy or in a hurry. Instead of taking the time to investigate a request for drugs, doctors write prescriptions to please their patients. This is malpractice.

You have a responsibility to take some of the pain away by other means. I'm not talking about pain related to operations, severe trauma, a sudden tragedy or a painful chronic disease. In many cases, people down powerful painkillers unnecessarily. If you have an acute episode of pain, you treat it and then discontinue the medication. And, for simpler bouts of pain, you resort to simpler painkillers.

Some of the most commonly used painkillers are aspirin, Tylenol (acetaminophen), Nuprin, Excedrin and the like. These work by blocking prostaglandins at the brain—or

cerebral—level. The next group of painkillers includes co-deine, Vicodin, Tylenol with codeine, acetaminophen with codeine, morphine and its derivatives like Demerol. These drugs block the pain and sedate the patient. Finally, there are the NSAIDs like Aleve and Advil that decrease swelling and relieve pressure.

Beyond simple painkillers, several varieties of topical agents exist. Dentists use benzocaine or even cocaine for a local anesthetic. For deep and lengthy procedures, xylocaine by injection works well.

These local, injectionable drugs work by putting pressure on the nerves and nerve endings in the specific tissue to be anesthetized, thus blocking the pain sensations from reaching the brain.

Finally, another class of drugs commonly used to relieve pain are the propoxyphenes, commonly known as Darvon or Darvocet. These drugs deaden the brain's ability to process various signals from the body—including pain.

As a society, we have become a drug society. We want a magic pill to relieve all of our ills. We want to hide from the reality of living—some of which is not wine and roses. We must learn to live with reality and not expect a pill to take away all the ills that exist.

Pain has been overtreated in our society. There are times when powerful painkillers are necessary...but there are far

too many times when they are overused and abused. Only you can determine the extent of your pain and how much you're willing to tolerate. Any overuse of painkillers will ultimately have a bad effect on your health.

Because the drugs to alleviate pain also seem to alleviate the "pain of living," so to speak, these drugs can become abused. The use of narcotics—such as codeine, morphine, heroin, cocaine, etc.—have created a new culture in society. Many companies now require drug-free employees and are making drug testing a requirement to obtaining employment. There have been too many lost days from work and accidents due to drug abuse.

There are five main categories of drugs commonly tested for:

1) marijuana;

2) opiates (including cocaine in all of its forms like morphine);

3) PCP;

4) amphetamines and methamphetamines (speed, ecstasy, uppers, date rape drugs like Rohypnol and GHB); and

5) barbiturates (phenobarbital, sleeping pills and butalbital drugs like Valium, Librium and Xanax).

Some of these drugs are easy to produce and obtain on the street. As dealers illegally grow and sell marijuana and

opiates, meth labs crop up in every major city. There is big
money in this business. But damage caused by drugs doesn't
necessarily have to come from powerful opiates; the non-
steroidal anti-inflammatories can cause bleeding, kidney
failure, blood disorders and other complications. You must
be careful while using any drug—over-the-counter or pre-
scribed. Most people do not realize the damage that drugs
do. Some of this damage is irreversible.

Too Quick to Treat

If you realize that pain is only a symptom and not a definitive
condition in itself, you'll be in a better position to understand it.
As already said, in many instances pain is overlooked and medica-
tion is quickly prescribed to relieve it. This also happens at home,
though. If you have pain in your abdomen, you very often think
that you've overeaten so you search for an antacid or neutralizer—
Tums, Rolaids, Tagamet or Pepcid—all of which are available over
the counter.

What if your abdominal pain has nothing to do with your last
meal? If the pain persists, you should not repeat the antacid but
instead, look elsewhere for the cause.

Persistent pain in the abdomen could be many different things:
appendicitis, intestinal blockage (intestinal obstruction), a blocked
arterial supply, bleeding, trauma, cancer or even a heart attack.

Popping continual rounds of antacids won't clear up any of these (more severe) problems.

The point is simple: Many things can and do affect the body, causing the symptom of pain. You can't treat pain with a pain-killer without knowing the source of the pain. In the long run, you and your doctor must investigate your pain and determine the underlying cause if you want that pain to go away.

Conclusion

Pain is not a mystery if you don't let it be one. If you have pain, there is a cause for the pain. You and your physician need to focus less on treating the pain and more on searching out the cause of the pain. Failing to do this is malpractice. Pain medication will mask the pain but not remove the source. Cancers can initiate with pain but not be discovered until much later, after the pain has been treated and the cancer continues to grow. Eventually the pain returns. As an informed patient, insist that your doctor find the source of your pain. Once a diagnosis is made, the recurrence of pain will be understood and can be properly treated.

To end this chapter, I'll give you another example. I knew a gentleman who was about 67 years old. He had been a smoker for 25 years and had stopped smoking. He had not smoked for the past 25 years and was told by his physician that there was nothing to worry about—his lungs were fine. Suddenly he began to have pain in his left groin. He visited his physician and got a complete physical exam. After, he was told all was fine and he probably had a groin strain. Because he was a golfer, this made sense.

But the pain persisted. He revisited his physician and was sent to a surgeon to be sure he didn't have a hernia. When no hernia was found he was told again that his pain was most likely from a groin strain.

The man underwent multiple tests and finally, after six to eight months had passed, someone noted a small spot on one lung. A lung biopsy confirmed a cancerous growth in his lung. More studies revealed the worst: the pain in his groin was due to the spread of the cancer to the bone in this area. A biopsy confirmed it.

The cancer treatments started but to no avail. Eight months after his diagnosis he died. Could he have been saved if the diagnosis were made six to eight months earlier? No one can answer that question, but I do know that he died a miserable death from the pain. In my opinion there was no need for the delay. We've all read about delays in the treatment of severe diseases due to the misdiagnosis—or malpractice in the diagnosis of pain—in the papers and on TV. This should not happen. You must be persistent as to the diagnosis and treatment of your pain.

4. Surgery Is Always Scary But Preparing Is Easier than You Think

One of the most opportune times for malpractice (either my definition or the legal one) to happen is during surgery. The newspapers cover the sensational occurrences: Doctor removes the wrong leg! Hospital transplants wrong organ! These are cases of gross legal malpractice. Because these cases are so obvious, they don't need to be addressed; instead, I will address some of the more common cases of malpractice that don't always make the news.

According to the legal profession, if a mistake or bad result occurs in the practice of medicine (even ones that happen naturally and to everyone's surprise), the doctor is often sued for malpractice. Black's Law Dictionary states that:

> In medical malpractice litigation, negligence is the predominant theory of liability. In order to recover for negligent malpractice, the plaintiff must establish the following elements:
>
> 1) the existence of the physician's duty to the plaintiff, usually based upon the existence of the physician-patient relationship;

2) the applicable standard of care and its violation;

3) a compensable injury; and

4) a causal connection between the violation of the standard of care and the harm complained of.

As medical machinery gets more advanced, surgery gets more sophisticated. But problems—sometimes very simple ones—still occur.

The doctor's window for mistakes is very small. He or she is not allowed to have one bad result or to make a mistake. But the point of this chapter isn't to focus on the malpractice lawsuits that land in court. I'm interested in the malpractice that happens and goes unnoticed. Doctors cover up their mistakes and indiscretions all the time.

With malpractice insurance premiums at an all-time high and the average jury award in medical malpractice cases up to about $3.5 million in 2003, doctors aren't so forthcoming with the mistakes they can easily cover up.

For example, if your doctor accidentally cuts your intestine during a surgical procedure, you might never know about it because he's good at sewing you up and sending you on your way. But, let's say you begin to have problems several years later—in 10 years you develop adhesions and pain. You won't be able to blame it on that surgeon because you don't know what he did.

You, as the receiver of medical care, must remember that there are errors of both omission and admission. In other words, errors

can occur because something or some part of the procedure was omitted, or errors can occur because some error occurred. You must be wary of both these types of errors—both of which fall into the category of medical malpractice.

Doctors' Fear Leads to Bad Decisions

Because the fear of legal malpractice looms large among physicians today, many things are done unnecessarily in the hopes of keeping the patient happy and protecting the doctor from malpractice allegations. Unnecessary x-rays and bloods tests are taken; too many tests in general are done that have no bearing on the diagnosis in question.

I know a doctor who, when called to examine a patient with a sore throat, will order an ear and throat culture immediately. This is going overboard. A complete diagnostic would be called for, but not to the extent of ordering so many extra tests. Increasing revenue from ordering these tests is also a driving force.

As a patient facing multiple tests, make sure you ask your provider what the tests will show and why they are necessary. When faced with these questions, some doctors might rethink their orders and limit the extent of their tests.

There is a lot of incompetence out there in the real world. Most of it is covered up by soft-spoken people or by the physi-

cians who cuddle their patients when something has gone wrong and it's their fault.

At the same time, within the medical field, those who speak the loudest are often the ones who have things to hide. And they hide these things behind political activism within the profession. In some instances, a well-trained person will make one single mistake during his or her lifetime and be severely penalized for it, while the "loudmouth" or politically active person will continue to make mistakes and commit malpractice.

Having served on many medical committees and reviewed thousands of charts, I can truthfully say that I have seen many cases of malpractice committed during a surgical procedure that have been covered up.

I would like to tell you about some of these.

Pathology Fitting the Diagnosis

Earlier, I told the story of the pathologist who told me to remove a woman's breast without knowing whether or not she had a malignancy. This is not an exaggeration. He said, "I can't tell if you have a malignancy or not; take off the breast and I'll make the pathology fit the diagnosis. After all, I'm the final word."

I was abhorred to hear this. I questioned the person further and found that, since he was the pathologist, the buck stopped there—he was the final word, right or wrong.

He read the slides and he declared the end result. Things like this were commonplace with him. I wondered, how many breasts

were removed for a benign disease just to satisfy the pathologist's ego?

Does this still exist? We only hear about the mistakes that occur in the positive—rarely in the negative. Who is checking up on the pathologists? Rarely are their diagnoses reviewed.

When a specimen is submitted to the pathologist it is first examined grossly. This means that the pathologist looks at the specimen to see if anything striking shows up. Is there:

- Any unusual colors?;

- Any lumps?;

- Any gross evidence of infection?; or

- Any noticeable abnormalities?

Then the specimen is opened in a sterile environment for closer examination. Sometimes cultures are taken and microscopic slides are made of certain areas. These slides are stained and fixed and later studied through a microscope. A diagnosis is then made.

Sometimes, when the diagnosis is difficult to make, the pathologist will send some slides to a physician at a different hospital for help or, if there is more than one pathologist at a hospital, they will each read the slides and come to a consensus.

In very difficult diagnoses, the pathologist may send a slide to a pathologist in a different city or even the Armed Forces Pathology Institute in Maryland to further assist with the diagnosis. Help is always available from various sources.

And yet, patients rely with often blind faith on their doctor's readings to make a definitive diagnosis. Should we demand a second opinion on the slide tissue diagnosis of the pathologist? Usually.

Abdominal Surgery

When your abdomen is opened for exploratory surgery and nothing is found except for a small adhesion (i.e., a collection of fibrous tissue resulting from an inflammation) that is causing the trouble, who is present to dispute the findings? Straightforward cases don't need explanations, but the questionable cases are often misdiagnosed. The threat of malpractice suits has gotten doctors to lie about what they find and what they do when you're under the knife.

Should a surgeon be allowed an occasional oversight—a missed diagnosis—a missed malpractice? Should he have to say he found something he was able to correct and that "you'll be fine" when in reality he found nothing at all?

An occasional oversight or missed diagnosis doesn't suggest criminal activity. Your doctor may still be good for you. But, if you are not improving in a short time (one to three days), you should be able to return to the doctor. At this point, other opinions are valuable and perhaps a discussion with another physician may be helpful. Having more doctors examine your condition dilutes the possibility of malpractice.

Doctors should be able to tell you the truth, but many have a hard time conveying truths that can lead to malpractice litigation.

> **If your doctor made a mistake during surgery, you might never find out about it—unless it results in a major consequence that bring the mistake to your attention. This isn't the best way to practice medicine, but it's the way it stands today. Fear of the truth because of mandatory repercussions is disrupting our entire medical system. Physicians know that this is going on but the general public does not.**

The Dangers of Surgery

Millions of people have hernia operations each year. Most of these people opt for elective repair of hernias. By *elective repair*, I mean that you can pick and choose the time for the procedure. This procedure is neither mandatory nor life saving. A hernia can be repaired when the patient wants to.

But there's no guarantee that after the hole is repaired, it won't recur.

Ask yourself, *What caused the hernia in the first place?* Have you had one in the past? Do you have a job that requires constant straining on the lower abdominals? Understand that repairing a hernia is simple—but fixing the problem can lead to more problems.

In males, the *vas deferens*—the tube that carries the sperm from the testicles to the prostate on the sperm's way out of the body— runs through this area. The blood vessels to the testes also run through this area. It's entirely possible for an injury to occur to these structures during the hernia surgery. The surgeon can injure the cord causing some degree of sterility or injury to the blood vessels, or he could damage the nerves, causing pain. As a patient, you might not notice any such injury if it happens on one side and doesn't cause any sterility—assuming your other testicle is fully functional and healthy.

Not all hernia surgery is done improperly. Most is done correctly but still there is always a chance that errors do occur and mistakes do happen. And again, in an effort to cover up their errors, the truth is not always told and a missed diagnosis of malpractice does occur.

I should mention that a small nerve that runs through the hernia area can also become damaged in surgery; if the repair is done too tight or the nerve is injured, pain may result. Or in some cases, numbness can occur. It's possible for the nerve to become entrapped in the repair, causing even more severe pain.

Some children are born with hernias that need to be repaired fairly soon after birth. In a child, an injury to the vas deferens may be overlooked until manhood or when he wants to have children. This could be 20 or more years later—after he's forgotten about the surgery.

More Room for Error

Going under the knife for a hernia and coming out with more than just a repaired hernia is possible. When you're in surgery, other things can happen that will have an effect on you. A few other things that can happen include:

- using the wrong sutures;

- putting the intestine back together slightly twisted;

- sewing the wrong tissues together or misplacing a suture; and

- leaving a hole in the repair of the intestine through which other loops of intestine can get caught (incidentally, this mistake often won't be noticed for years to come).

Eventually, these mistakes will cause trouble down the road, resulting in even more surgical procedures to correct the mistake. However, usually by that time the area and the defect will have been covered by tissue so blame cannot be pinned to the original surgery.

Preventing Surgical Errors

One of the most important things you can do to prevent surgical errors is to choose a competent surgeon and anesthesiologist. Don't look at the person's personality. Look at his training, his experience, his expertise, his reputation and frequency with which he has done the procedure you are about to have. Ask him, "Would you have this procedure given the condition that I have if it were you?"

Find out how many of the procedures he has done in the past month, year, etc. After you have questioned your doctor about his history, how many procedures he's performed and of what kind, ask about his or her board certification. You can verify this by either looking at his diploma or checking to see if the American Medical Association has a detailed listing of his experience (www.ama-assn.org).

Talk to your internist or general practitioner about the surgeon you pick. Don't let him pick the surgeon for you; your doctor will often send you to his or her friend. Ask your internist, "If you were in my shoes, would you pick this person for your spouse or children?" Looking up your doctor on the Internet will not gain you any real information. Everyone in good standing is listed.

Talking to the nurses is your best way of finding out the level of competence in a given doctor or surgeon. Nurses are a great resource. They see the physicians on a daily basis and know who is good. Call the hospital and talk to the head operating room nurse. Ask your friends and don't be afraid to interview the doctor.

Remember: A good personality does not always reflect competence. This is especially true for surgeons who are sometimes expert technicians with abrupt manners. Rely on your gut instinct. If you get a good feeling from the doctor—he or she looks competent and acts well—then usually you're in good hands.

If you're not satisfied with what you discover, go elsewhere and find someone you can trust. In all cases, you should seek another opinion to verify the findings and need for the procedure. Remember, you don't have to like him or her as a person as long as he or she is competent. Be sure to ask questions about the follow up and instructions when you return home. Before going under the knife, some of your questions might include:

- Where will I be when I wake up?

- When will I be able to go home?

- How long will I have to remain in bed?

- When will I be able to drive?

- What kind of drugs will I have in me when I wake up?

- How will I feel when I wake up?

- What kind of pain—and for how long—am I to expect pain?

- When will I see you again? When should I make an appointment for an office visit?

- Is there anything else I should know before we begin?

- Will I be able to go back to work?

- When will I be able to go back to work?

- When will I feel good enough to resume normal activity?

- When will I be able to resume golf, tennis, etc.

- Will I be able to do everything I did before surgery, such as taking care of my little children?

- Will my looks be altered in any way?

- Will I have to take any special medications?

- After a reasonable recuperation period, will I regain all the energy I had before?

- What will this cost?

- What are the most likely complications that can exist?

Make it clear to your surgeon that you're informed and want him or her to ensure that you get proper instructions all the way through. It's easy to get information about everything medically-related (from drugs to procedures) so get some material about what you are about to have done and read and understand it all. This will give you some insight into the problems, procedures and misgivings about what is about to happen.

And, by all means, ask questions. If you have an understanding about what is going to occur, then you'll understand the entire situation better.

Do the same with regard to your anesthesiologist. Meet him or her prior to getting into the operating room. During the surgical procedure, the anesthesiologist will be maintaining your life.

Just remember you are not going to a resort or a hotel. You are going to a hospital. This is not a gourmet restaurant but a hospital to make you well. If the food tastes too good then you must not be sick.

Unnecessary Procedures

This is a touchy subject. During the 1970s and 1980s, elective and specialty surgery became common parts of medical care in the developed world. These trends reflect some larger issues related to how medical services are delivered to people in developed countries. As medical service providers become more specialized, a fragmentation takes place that makes excesses and abuses harder to prevent—or even identify.

Trends in the use of cataract surgery illustrate this point. Cataracts are a cloudiness in the lens of the eye caused when proteins in the clear fluid clump together, blocking the passage of light. They can be caused by diabetes and other illnesses, but the most common cause is aging. More than half of all Americans over the age of 65 have a cataract, and cataracts that are not operated on remain a leading cause of blindness.

Cataract surgery entails removing the cloudy lens. Vision then can be restored by inserting a plastic lens in its place or with special glasses or contact lenses.

Many people in nursing homes have cataracts. However, they do not read or see very well due to their advanced age. They are often confined to a wheelchair and cannot live without the help of others to get dressed and eat. Nonetheless, ophthalmologists visit these people and recommend cataract operations for them. This is malpractice—even if the procedures are mechanically successful.

About 1.4 million cataract operations are performed in the U.S. each year and, at an annual cost of $3.4 billion, such surgeries represent the largest single expenditure by Medicare.

Is cataract surgery necessary? To answer this question, doctors must ask: Will the patient be able to function better after surgery? Will he or she be able to see better? Will the patient's lifestyle benefit from the surgery?

Many patients in nursing homes undergo cataract surgery but find out that they cannot see any better than before the surgery. Some of them are even disabled to the point of a vegetative state but still have undergone cataract surgery.

It's of no benefit to do surgery on such a patient; the compensated doctor is the only one who unfairly benefits. But some ophthalmologists will argue that only another specialist—another ophthalmologist—is qualified to question the procedure.

Another commonly overused surgery relates to elderly men who have trouble urinating. A natural process to aging involves the enlargement of the prostate glands, which causes this trouble. Two of the most common ways to treat this problem are either by surgery or by the use of a catheter. But, as with the cataract patients, many of these men are only vegetating in the nursing homes—and may have many other medical conditions. They may be paralyzed, stroke victims, etc. Their being able to urinate normally will not change their existing condition or quality of life.

Urologists have been known to target elderly men and recommend the surgery. As with the cataract surgery, I consider this malpractice.

Just because a procedure is available to correct a problem doesn't mean it's necessary. Costly cataract and prostate

surgery won't improve the quality of life for many of the people who suffer from these and other ailments common to old age. Sometimes, the risk to the patient going under the knife outweighs any benefits the surgery would provide.

There's no reason to assume that all doctors are out to make an extra buck—and that they are dishonest. But this is a problem.

To prevent the prevalence of unscrupulous doctors, the insurance industry has adopted the second opinion system. Through the use of second opinions, a system of checks and balances can be reached.

Even this kind of system can be manipulated when unscrupulous doctors send patients to other unscrupulous doctors, which is why it's important that you take control of picking the physician who will give you the second opinion.

Be careful when choosing your physician, surgeon and second opinion physician so that you will get a completely honest opinion. To emphasize this point, let me tell you a story.

I once saw a patient who needed surgery for a markedly enlarged uterus. She had been bleeding heavily—her blood count

was dropping—and she was in a miserable state. The only option open to her at that time was a hysterectomy, or removal of her uterus. She was 50 years old, beyond her childbearing years. As required by her insurance company I sent her for a second opinion to the ob/gyn specialist. A few days later I received a phone call from the other specialist telling me that she did not need any surgery. The other doctor told me I was an absolute idiot for recommending this and that he could treat her conservatively.

Approximately two months later the patient returned to see me telling me that now the specialist recommended that she have the surgery but that she wanted me to perform the operation.

The ob/gyn specialist thought he could steal the case from me if he gave the patient a breathing period. He wanted to perform the surgery all along, and knew it was a necessary procedure in the patient's best interest.

The idea of a second opinion is not meant to work this way...but it often does. In the end, the patient loses.

A second opinion is meant to foster a system of checks and balances—not a means to manipulate the system, steal patients or force unnecessary procedures onto unknowing patients.

If you feel uneasy about the doctor who gives you a second opinion, go get a third. Remember: your original physician may

give you the correct diagnosis and suggest a treatment better than anyone else.

Despite the negative feelings many people have toward HMOs, this kind of bait-and-switch activity doesn't happen as often in an HMO. The chances of getting a more reliable second opinion in an HMO are good.

Wrong Organ

There's a low occurrence of doctors removing the wrong organ, but it does happen enough to talk about it. Surgeons have removed the wrong limbs, wrong internal organs, wrong skin lesions, wrong discs in back surgery, etc. When starting my residency, some 40 years ago, everyone was talking about a dancer who was operated on for varicose veins. By a gross error the physician removed the main artery instead of the vein. This mistake cost the dancer her leg—and her career. You've probably read about wrong kidneys having been removed, wrong legs amputated and mismatched transplants.

You might have the wrong area operated on internally and never know about it.

At one point in my career I was asked to look over a case where a surgeon reattached the intestine backwards—gross malpractice. I also was asked to review another case whereby the intestine was stitched closed so that no contents could pass through the intestine. Again, gross malpractice.

Many times small omissions occur and no one except the people performing the surgery know about them. Omissions can include leaving holes in the areas of tissue between the intestines, which could result in adhesions; cutting nerves that result in mild loss of sensation; or cutting a major motor nerve resulting in paralysis of some muscle that you do happen to notice. All of these things do occur...and are often discovered later.

> **When you ask about the feelings of numbness in the area where the doctor cut nerves by mistake, you may be told that the feelings are a "normal" experience post-surgery. But many times these consequences could have been lessened or eliminated if the doctor took greater care with the tissues and had better expertise.**

Doctors can be tired and mindless when they operate, just like you can be the same at work. X-rays can be read backwards and cause the doctor to work on the wrong side of the patient. Back surgery poses many risks; removal of the wrong disc is possible when the doctor tries to work quickly and doesn't take extra precautions in this complicated area.

Iatrogenic Disease

An estimated 2 million infections occur in the U.S. each year, causing about 90,000 patient deaths. If you catch a disease or

infection while in a hospital, it's called an *iatrogenic*—or nosocomial—disease. They are diseases caused by the doctor, hospital, nurses or others. For example, if you are admitted to the hospital with a heart condition and contract a bacterial infection while in the hospital, this is an iatrogenic disease. If you are given a medication and then contract severe diarrhea because the medication caused the diarrhea—this is an iatrogenic disease. Pneumonia is a common iatrogenic disease.

A great deal of iatrogenic diseases gets passed back and forth among people in hospitals and not all get diagnosed by physicians. Experts believe most hospital infections are from contact with health care workers.

Since *iatrogenic* means "generated by either the hospital, hospital personal or the physician," then theoretically all cases of iatrogenic disease are cases of malpractice. Let me illustrate this further.

If you're undergoing surgery and your doctor happens to have a cold—an upper respiratory infection—you could catch his illness. During the procedure, the virus or bacteria can be transmitted to you. Or the surgeon could fail to properly scrub his hands and transmit germs to you during a surgical procedure from a small hole in his gloves. Being in a medically vulnerable state during surgery makes even a doctor with pimples on his face look menacing.

Many articles in medical literature point to the problem of hospital staff transmitting germs to patients. If you consider the number of people who work in a hospital and who can carry invisible germs, there's a lot of risk to be borne by a sick and vulnerable patient. And, if the doctor doesn't wash his hands, no one under him—the nurses, residents, interns and medical students—is going to wash up, either.

The Centers for Disease Control reported in 2003 that only half of doctors and nurses wash their hands after having contact with a patient. According to this study, conducted by the CDC and Chicago's Northwestern Memorial Hospital, better access to sinks does not lead to better hygiene. So, just because you go to a new hospital that has more sinks and amenities doesn't mean the people who work there are better about being clean.

A dirty hospital can make any visit a scary endeavor, let alone a visit to the ER. Sometimes diseases get passed through improperly cleaned anesthesia hoses or other such devices. These incidents tend to get reported in the newspapers.

Improperly sterilized instruments and gloves can cause problems. I recall a time when a hospital received properly packaged gloves that were to be sterilized but the night crew forgot to turn on the sterilizer. The gloves were used regardless during surgery the next day.

Disease also spreads via improperly cleansed air and improperly sterilized needles and other equipment. Especially when so many diagnostic procedures are being done, you must be sure that the equipment is properly prepared, sterilized and safe. Because

"hospital hygiene" is regulated by law, it can be hard to know what's going on behind the scenes at any particular hospital. This is when keeping abreast of bad press and rumors about your local hospitals is good. Ask around if you're wondering which hospital is considered the best and most clean. Word-of-mouth recommendations can be useful.

Medication presents another large area of iatrogenic disease. We all know that medications come with side effects. Sometimes the side effects are worse than the original condition for which the medication was ordered. In other words, the treatment is worse than the disease. To that end, you must be careful about any medication you use and be aware of all indications and contraindications.

Side effects to drugs are listed on additional slips of paper that accompany medications. Many people don't bother to read them. Why? Probably because most assume that if there is anything serious to worry about, their doctor would tell them.

> **Don't ever assume this. Understand what you are taking, why you are taking it, for how long you should take it and what the side effects are. A more informed public is a healthier public.**

When you take the medication properly, for the correct length of time, for the proper treatment, you won't overtreat yourself. If

you overtreat a condition, you'll bring on another disease and have more problems to worry about.

To prevent iatrogenic disease, you need to be careful in choosing your hospital, your doctor and the medication you take. In some cases, you won't be able to prevent iatrogenic disease, but knowing about its existence will decrease the odds that you'll fall victim to it.

Mistakes Do Happen

As many as 44,000 to 98,000 people die in hospitals each year as the result of medical errors. Medical errors are the eighth leading cause of death in this country—higher than motor vehicle accidents (43,458), breast cancer (42,297) or AIDS (16,516).

About 7,000 people per year are estimated to die from medication errors alone—about 16 percent more deaths than the number attributable to work-related injuries.[2]

Many mistakes occur because everyone is in a hurry. The x-ray may have been mislabeled—top becoming bottom or right becoming left. Be sure that the correct side is marked. You can put a mark on your body with a marking pen to be sure that the correct area is operated on. This should prevent the wrong kidney being removed or the wrong leg being amputated. Go over the details with your physician to be sure the correct side is being operated on.

[2]Institute of Medicine; To Err is Human: Building a Safer Health System. Washington, DC: National Academy Press, 1999.

Don't forget the story I told in the earlier chapter about a woman who lost both of her breasts because the doctor initially removed the wrong one—a complete cover-up. The patient was so excited to learn that all the disease was removed (and then some) that she sat up and kissed the doctor. As a witness, I vowed then that I would never cover up anything in my practice. But I began to see how cover-ups worked.

Cover-ups aren't necessary when a doctor is honest and careful. One afternoon I got a call from a hospital administrator at a hospital where I had done three small cases in the morning. The administrator told me that the gloves I—and other doctors—had used had not been sterilized. The hospital had received a new supply of gloves, which were put out without being sterilized. I immediately called all three of my patients in to see me the next day and informed them of the situation. I also said that I thought no dire consequences would arise but that we had to be cautious. I saw the patients at regular intervals and nothing happened. But this proves that mistakes do happen.

Another serious mistake that happens more than it should: patients receiving the wrong food tray. Many patients are on special diets. Trays get mixed up, numbers get mixed up, rooms get reversed, floors get mixed up, etc. As a patient, you should be sure you are getting the correct diet. If you are on a sugar-free diet, be sure there is no sugar on the tray. Watch for fruit and other foods that contain sugar. If you are on a vegetarian diet, be sure you get no meat.

Is this Surgery Necessary?

Many surgeries are performed unnecessarily. After serving on committees of 17 or so hospitals, I can attest to seeing many medical charts that didn't point to surgery. Until very recently, 20 percent of all appendectomies were done unnecessarily. Why? Because doctors cannot definitely diagnosis appendicitis until they are inside and looking at, feeling and examining the appendix. If doctors waited, they'd have a high percentage of ruptured appendices—a serious complication—on their hands that would result in deaths to some.

The opposite scenario is possible: if doctors operated on everyone with pain on the right side of the abdomen, 20 to 30 percent of alleged appendicitis surgeries would be unnecessary.

For this reason, a reasonable margin of error is acceptable. But I have seen some flagrant abuses of this "margin of error." I knew of one surgeon who, when called in the middle of the night, would fill the right blanks in on the chart to call for an appendectomy. His reasoning: "If I had to get up in the middle of the night to see a patient, I would make him pay." And because this doctor was on the board as the senior surgeon at the hospital, he was able to get away with it. He always kept his statistics within the allowed 20 percent margin of error. This is a version of malpractice.

As I've already mentioned, hernia surgery is an area for possible abuse. Although there are cases where the hernia is visible to even the patient (i.e., you can see the bulge from the outside of your body), many cases involve hernias you can't see from the outside. And, at the time of surgery the area is actually hidden

from all but the surgeon and his assistant and before you know it a repair is done. There is no tissue to justify the repair; in other words, there is nothing removed to show as evidence of damage. All you have is the surgeon's word against yours. You must pick a reliable, ethical and honest surgeon to prevent this type of malpractice.

Throughout my practice I turned down about 30 percent of the patients who were sent to me for hernia surgery. No hernia was present, so there was no need to perform surgery. Some surgeons, however, would operate on all potential cases of hernia. If you think you have a hernia and your doctor tells you he's ready to operate, you might want to get a second—unbiased—opinion on the matter before going under the knife.

On the other end of the spectrum, there are many instances of necessary surgeries that have been postponed. Your insurance company might decide to say no to your back surgery after a car accident. It might ask that you resort to physical therapy instead of an expensive procedure.

There are many other excuses an insurance company will use to deny coverage for procedures. Some include: you are too old for the surgery; you will live just as long with or without the surgery; or the procedure is "experimental" and won't guarantee a better quality of life. In some instances, these statements are true, but in many cases they are not true.

Investigate any excuses you hear from your insurance carrier or HMO. In some cases, the carrier—insurance company or HMO—is dictating to you the type of care you will receive. This doesn't mean you don't have a say in the matter. You must be fully aware of your options and direct some of your care yourself. Sometimes you have to fight for your rights.

I am not saying that you should tell your doctor how to treat or care for you, but be aware of all of the possible choices available to you. Make an intelligent choice as to your treatment. Assume, for example, that you have a serious infection. You visit your physician and are prescribed an antibiotic. Don't assume that the antibiotic you get will treat your infection effectively. You may get an antibiotic that doesn't work on your particular infection. So, what happens to you when you return to the doctor later and with more severe symptoms? By the time you realize you're not getting better and you have to make another trip to your doctor for the correct antibiotic, the infection has progressed to an abscess that has to be drained, causing unnecessary pain and suffering and time.

Be aware of your treatment. Be sure that you are getting the correct, most effective treatment. Ask questions. Make your doctor explain the type of infection you have and why a certain medication will help.

If you take your car in to be repaired, you always try to be sure that you are getting good parts. This is why you probably don't

take your Volvo into a Honda repair shop; you call the repair man who fixes the brand name of the car you have. Dealers especially advertise this. Imagine how hard it must be to repair a Saab in Japan. It could take months to get certain parts.

Keeping Records

As I've mentioned before, it's a good idea to treat your body at least as well as you'd treat your car. When you sell a car, you try to gather all the maintenance records and tune-ups that you've had on the car—proof that you took care of it and that it'll keep driving for years to come. And, when it comes to your body you should keep good records. Sadly, however, when it comes to the maintenance of people's bodies, they don't do the same. I've had many patients draw blanks when asked what kind of surgery they've had in the past or where a particular scar came from.

Keep records of the types of surgery you've had, when you've had serious infections, who operated on you and where it was done. Without this information you are asking a lot of your current physician. He or she must now be a detective in addition to being a physician. He must try to figure out exactly what was done to you to see if it relates to your present complaint.

Take, for example, a young woman complaining of severe abdominal pain. There is a scar on the right of her abdomen, the same place where she feels pain. The scar, however, is not typical of an appendectomy scar. She doesn't know if she had an appendectomy or not. Since there is no definitive test for appendicitis, the physician must make an educated guess. Lab tests point to an infection—a clue to appendicitis. X-rays and an ultrasound are not conclusive. Some doctors will proceed to surgery at this point; others will not. It's entirely possible that a doctor will operate on this woman only to find that she'd lost her appendix long ago. Her surgery will get her nothing but a fresh scar.

All of this could have been prevented if the patient had known whether or not she had an appendectomy in the past or what kind of surgery she had in the past. A certain amount of unnecessary surgery is done simply because of patient ignorance. Keep records. You will be glad that you did.

Scars

Most people don't know what a scar is. According to Dorland's Medical Dictionary a scar is "a cicatrix—the mark left by a sore or wound." This means whenever you have a wound—or, in other words, whenever you cut the skin you are left with a scar. The skin heals by bringing the two ends together with fibrous tissue and leaving you with what you call a scar. In reality, this is part of the body's way of healing. However, you are left with a scar or blemish when healing occurs.

No matter the level of expertise a surgeon has, you will always be left with a scar. A plastic surgeon can try to minimize scars, cover them over and use all sorts of tricks to prevent their showing, but scars are a body's way of healing. It's almost impossible to completely erase a scar.

Plastic surgeons often try to place a scar in a normal fold to minimize the scar showing. This can often be done in a hairline, behind the ear, under the breast, in an area where there is hair or in an area that is less visible. The scar is still there but you don't see it as much.

How the scar forms in most cases depends on your own body's healing capacity. There are some people who heal with hypertrophic scars—elevated scars. Others heal with keloids—large elevated scars that are often reddish in appearance and my not fade over time as can the smaller, hypertrophic scars. African Americans are more prone to form keloids, but hypertrophic scars are common through all races.

Very often the formation of scars has nothing to do with the suturing or repair of wounds. The scar will form regardless of who does the repair or if the wound is repaired. Many wounds now are repaired with clips and in some cases with tape to bring the edges together.

Although some argue that scar formation depends on whether the edges of the wound are completely perpendicular to the top of the skin, I don't know if anything (like injecting cortisone) can minimize scarring.

One day I was called to the emergency room because three people had been injured in an automobile accident. Upon arrival I introduced myself as a general surgeon and was told by one family that they wanted me to repair their loved one's injuries, who had severe lacerations on the face, arms and legs.

Another family elected to call a plastic surgeon for similar damage.

The third family wanted their family physician, a general practitioner, to do the repair.

We all were working in different rooms with similar type injuries. After we finished, I had the idea to compare the healing of the wounds six weeks later so I asked the other physicians, whom I knew, if the patients could meet me in the emergency room six weeks later to evaluate the wounds and healing.

One would expect the plastic surgeon's work to be the best and far superior to all the rest. However, after six weeks, the patients who had been repaired by me and the general practitioner were the best. The repair done by the plastic surgeon had a wider scar, more visible and more elevated than the others.

From that experiment, I concluded that most of the healing was dependent on the patient and not on the person doing the repair—within reason of course. However, the cost of the repair varied greatly. The plastic surgeon charged almost three times what

I charged; and my charges were 1½ times that of the general practitioner.

Scarring is hard to avoid. In most cases, the outcome of a repair depends more on your body's chemistry and (genetic) ways of healing than the dexterity of your doctor. There is something to say about experience, however, so choose a provider who has had some experience in the field.

Conclusion

In studies where patients are asked to rate hospitals, they place a significant importance on the quality, quantity and taste of the food. I think that would be the least important. Next important is the availability of parking and finally the quality of care. Patients place importance on things that aren't so important in the grand scheme of things.

Quality of care should be on everyone's top list. People don't seriously regard quality of care until it's compromised and a mistake happens. Then lawsuits emerge; and when money gets involved, people pay attention.

Quality should be foremost on everyone's mind. If you are given something that you believe is wrong, question it. Say you are recovering from bowel surgery, and the nurse brings you a tray of food even though the doctor had said you wouldn't be able to

eat solid foods for a week. Question the error. Insist that the nurse call your provider to verify the treatment.

Your attention and persistence when it comes to your care will make a difference in the quality of care you receive. Do not become the victim of the wrong test, wrong procedure or wrong food tray. Mix-ups and mistakes happen every day—in hospitals, doctors' offices and emergency rooms. I remember falling down as a child and the hospital x-raying the wrong arm. I kept telling them it was wrong but no one listened. What does a child know? You know. No matter one's age, everyone knows when something isn't right. Speak your concerns to those around you—the nurses, technicians and doctors. Insist. Eventually your persistence will not be denied.

5.

Health Plans and Doctors Are
Choices *You* Make

Choosing a health plan is not the easiest task in the world. Or the most enjoyable. But going without health coverage is a bigger risk than most people can afford. What if you get injured and require surgery? The cost of a hospital stay can be as much as $1,000 to $2,000 a day. What if you or your significant other becomes pregnant? Even through a clinic, the price of prenatal care and delivery can exceed $5,000 to $10,000.

Health insurance is designed to help you in these situations—to assume the risk of paying your medical bills. A good plan provides you with necessary funds to cover hospital and physician expenses, thus preserving your savings and other assets. So, it's important that you put some time and effort into deciding which plan is best for you and your family.

Although there is no one "cream of the crop" plan, there are some plans that are better than others for your specific needs. Health plans tend to vary, both in cost and the ability to get the services you need. Although no plan will pay for every health care cost that you may incur, some will cover more than others.

Health insurance plans are usually indemnity (fee-for-service) or managed care. But, there are other ways to obtain health insurance, including:

- workers' compensation benefits for occupational disabilities;

- Social Security disability benefits;

- Medicare, if you are eligible;

- Medicaid, if you are eligible;

- work-related benefits through employer-sponsored plans; and

- health coverage under any statutory plans.

Any of these programs may offer you enough health coverage that you would not need to buy standard policies. However, that will usually not be the case.

When considering a health plan, you should try to figure out the total cost to you and your family, especially if someone in your family has a chronic or serious health condition.

Indemnity and managed care plans differ in their choice of providers, out-of-pocket costs for covered services and how bills are paid. Indemnity offers you more choice of doctors (including specialists, such as cardiologists and surgeons), hospitals and other

health care providers than managed care. In addition, indemnity plans pay their share of the cost only after they have received a bill.

Managed care plans usually have agreements with certain doctors and hospitals to provide services at reduced costs. With this type of plan, you will have less paperwork and lower out-of-pocket costs.

Over the past decade, the distinctions between indemnity and managed care have blurred. Indemnity plans offer managed care-type cost controls, and many managed care plans allow their members to use providers that are not within the plan's network.

Indemnity Plan

With an indemnity plan, you can use any doctor or hospital you wish. You or they send the bill to your insurance company, which pays part of it. Under most plans, you have to pay a deductible before your insurance company will pay. A deductible can be anywhere from a few hundred dollars to a few thousand dollars.

Once you meet the deductible, most fee-for-service plans pay a percentage of the usual, customary and reasonable charges (UCRs) for a service.

Your insurance company usually pays 80 percent of the cost and you pay the copayment (co-insurance), or the other 20 percent. If a doctor charges more than the company's UCR rate, you will have to pay the difference.

> An indemnity plan typically pays for things like medical tests and prescriptions as well as charges from doctors and hospitals. But, it usually won't pay for preventive care, like annual checkups.

Managed Care Plans

If you decide that an indemnity plan isn't for you, you may want to look into one of three basic types of managed care: PPOs, HMOs and POS plans.

A *PPO* or *Preferred Provider Organization* is the closest thing to an indemnity plan. A PPO contracts with doctors, hospitals and other providers who have agreed to accept lower fees for their services. If you choose a doctor within the network, you will pay a lower copayment (around $30 for a doctor visit or $25 for a prescription). You can also go outside the network if you choose. However, if you do go outside the network, you will have to meet the deductible and your copayment will be higher due to higher charges for services outside the network.

HMOs—health maintenance organizations, the oldest form of managed care—offer a wide range of benefits, including preventive care, for a set monthly fee.

There are several kinds of HMOs. There are staff or group models in which you visit a plan doctor at central medical offices or clinics. Another type of HMO, an *individual practice association* (*IPA*), has network contracts with physician groups or individual doctors who have private offices.

> **HMOs provide you with a list of doctors from which to choose a primary care doctor, who will coordinate all your medical care. Your primary care doctor will be responsible for referrals to specialists.**

Some HMOs require you to pay a copayment, usually around $5 to $35, for a visit. But many HMOs don't require you to pay anything.

If you belong to an HMO, it will cover only the costs for doctors in that HMO. If you go to a doctor outside the plan, you could end up footing the bill.

Point-of-Service (POS) Plans are similar to indemnity plans in that you can still get some coverage if you go outside of the plan. Although a POS requires you to choose a primary care doctor from the plan's network, he or she can make referrals outside of the network—and your plan usually foots all or most of the bill.

In addition, a POS allows you to refer yourself to a provider outside the network and still find some coverage—that is, if you are willing to pay co-insurance.

Group Policies

Many people get their health insurance—indemnity or managed care—as an employee benefit through their job or the job of a family member. Health insurance first became an employee benefit in the U.S. during World War II. (Companies found that offering health care coverage was an effective way to attract scarce workers without violating the wartime freeze on salaries; and after

the war, full health care coverage soon became an expected benefit of big-business jobs.)

You can usually join or change group health plans once a year during open enrollment. But once you make a decision, you have to stay with that plan for at least a year.

Individual Policies

If you are self-employed or if your company does not offer group policies, you can buy individual health insurance. The policies often cost more than group policies—but it's usually better to be safe with coverage than sorry without it. Especially when one major medical expense can make one, two or even 10 years' worth of premiums pay for themselves.

If you belong to a union, professional association or social or civic group, which usually have health care coverage, you could be eligible for health coverage they provide for members.

Medicare and Medicaid

If you are 65 or older, you are probably eligible for coverage under Medicare, the federal health insurance program run by the Health Care Financing Administration.

If price is the problem, you might want to look into Medicaid. This type of program provides medical assistance to low-income

families (especially families with children and pregnant women) and disabled people.

In some cases, if you are covered under Medicaid, you are required to join a managed care plan—so check with your county's Social Services Department to learn more.

Pre-Existing Conditions

You'll also want to investigate whether or not the plans you are looking at exclude coverage for pre-existing conditions. Most insurers would prefer not to pay for treatment for a pre-existing condition, such as an ulcer or a gallstone and others will cover the condition, but not until after a waiting period (usually six months to a year).

However, under the Health Insurance Portability and Accountability Act (HIPAA), a pre-existing condition is covered without a waiting period when you join a new group plan if you have been insured the previous 12 months.

Your insurance company may also restrict certain benefits for a set period of time. For instance, it may not cover any expenses related to pregnancy until your coverage has been in effect for one year. So, if you or your spouse is planning to become pregnant, you'll want to get your health coverage sorted out as far in advance as possible.

Plan Benefits

What kind of plan is right for you and your family? Only you know for sure. The plan that is "best" for your next-door neighbor may not be the "best" plan for you and your family.

In addition to basic benefits, you might want to find out if the health plan you are considering covers:

- physical exams and health screenings;

- care by specialists;

- hospitalization and emergency care;

- prescription drugs;

- vision care;

- dental services;

- mammograms; and

- x-rays, CT scans or MRIs.

The Department of Health and Human Services Agency for Health Care Policy and Research (AHCPR) also recommends looking into how a plan handles the following:

- care and counseling for mental health;

- services for drug and alcohol abuse;

- obstetrical-gynecological care and family planning services;

- care for chronic (long-term) diseases, conditions or disabilities;

- physical therapy and other rehabilitative care;

- home health, nursing home and hospice care;

- chiropractic or alternative health care, such as acupuncture; and

- experimental treatments.

If health education and preventive care benefits are important to you, you might want to ask about services such as shots for children, breast exams, Pap smears or programs to help quit smoking, nutritional counseling, foot care clinics, diabetic clinics, back care clinics, etc.

Making the Right Choice

When comparing coverage, it is vital to look into a plan's limitations, exclusions and reductions to determine which expenses are not covered.

For instance, many policies will pay only for treatment that is deemed "medically necessary" to restore you to good health. These policies often will not cover routine physical examinations or plastic surgery for cosmetic purposes, or any cosmetic surgery regardless of the type. Additionally, some plans limit or won't pay for programs for chronic disease, or for various medicines or equipment.

Indemnity and managed care plans typically won't cover treatments that are experimental. In this case, you would want to find out how the plan decides what is or is not experimental as well as your options if you disagree with a plan's decision on coverage.

What You Will Pay

Your health insurance won't cover you for everything. If you opt for a reimbursement-style program, you'll also have to choose a deductible and at other times you'll have to pay a copayment.

In order to get a true idea of what your costs will be under each plan, you need to look at how much you will pay for your premium and other costs. You can't possibly know what your health care needs for the coming year will be, but you can guess what services you and your family might need.

To figure out what the total costs to you and your family would be for services under each plan, it makes sense to ask the following questions:

- Are there deductibles you pay before the insurance begins to cover your costs?

- After you have met your deductible, what portion of your costs are paid by the plan?

- Does this amount vary by the type of service, doctor or health facility used?

- Are there copayments you must pay for certain services, such as doctor visits?

- If you use doctors outside a plan's network, how much more will you pay?

- If a plan does not cover certain services or care that you think you will need, how much will you have to pay?

- Are there any limits to how much you must pay in case of major illness?

- Is there a limit on how much the plan will pay for your care in a year or over a lifetime? (A single hospital stay for a serious condition could cost hundreds of thousands of dollars.)

Some people choose a deductible in the thousands of dollars—making theirs, in essence, a catastrophic insurance policy. In this case, you'd absorb all the everyday costs of medical care, from doctors visits to prescriptions. But, if you got seriously ill, you'd be covered. If you are single and healthy, this could wind up saving you money.

For most people, a deductible in the $100 to $250 range is easiest to live with. But look into other deductibles, too. If your family has been healthy for a number of years, you may want to switch to a deductible of $500 or $1,000. You'll notice a sizable reduction in premiums. (Just remember that you'll have to pay your own way until you satisfy the deductible.)

You'll also want to investigate what the insurance company considers usual, reasonable and customary charges, if at all possible. That's because the charges a company considers normal for a particular medical procedure in a specific geographic area are the maximum it will pay. If the charges are higher, you'll be stuck paying the difference.

Another way you can save money on your premiums is by paying them annually. It's worth looking into how much the service fee is for monthly payments—and inquiring about a discount for prepayment.

Even if you don't get to choose the health plan yourself (for example, your employer may select the plan for your company), you still need to understand what kind of protection your health plan provides.

The more you learn, the more easily you'll be able to decide what fits your personal needs and budget.

Applying for Insurance

To get an accurate quote for health insurance, you will have to fill out an application—completely and correctly. If you lie on the application, the company cannot only deny you coverage for a problem down the road, it can rescind the policy entirely. And, most companies can get your medical information anyway through a non-profit association called the Medical Information Bureau (MIB).

The MIB was formed in 1902 by a group of doctors who were also medical directors at several large insurance companies. Because their insurance companies had lost significant dollars to dishonest applicants, they sought a means to centralize health-related information on individual applicants and reduce the potential for fraud.

Before you apply for insurance, it might be a good idea to check if there's a report on file for you. And, if there is one and it's wrong, you can correct it. Telephone MIB at 1-617-426-3660 and ask for your report. There's a nominal charge and in some cases it can be waived.

The application will ask for your age and health history. In addition, insurance companies often ask your doctor for your medical records, and they may require you to undergo a physical with one of their doctors, or even get additional blood tests. (However, they cannot ask you for an HIV test, unless you are also applying for disability income insurance—and then it has to be with informed consent.)

In completing the application, you will have to let the insurance company know about pre-existing conditions—even if you're getting coverage through a new plan at work. The company will want to know what illnesses and health problems you have had during the last couple of years (possibly longer).

Your age is an important factor in pricing and obtaining insurance. Many insurance companies have age bands, when it comes to costs for coverage. For instance, everyone 21 to 25 may fall into one price range. Everyone 26 to 30 would cost a bit more to insure each month. And so on.

Insurance companies prefer to write policies for young, healthy people—and they prefer to stay away from older, less healthy ones.

So, it pays to pick a good plan when you're relatively young and stay with it, if you can.

You may even want to ask your pharmacist and your doctor how different plans are handled before you sign on the dotted line—or sign your check. Your regular providers should be more than happy to tell you which companies and which plans are easy to work with, and which ones make life difficult for providers and patients.

Choosing a Doctor

Whatever type of plan you choose, you will need to select a doctor, whether it's from a network list, a preferred list or on your own. If you are in a managed care plan, ask your plan for a list or directory of its providers—they may also offer help in choosing a doctor that's right for you.

Once you have the names of doctors who interest you, you should check them out. The AHCPR (Agency for Health Care Policy and Research) provides the following list of suggestions:

- Ask plans and medical offices for information on their doctors' training and experience.

- Look up basic information about doctors in the Directory of Medical Specialists, available at your local library. This reference has up-to-date professional and biographic information on about 400,000 practicing physicians.

- Use AMA Physician Select, which is the American Medical Association's free service on the Internet for information about physicians (www.ama-assn.org).

- Find out whether the doctor is board certified. Although all doctors must be licensed to practice medicine, some also are board certified. This means the doctor has completed several years of training in a specialty and passed an exam. Telephone the American Board of Medical Specialties at 1-866-ASK-ABMS (275-2267) for more information.

- Find out if any complaints have been registered or disciplinary actions taken against the doctor. To find out, call your State Medical Licensing Board.

- Find out if any complaints have been registered with your State department of insurance. (Not all departments accept complaints.)

- Set up a "get acquainted" appointment with the doctor. Ask what charge there might be for these visits, if any. Such appointments give you a chance to interview the doctors—for example, to find out if they have much experience with any health conditions you may have.

Choosing the right health coverage comes down to asking a lot of questions. These questions will generally fall into two categories: first, how the plan responds to various medical conditions and needs; second, what limitations and exclusions the plan uses to control costs.

It can be tough to find someone who will answer these questions at a specific insurance company or HMO. In some cases, you may need to talk to a broker or agent. In others, you may have to spend some time on the telephone finding the right person.

You may not want to do all this research for six or eight different plans—but most insurance decisions boil down to two or three options.

If you find yourself wondering whether to choose a flexible managed care plan or a cost-saving indemnity plan, the decision is probably worth an hour or so and a couple of calls. If you get your health coverage through work, contact your human resources manager. He or she should be able to give you information on the coverage and plans available through your employer. Or, you may wish to call the plan directly.

In the end, though, the decision will usually be yours. It's the way that the insurance and health care industries are moving. Self-service coverage means asking questions for yourself.

The Bad Doctor

There's more to finding a good doctor than checking references and getting referrals. I don't like writing about the bad doc-

tors, but they do exist. Knowing how to spot a bad doctor will help you prevent becoming a victim of malpractice.

What do I mean by a "bad doctor?" I'm not necessarily referring to what a doctor does or does not know, but how the doctor practices. For example, a doctor who sees a patient in the office and has dirty fingernails or dirty hands or dirty clothes is, in my opinion, a bad doctor. I certainly hope that you have never experienced this but I have seen this in my years of practice. How can a physician who has dirt on his hands or under his nails be a good physician? You wouldn't want to go into a restaurant and have a waiter wait on you with dirty hands. In my opinion, this is not sanitary and constitutes malpractice.

During an emergency or illness we all want a degree of compassion from those who are with us. This includes the people caring for us—the nurses and doctors. Most doctors have been trained to give some degree of compassion.

Showing compassion for the ill is part of the practice of medicine. How can a doctor properly treat those who are ill and in pain or assess complaints if he or she does not have compassion and empathy? Doctors must be feeling, caring and compassionate to the needs of patients. Therefore, your doctor should have compassion and empathy built into his or her personality and into the practice of medicine.

Many physicians don't have this. I think this is another case of malpractice—or, certainly bad practice. Especially in times of hopelessness, when little can be done for the patient, there's nothing more comforting than a kind word, the warmth of a pat on the back or a kind saying offering some ray of hope and understanding. Miracles sometimes do occur.

> **Doctors must have compassion for the sick if they are to treat them properly. There are plenty of physicians who are non-caring, cold and callous. They do not care for their patients or like the practice of medicine. And they do not care for their practices. They may only care for the financial benefit they gain, and the accumulation of awards and degrees.**

These people, in my opinion, are practicing malpractice—not good practice. They may be very intelligent physicians but they certainly aren't good doctors.

Then there is the opposite end to this spectrum. There is the overcaring physician. He or she is too caring, too protective and available at your beckoned call. These doctors call you on the phone too often to ensure you are doing well. Unfortunately, these doctors are often not the competent ones. Often, they are covering up their lack of knowledge and competence by the amount of attention and by being overbearing. They will have you come back unnecessarily because they are not sure of their treatment, and

they are eager to send you to another specialist or to seek another opinion. They don't have faith in their own opinion because deep down they know that they are not completely competent.

One of my earliest teachers taught me: "A physician is always a student. He is always learning. Keep reading and learning over and over again."

Remember: In the changing field of medicine and the fast moving field of medical technology, if you don't keep up almost daily, the field will pass you by very quickly.

Another physician to watch out for is the inconsiderate and egotistical one. This person doesn't care about you or your medical needs. He or she acts callously and arrogantly toward you and your complaints. "Don't tell me what is wrong. I certainly know and can handle the problem quite well. I have seen many like this before!"

You might not have run into a doctor this bad, but they do exist—I've seen them! So beware of this type of doctor.

You want a doctor who has some degree of humility, humbleness and empathy to properly practice medicine. Mistakes do occur. However, being overconfident and overbearing won't make up for incompetence. There is a fine line between confidence and overconfidence. Those who

are overbearing are doing some degree of malpractice...and a great disservice to their patients.

The existence of bad doctors is what urges hospitals to have committees that oversee their physicians' attitudes and practices. These are the checks and balances that happen today in medicine. Nonetheless, it's up to you as an informed patient to weed out the bad physicians and find the good ones. Nobody will do that for you.

More About the HMO

I gave you the mechanics behind the HMO, but because of this organization's prevalence today, I think it's worth more discussion. No book about medicine today would be complete without a lengthy conversation about HMOs.

Years ago before Medicare and government intervention into medicine, the hospitals were largely owned either by the doctors themselves, by religious orders, by the government (such as the city or county), by universities or by private groups. After the third-party payer came into the picture, the business community decided that medicine was a good business investment and medicine became a business.

You must first understand the concept of the third-party payer. Until health insurance became popular, it was understood that when you needed medical care, you went to see the doctor and, if

necessary, you were hospitalized for treatment. Payment for this service was to be paid by you—from savings or borrowing or in any way that you could afford. In the event you were unable to pay for the service, the county or (welfare system) came to your aid.

Then came the third-party payer. A third party—the insurance company—would pay for the service you were to receive. There may be a deductible that you would have to pay but the insurance company would cover all the rest of the costs.

> **This idea completely changed the way the billing and practice of medicine went. You, as the patient, were no longer responsible for the large bills of the health coverage. By insurance, the cost could be spread over everyone in the policy, thus reducing the cost of the premiums, etc.**

Other business interests shaped the way medicine was practiced in the 1970s and 1980s. A plan was devised whereby companies could take over hospitals, then medical practices that had formed large groups and business could take complete control of medicine as a business. Since medicine today is one of the largest businesses in the country, the course was evident. Business would first buy up the doctor-owned hospitals.

Especially since the doctors were so busy with their practices. They would sell the hospital when money was waved in front of

them. This is exactly what happened. When I was practicing at one doctor-owned hospital (although I wasn't among those who owned a share), my colleagues told me that they were all happy to be making a $100,000 profit of running the hospital every year. They sold the hospital to a corporation and if the profit was not increased to $5 million per year, the corporation threatened to close the hospital.

The next thing that occurred was the formation of large groups of physicians. There had already been groups that had formed for the convenience of the doctor—multi-speciality groups, mixed clinics, etc., like the Mayo Clinic and the Cleveland Clinic, but they were group owned. Now the business world saw a chance to buy them out for a large sum of money and obtain control of the medical practice.

The Kaiser-Permanente Group already existed, among a few others, but business and insurance companies decided to buy into medical practices by buying the large medical practices first—then buying out the competitors or the smaller medical practices in the area. The businesses would either combine both practices or close the one that made the least money.

> **As a result, the remaining practices had to take on more patients. This brought in more money and the organization would find other ways of increasing its revenue. It could do this in two ways: by having a large base of young (healthy) people who don't necessarily need medical care or it could reduce the number of times patients could visit.**

Either way, the patient pays a monthly or annual fee for the services.

At this same time, Medicare was progressing—government-sponsored health insurance for the elderly. This presented a good base for the HMOs because they could get a base of people whereby the government would pay them a monthly fee for taking care of these patients. But problems were likely to arise; a large base of elderly would require more care as they got older. They'd get sicker and need more attention.

Private doctors began to lose patients to the HMOs and had to become inventive to keep up their cash flow and not go broke. Therefore, two different things happened. The doctors in private practice embellished their practice of medicine. They ran more tests, took more x-rays and performed more surgeries. More extra, unnecessary care was given to keep up their flow of cash. Doctors who could not do this or who did not have a large patient base were forced to work for the HMO.

Thus, doctors became salaried employees confined to the whims of big business. At first there were no restrictions but then restrictions began to appear. HMOs limited the amount of expensive drugs, pushed generic and cheaper drugs whenever possible, eliminated expensive tests and did not allow experimental procedures to be done. New procedures were quickly labeled "experimental" and excluded from coverage.

All of these were ploys used by some of the HMOs to cut the cost of the service. Many lawsuits resulted from this new management, and this is exactly where we are today. However, let me try to give some insight into the problem and explain how you can help yourself when it comes to your own health.

There are some distinct advantages to HMOs if you know how to use them. First of all, the large ones have all the services in one location. You don't have to travel or go anywhere to get the desired service. To illustrate the benefits of this, I'll tell you more about what happened to my wife toward the end of my active career when she woke with an upset stomach. By then, I was working for an HMO (and had been there for five years). I saw all that was happening and was able to treat my patients *cart blanche*. I had no restrictions, only mild directives, so I treated my patients the exact same way as if I were in private practice. Despite the rumors, this can be done and it's up to your doctor.

When my wife woke that morning with an upset stomach, I assumed she'd had bad food. I immediately gave her something for relief but we noticed that she had paralysis of the muscles of one eye. The lid was drooping, her vision was blurred and she was seeing double. Worried, I immediately gave her a large dose of antibiotics, thinking it was something infective. We then went to see an ENT (ear, nose and throat) specialist (thinking it was a sinus infection) at the HMO. He examined her, took sinus x-rays and sent us to see the neurologist, thinking it may be a brain tu-

mor. Within one hour a MRI of the brain was done, with a final reading by a radiologist who said the brain was normal. Thus, no tumor.

This kind of attention and these kinds of services in a short time period could not have happened at anywhere other than an HMO. Although a stool specimen was taken to test for botulism, the city's health department refused to do the test, saying it was only one case and to treat it as if it was.

My wife was treated with more antibiotics and she survived. After four weeks, the symptoms gradually subsided. To this day, I am certain that she had a mild case of botulism from tainted scallops...but there was no way to prove it. The quick action by the HMO actually helped save her life.

A few years later, my wife woke me in the middle of the night with a racing heart. I checked her pulse rate, which was 160 beats per minute. When you're sleeping your heart is usually between 60 and 80 beats per minute.

I told her to rest and that after five minutes I'd check it again. When I checked it the second time, it had come down to 80.

She woke me again at 8 A.M. with a pulse of 140 beats per minute.

I then took her to the HMO where an EKG was done within five minutes of our arrival. She was diagnosed with supraventricular tachycardia—a very fast heart rate due to an irritation of one area of the heart but not a heart attack. Medication stopped her racing heart and she was kept in the hospital for five days.

> **The point of these stories is that an HMO can provide you with immediate and extensive services, whereby your private physician may not be able to.**

You are probably thinking that I (and my family) get the best care because I am a physician. That is not true. I saw patients in the same ward as my wife who were getting the same type of care.

Because the HMO will give necessary care only, I have seen cases of elective surgery refused by the HMO. For example, several patients came to see us in surgery with supposed hernias. Two physicians had examined them and no hernias were found. Either the physician who first saw them did not know how to diagnose a hernia, or he or she wanted to operate for the money. Remember, you are at the mercy of your doctor. He or she is the last word here.

A lot has been written about the HMO "gatekeeper," the person in charge of your health. Gatekeeper sounds like a bad word, as if the gatekeeper is more like a guard you can't get past. But having a gatekeeper in charge of your primary care who has to determine when it's appropriate to call in a specialist, isn't necessarily a bad thing. In the days before HMOs existed to popularize the concept of the gatekeeper, you went to your primary doctor first anyhow—to get advice and a referral to a specialist. Don't assume that a gatekeeper is bad; if you don't like your gatekeeper, you can probably switch. Most health plans allow you to switch gatekeepers.

Remember: Much of the treatment that you are going to receive relies on you. Take advantage of your power and speak up if you don't like your gatekeeper.

A Private Insurance Scenario

A friend of mine one day fell at home and had pain in his back. He had private insurance. He went to see his doctor and was told to see an orthopedist. It took him 10 days to make an appointment. By then, he already had numbness in his leg and some paralysis. Since he had had polio as a child, he attributed this to the post polio syndrome. When he finally saw the orthopedist, surgery was recommended but there was some residual damage done to the nerve that to this day gives him residual paralysis. I don't think this would have happened if he were in an HMO.

I know there are horror stories about the care at HMOs. I have heard all of them from my colleagues. But this brings me back to one of the first statements I made: You must know the doctor who is treating you. There are just as many bad doctors in HMOs as there are in private practice. You must have an honest, ethically correct physician. Sometimes he or she is hard to find. Personal recommendations do not always stand up.

A good question to ask your physician: Is this the way you would go? Is this the treatment route that you would pur-

> sue? What would you do if this were you or your loved
> one?

If the physician is honest, he or she will give you an honest answer. Keep in mind that in today's legal climate most physicians loathe to give you an answer because it is an opinion and constitutes treatment advice—for which they are liable. Sometimes it's best to ask that type of question in the form of "Which would you do." Let me give you an example.

Assume you have a condition that has several treatments. Your condition can be treated with medication, surgery, radiation therapy, radon needles and hyperthermia, which is treatment with heat. After you learn about the treatment possibilities, you are in a quandary. You ask yourself, *Which should I take? Which is the best?* You might even get some information from the Internet or medical library books. Most of the newer treatments are not in print. It often takes two to three years for new articles of medical knowledge to appear in print. Many times I will hear of a procedure or treatment at a medical meeting and not read about it in print for a long time.

As mentioned before, you must be sure that you get honest, unbiased second or even third opinions. You should insist that you get a second opinion from a physician who is not known by your doctor.

I cannot emphasize enough that you must be on the correct track to get the proper treatment. If you think doctors get the best treatment, then understand it's because they know the correct questions to ask and they know the right resources to get the proper information. In essence, doctors know how to use the system. If you understand how the system works, then you can utilize it to your advantage.

The next thing to remember in understanding the mechanics of an HMO—which is to save money—is that the least times you are seen the more money they make. They are being paid on a number basis; they are being paid for you regardless if you are seen or not. If you are not seen they get the same amount of money as if you were seen. So it behooves them to see you less. And, the less you are seen the more time the physician has to see others, which also makes money.

No More Neighborhood Doctors

Sadly, gone are the days of the family doctor. There's little time for chitchat when you visit your doctor, whether he or she is in an HMO or private practice. Some would rather get down to the real issues and stop the chitchat about extra issues, but many elderly miss the chitchat and old-fashioned approach where the patients regard the doctor as a friend.

The chitchat is a dying type of practice—as is the mom and pop grocery store of past years. You must be more wary of your health problems, whether it's disease or irregularity. In other words, you must know exactly what is wrong with you. You must understand completely the medical terms given to you. Make your health care provider give you in simple terms the complete definition of your condition.

> **You have to understand what it is that you are going to be treated for. If you need to, write down ahead of time what to ask. Patients are often anxious when they see their physician and forget what they were going to ask him or her. This is why it's a good idea to write things down, including the instructions your physician gives you.**

When you take your car in to be repaired and the mechanic explains everything to you, you don't like to leave until you understand everything. So why not understand everything about your health when you take your body in to be treated?

The better you understand your health (and your problems), the more you can cope with your condition and best determine which way to go for the best treatment.

In the past, we relied on our physician to make decisions for us. This is no longer possible. You can get advice and help from loved ones, friends, relatives, acquaintances and people who have

had the same problems, but in the end, it's you who makes that final decision.

Conclusion

Whether you're in an HMO or have your own private doctor for which you pay out of pocket for your care, your goal should be to make every visit to the doctor count. Be sure you receive the proper treatment in the allotted time. Know your condition. Know what medication you are getting and be sure it is correct. It has been said that if a patient leaves a physician's office without a prescription, something is wrong. Stop and think about it. If you go to see your physician and leave without a prescription, you might feel abandoned because nothing was done. You went to see the doctor because something was wrong and he or she gave you nothing. I will never forget the time I had patients come to see me with a small developing infection of a hand or foot where the only proper treatment at the time (before antibiotics) was heat several times a day.

I learned early on that if all that I prescribed was a hot water bath, the patient felt cheated—as if I did not care and had no sympathy for their condition. Thereafter, I arranged with the pharmacist to give the patient, by prescription, either a red or blue dye to put in the water to soak the area. I can't tell you how many compliments I received on my "miracle red solution." If it stained their clothing it was even better.

These are the ways that you must deal with the problems with the health care system today. If you understand what health plans expect and what you expect, you can cope with the system. Re-

member, your physician—either private (fee for service) or HMO—and you must form a pact. If you have a good relationship with your health care provider, you'll get good and proper medical care.

6.
Diagnosing Requires Teamwork—
You and Your Doctor

Once upon a time, people could go to any doctor they wanted. If your general practitioner decided that you needed to see a specialist, you could see any specialist you pleased. If you needed medicine, you could go to any pharmacy and get exactly what your doctor ordered.

But things have changed. Today, you have a lot more choices, including HMOs, PPOs, generic drugs, lists of doctors you can and can't see, treatments you are allowed to have—only after two or three doctors agree that it's necessary. Doctors used to be like extensions of family—you knew your doctor well and spent a considerable time chitchatting with him or her before getting to the point of your visit. Nowadays, it's harder to have a close relationship with your doctor because he or she can't afford the luxury of spending a long time with you in the office. At the same time, the relationship you do have with your doctor is critical to your overall health and should not be compromised.

The mechanics of medicine today require you to form a pact with your doctor. In this pact, you learn to take charge of your health care and use your doctor to help navigate your path. You

can't rely on any doctor to provide you with the best of care without your input. There's no such thing as the passive patient; smart, aggressive patients are the ones who get the best care.

Symptoms vs. Diagnosis

There's a difference between symptoms and diagnoses. In simple terms, when you experience symptoms of an illness, it's your doctor's job to diagnose the problem (i.e., find the reason for your symptoms) and suggest a solution (or treatment). There's also a difference between treating symptoms and finding a diagnosis for the symptoms.

Many times a physician will treat a symptom and not arrive at a diagnosis, which can mean he or she fails to properly treat the underlying cause or illness.

This is malpractice. I am not suggesting that symptoms should go untreated, but failing to find an underlying cause for the symptoms is failing to practice medicine.

Doctors who treat symptoms without searching for the underlying cause of the symptoms are not diagnosing as they should. Symptoms should not be treated as diagnoses but should be treated as symptoms.

If you understand the mechanics of the human body then you'll realize what I am saying. The body sends out symptoms to tell you

when something is wrong. Many of these symptoms are an indication that something is going on that needs correcting. For example, common symptoms include pain, itching, fever, diarrhea, nausea, vomiting, etc. These are just a few of the many symptoms that can occur.

Let's say you go to the doctor with the symptom of itching. You probably have a scratch on your skin from scratching the itch. If you are given a cream or other medication for the itching, then you are being treated for the symptom and not for the disease or diagnosis. You could actually have a more serious disease because itching could be a symptom of a bite, allergy, parasitic infection, etc. and even a more serious condition such as cancer, etc. If you are treated only for the itching and your doctor does not investigate for the other conditions, you are being improperly treated and misdiagnosed. If, however, you are treated for the itching and at the same time your doctor tries to learn how the itching began, then you are being properly treated.

Fever

Fever is the body's way of killing or warding off a germ, such as bacteria. If you visit your doctor for a fever, your doctor will treat the fever with medication like Tylenol. But treating the fever won't solve the problem. The human body is sensitive to heat and uses its own heat to burn off certain germs. If you are not treated for the fever, then certain vital parts of the brain could suffer damage. This is much like a wire that becomes overheated and burns up if the heat continues. However, like a wire, if the cause

of the fever is not found, then the next time damage could occur. So, treating just the symptom and not pursuing the diagnosis could result in irreversible damage.

Fevers can accompany obvious illnesses, like colds and flus, but they can also mask serious illnesses that need attention. Never treat a fever with simple fever-reducing medications without knowing the underlying cause of the fever.

What about vomiting, nausea and diarrhea? These symptoms often go together as a group. Sometimes, though, they happen separately. None of these symptoms should be disregarded as a simple case of the flu. Each should be investigated if it persists.

Nausea is an interesting symptom since many different diseases can trigger nausea as an initial symptom. And, all too often, nausea is treated while the more serious underlying disease is overlooked until other symptoms emerge.

If you treat your fever but it persists, you should see your doctor. If you think you have a cold or flu, and treat your illness with over-the-counter medications but to no avail, you should see your doctor. Sometimes, more serious illnesses are masked by what you think is the common cold.

However, if symptoms persist then you do not just have a cold or the flu but something else causing cold- or flu-like symptoms. I've seen several cases of patients whose cold- or flu-like

symptoms mask a more serious condition. If that serious condition is not diagnosed until it worsens and finally presents itself, it's considered a missed diagnosis—a malpractice.

The fine line between investigating and treating every symptom is very fine. Never neglect persistent and long drawn out symptoms, disregarding them as symptoms of the "flu."

Ouch!

As I have already stated, pain is one of the most missed diagnoses of malpractice. I remember a case when I was in medical school of a young healthy boy of 19 years old who supposedly injured himself while playing baseball. He was a pitcher and complained of pain in his shoulder. No one questioned him if the pain began during his pitching. After the doctors treated him for the pain he continued to pitch. About a month or so later he returned to the university hospital complaining of pain in his shoulder. Finally, an x-ray was taken, which revealed a malignant tumor in his shoulder area that required his entire upper extremity—his pitching arm—to be removed.

This case shows how treating a pain without going deeper in the investigation can lead to more serious consequences.

The human body reacts to injury or disease by causing pain. Diagnosing the source of pain requires a diligent doctor and a willing patient. You have to provide your doctor with the clues to solving the problem. Good medical judgment and a good evaluation should be exercised to assess every pain.

I'm Feeling Light-Headed

Another commonly misdiagnosed symptom is dizziness. Many things cause dizziness. It can be a symptom of serious illness or it can be caused by something as simple as motion sickness, such as going on a merry-go-round or a roller coaster, or vision problems. Again, if the symptom persists then a complete investigation should be undertaken. If, on the other hand, a cause is found (i.e., you just came off a theme park ride), then you can wait and see if it persists.

Treating symptoms for a long time can amount to malpractice. Whether you're experiencing pain, a fever, dizziness, nausea or diarrhea, if your symptoms don't go away you should seek medical attention and make sure your doctor investigates the underlying cause.

Also important when it comes to visiting your doctor is making sure that you mention every symptom you are having. Leaving out even the most simple and obvious complaint or symptom can certainly lead to a misdiagnosis.

What Would You Do if You Were Me?

This question is seldom asked of a physician. You are diagnosed with a serious illness. There are tissue biopsies to confirm the diagnosis. You have been given three to four options of treat-

ment. Where do you go from here? Should you elect option one, two, three or four? Which option will give you the least amount of discomfort? The best chance for survival? The best quality of life? Which door should you open?

At this point, a second opinion or even a third opinion may be useful. However, ask your physician: *If you were me, what would you do?* Also, if you want another opinion, ask him or her whom they would go see for another opinion. Use your physician's expertise to your advantage.

I cannot emphasize how important questioning can be. Remember when you were young and learned by asking questions? One of the best learning sessions in medical school is the Q&A session. Even today, after most medical lectures there is a question and answer period whereby the visiting professor is questioned. And a mark of excellence in a medical conference speaker is how he handles this part of the talk.

Hopefully, when you question your doctor about the course of your treatment as well as where you should go for more opinions, your doctor will be responsive and helpful. He or she should sound competent and ready to deliver sound advice. If he or she fails to do so, you're not seeing the right doctor to begin with.

Over-Diagnosis

Now that you understand the difference between symptoms and diagnoses, it's important to understand cases of over-diagnosis. A doctor over-diagnoses when he or she exaggerates the symptoms you describe and over-treats those symptoms. An example: suppose you hit your side while doing some work. You get a contusion—a black and blue spot—over the area. Naturally, you experience some pain, but you have no limitation of motion. Nonetheless, you go see your physician and he takes an x-ray. This is unnecessary.

Because of the economic situation in medicine, some doctors (especially those in private practice) have incentives for ordering more tests, handing out more prescriptions and asking you to come in for check-ups more often or your medications won't get refilled.

I've heard several physicians say that because their incomes have suffered from cutbacks and restraints, they order more tests or more complete exams to compensate. More testing means more income for your doctor; more office visits means more income also.

Some of the extra tests and over-diagnosing happens as a precaution. Because of our litigious society, doctors worry about litigation. Therefore, many physicians would rather err on the side of over-treatment than risk a lawsuit.

I don't think this is good medicine. There is a fine line between over-diagnosing and good medicine. Doctors used to examine an area thoroughly before ordering extensive and expensive tests; if your doctor is quick to order tests without examining you and asking you questions, I'd find another doctor. When I was a child, if I were to injure my arm or leg and visit my physician, he would examine the area and determine if an x-ray were warranted rather than send me first for an x-ray before seeing me.

Overdoing Rx

Drugs are overused today. People ask for too many drugs and doctors write too many scripts for drugs. You can pop a pill for just about everything these days, and all too often drugs are used when time would heal the problem. Think of a bruise again. One of the best treatments for a bruise is first cold applications and then heat 24 hours later. But imagine going to the doctor, spending the money for an office call, possibly an x-ray and then having the physician tell you to use cold and then heat. You must get a pill for the treatment or you have wasted an office call.

Several physicians have told me that when patients leave their offices they always have a prescription. If they don't, the patient is not satisfied. This is malpractice because in many instances a problem will resolve itself with some time and minor treatment.

People have gotten into the habit of wanting and sometimes demanding medication for the treatment of minor inconveniences. Skin rashes, for example, are frequently overtreated. People want magic cures even though magic cures often include the consumption of chemicals. Drugs are chemicals. Thousands of patients have asked me for a pill to cure their common colds. There is no cure for the common cold. You can treat the symptoms with over-the-counter drugs, but they won't kill the germ that is causing the problem. You have to wait until your immune system kills off the germs.

When it comes to colds, people are quick to call their physician and beg for antibiotics. But antibiotics won't help cure colds when they are caused by viruses—and not bacteria. Taking antibiotics for the common cold will only weaken your body's responsiveness to antibiotics (and might make you resistant). Later, when you get a bacterial infection like pneumonia, those antibiotics might not work.

Be careful about what pills you decide to take. Just because your doctor is willing to prescribe a medication for you doesn't necessarily mean you have to take it. Knowing when you need or don't need to take medicine is an issue you should discuss with your doctor. Ask him or her questions about any medications suggested.

Test, Tests and More Tests

With so much technology available, some people visit their physician and ask for certain tests. Certain tests become popular at certain times. For example, the total body scan has become very popular today. It's highly advertised and advised by some as the way to prevent various diseases by catching them in their early stages. I'm not sure, however, that body scans are a good thing. First, they can find harmless abnormalities that lead to invasive, unnecessary follow-up tests. And second, we don't know some of the long-term effects of having a body scan, given the techniques used to produce such images.

In simple terms, the MRI scans, which are popular today, actually work by aligning the cells in the body to be all in a certain way, as if they were soldiers all standing at attention. Is this healthy? Is this okay or does it make one prone to develop diseases? The answers to these questions are unknown.

Some argue that body scans are harmful to your health, while others say that the benefits outweigh the risks. The final answer will not be known for some time.

I remember when there were x-ray machines outside shoe stores so you could x-ray your feet to see if the shoe fit properly. Now we know that this is not healthy and rather detrimental to your health. Excessive x-rays will do more damage than good.

Another question to ask: Are all of the pushes for scanning done for money? Providers of body scan services can make a lot of money. Are they doing it for monetary gain or for the good of the patients? I don't know the answer. All that I would advise you is to be cautious. Know the pros and cons of the situation and then decide for yourself. Don't be swayed by advertising. On the other hand, if a doctor suggests getting one, it's up to you to think out the situation clearly and do the correct thing. Go over all of the advice and make an informed decision.

Some people get demanding when it comes to asking for certain tests. If requested tests are not ordered, they get angry. Doctors who say yes to their paying patients and order myriad tests that have no bearing on any present condition is over-treating, which leads to over-diagnosing. Your job is to make sure there's a good balance between you and your doctor. You are on the same team together.

If you take a genuine interest in your treatment and diagnosis and limit the medication you take and tests you get to only what you need, everything about your health care would work better. I don't want to suggest that all medications are bad. Most of the time medications are useful, warranted and helpful in relieving your symptoms. However, you must be sure that any medications you take are properly used, used for the correct symptom and for the correct amount of time.

Under-Diagnosis

If you go see your doctor complaining of various things and he or she fails to take your symptoms seriously, you are a victim of

under-diagnosis. I've mentioned this before: If your doctor treats your symptoms but fails to search for the underlying problem and diagnose you, you're a victim of malpractice. Cases of under-diagnosis land in the news on occasion and they are usually linked to an HMO story. This is probably due to the limitations that are being put on the physician by the large health organizations who control medicine. Because much of medicine is controled by corporate giants that squeeze every dollar, sometimes this results in the curtailment of treatment.

Limits have been placed on office visits—not directly but indirectly. Physicians are given a certain number of patients and they are paid a fixed amount of money for seeing those patients. Thus, it pays to see fewer patients. Restrictions have also been placed on the amounts and types of drugs that can be prescribed.

These kinds of "rules" in medicine have resulted in under-diagnosis, and I don't see an end to this soon. Until the field of medicine—and how it gets delivered—is changed, new restrictions to offset rising medical costs will keep emerging.

Other examples of under-diagnosis include failure to pursue a diagnosis because of costly tests that would confirm it. Expensive technology makes for expensive tests. This, in my opinion, is due to the fact that the large corporations want to recover their capital outlay for equipment in a very short period of time.

Twenty-five years ago, a hospital owned by physicians was happy to gross $50,000 to $100,000 per year. Profits were divided up by the owners at the end of the year, which amounted to a nice bonus. Today, however, a large corporation would be very unhappy with such a small net. Corporate-run hospitals must net in the millions or consider closing a hospital because it does not live up to its expectations. When these factors come into play, under-diagnosis is the end result. Taking interest in your health care will prevent most cases of under-diagnosis. If you know what to expect and be aggressive when it comes to receiving treatment, you'll get what you deserve.

Remember that the "squeaky wheel gets the results." Assertive, informed patients will receive the best care overall. Always.

Conclusion

Always keep in mind the importance of forming a pact with your doctor. You must be in charge of your health. The advice given to you by your physician is important but it is ultimately up to you to make any final decisions. The idea of the second opinion gives more credence to the patient's ability to make decisions. Especially today when there are many choices as to the types of therapy, the choice and final decision is up to you—the patient.

Go over all of the facts. Learn all of the different methods of treatment. Seek as many opinions as you need. Use all of the resources available and, most of all, ask questions.

Ask your health professionals. Seek their opinion. Find out what they would do if they were you. Consult literature, the Internet, all of the sources at your command and then make the correct decision. Most of all, maintain a good relationship with your doctor as demonstrated in this chapter, and by all means read, read and read so that you will be well informed. There is nothing secret today about medicine and your treatment. In short, be informed.

10 Things You Need to Know...

7. Every Pill, Every Swallow Counts

The pharmaceutical industry is the most profitable industry in the U.S., with profit margins that are nearly four times the average of Fortune 500 companies. According to a report conducted by Families USA, a Washington-based consumer health organization, all of the nine U.S. pharmaceutical companies that market the top-selling 50 drugs for seniors spent more money on marketing, advertising and administration than they did on research and development in 2000.

You are equally aware of this advertising and marketing from the magazines you read, the television shows you watch and the billboards you see when you're driving. You might have seen one that urged you to ask your doctor about a particular drug—and you might have done just that. When the Food and Drug Administration (FDA) relaxed its rules on mass media advertising for prescription drugs in 1997, it became easier for pharmaceutical companies to promote their products in 30- and 60-second television ads without giving detailed medical information on the indications, potential side effects or proper use.

Spending on mass media advertising for prescription drugs has risen sharply and steadily, which has also coincided with a rapid rise in the spending on prescription drugs in the U.S. Prescription spending, a multi-billion dollar market, is now the fastest growing health care expense.

> **To put this kind of spending into perspective, in 2000, PepsiCo spent $125 million in ads for Pepsi, while Vioxx (an antiarthritic drug) was promoted directly to consumers on a campaign that cost $160 million. Vioxx also beat out Budweiser beer, whose ad spending was a mere $146 million.**

As a consumer, you have to be careful about these ad campaigns. Many exaggerate a drug's effectiveness—while underestimating their side- or long-term effects. Some have gotten into legal trouble for false and deceptive advertising. While they might make you feel more informed about various conditions and available treatments, you must make every decision about medication with your doctor. Only he or she can know what's best for you and your body.

Care with Meds

I cannot emphasize enough how important it is for you to be careful with the medications you take. Generic drugs have be-

come the norm today for many prescriptions. They save you money while being just as effective as their name brand counterparts. But all of the different names and products can cause confusion— even among medical professionals. Be certain that when you leave your pharmacy you have the correct prescription—the right drug in your hand. And if not then, before you pop the pills in your mouth. If it's your first prescription, have the pharmacist explain to you any side effects and special instructions. If it's a refill, be sure the pills are the same color, size, etc. as the ones you have been taking. If not, ask.

I have seen cases whereby the wrong medication is given to the patient. This can happen easily. Different drugs can share similar spellings or sound alike. A doctor with poor penmanship can cause a misinterpretation at the pharmacy when the prescription is being filled.

Be sure you are getting the correct drug. Ask your doctor to write the name of the drug on paper. When you receive your prescription at the pharmacy, compare the two names. It's your responsibility. Don't leave it up to your pharmacist to get your medication right.

I also strongly advise that you have some knowledge of the care the doctor suggests. This can be found easily on the Internet, through numerous books and periodicals printed for the lay pub-

lic, by asking questions and getting answers from your provider. You can access pamphlets and informational brochures from the government, medical school libraries and many other sources. Use these sources to your advantage and you cannot go wrong. Do not accept the first opinion if you think it is not correct.

Wrong Medication

Much has been written elsewhere about receiving the wrong medication—but the subject still deserves attention. First, let's discuss the medication problem that can happen when you're in the hospital.

When you're being hospitalized, you're at the mercy of the physicians and the hospital staff. You feel that they are the experts and you are the patient. Most people don't question what medications they receive while in the hospital. If a nurse comes by with a pill, they take it without asking. Or the nurse arrives with an injection and they accept it. Or an IV is started and they let a solution drip into their bloodstream.

Hospitals are more likely to use generic drugs with long chemical names in place of the more commonly named drugs you may be familiar with. There is nothing wrong with generic drugs. They are made with the same chemicals but lack the advertising behind the popular name. Many over-the-counter drugs have generic versions as well. For example, you can purchase Tylenol or generic acetaminophen. People are usually less knowledgeable about generic forms of prescription drugs. It's hard to remember long chemical names. And, in many instances, the pills even look different.

> **The incidence of wrong medication prescribed is higher than you think. Always double-check your medications whether you're in the hospital or pharmacy.**

If there is any question, ask the hospital personnel to contact your doctor to verify the medication and the dose. Good questions to ask:

- What am I getting this medication for?

- Why am I getting two pills and not one?

Many years ago, I had a patient who was scheduled for a small surgical procedure the following morning. As was the custom at that time, the patient went into the hospital the night before the procedure. The procedure was for a removal of a skin lesion. Although it was routine for patients to receive an enema before major surgery, enemas were not routine for minor things like the removal of a skin lesion. In this situation, however, the nurse came in and gave the patient an enema. Before surgery the next morning, the patient asked me, "Why the enema? I was not constipated."

This is a prime example of receiving the wrong medication or procedure. Learn to question things that do not seem correct to you and learn more about the medications that you receive. The patient mentioned should have questioned the enema and should not have passively received it.

You can end up with the wrong medication for various reasons. The wrong medication can be prescribed. You can go into the pharmacy with a prescription for one drug and come out with another drug; or you can come out with the right drug but at the wrong dose. Or your doctor can confuse two different drugs and write a prescription for you with the wrong one. Today's plethora of medications can be confusing for even the most learned physician. So many medications fall into the same class that physicians are more apt to make mistakes.

Suppose you have seen your physician for an infection and your doctor takes a culture to determine the origin of the infection. It's determined that you need a combination of two different antibiotics.

Assume that the two antibiotics prescribed actually enhance each other. In other words, a dose of one when given with the other actually increases the amount of the first. This means you get more of the drug than necessary and more than you should have. Because of this, you develop symptoms reacting to too much drug—such as nausea or diarrhea, etc. You are being treated improperly.

Suppose that the opposite occurs; you are prescribed two drugs but one of them lowers the effectiveness of the other. In this case, you are not taking enough drug.

This is again a malpractice.

Over-the-Counter Overload

Another problem that I see is the abuse of over-the-counter medications. People are accustomed to popping pills for every-

thing, but not necessarily telling their doctors when they need to. You take medications for pain, colds, flus, aches, stomach bugs, etc. If you don't inform your doctor about the pills you pop, he or she might write you a prescription for something that will react with another medication. You might also decrease the efficacy of a medication by taking other medications at the same time.

I once saw a patient who contracted a severe infection overseas in Asia. She had gone into a pharmacy in Asia and bought some medicine. When she returned to her own doctor, she was given a prescription for more antibiotics. Because she was taking two strong antibiotics, the infection cleared but she developed a severe case of dehydration and diarrhea for which she had to be hospitalized. She almost died as a result—all because she didn't inform her physician that she had already been taking medication purchased overseas.

With all of the available medications on the market (over-the-counter and prescription), taking too much is a real problem. You must be aware of what you are taking and let your doctors know. Otherwise, you won't get the best treatment...and you'll end up seeking treatment to reverse the problem.

Wrong Dosage

When it comes to errors in medication, it's usually with regard to dose. That is, physicians fail to write prescriptions for the right doses, or your pharmacist fails to fill your prescription correctly.

Because medication errors are the second most frequent reason for claims against physicians (behind faulty diagnosis and evaluation), the Physicians Insurers Association of America (PIAA) studied the problem in 1993. The PIAA is a trade association of more than 60 professional liability (medical malpractice) insurance companies owned and operated by doctors and dentists.

In the study, called the Medical Errors Study, the PIAA analyzed drug-related claims resulting in payments of $5,000 or more to victims. In 1993, the association investigated 393 such claims that were filed—and whose payments averaged $120,722 by the PIAA member companies. One-fifth of the errors resulted in the patient's death, another fifth to significant permanent injury. Incorrect dosing, inappropriate drug selection, failure to note drug allergies, failure to monitor for side effects and communication failures between doctor and patient were among the common types of problems.

Because this study referred to the errors that resulted in claims, imagine how many went—and still go—unreported. Most errors do not result in claims so you can imagine how frequently this does occur.

As of this writing, incorrect doses accounted for 27 percent of the cases receiving payment for legal malpractice. I don't

think this figure reflects the true percentage because most cases go unreported.

The next most common error was prescribing medication that was inappropriate for the medical condition that exists. This means you receive a medication that has little effect on your condition, or the medication is simply the wrong one. This happened in 25 percent of cases that ended up in litigation.

The third most common error, failure to monitor for drug side effects, occurred in 21 percent of cases. Communication failure between physician and patient occurred in 18 percent of cases. Remember: these figures refer to cases that ended up in litigation. Imagine how often this really does occur. Failure to monitor the drug level occurred in 13 percent of cases; doctors also lacked sufficient knowledge of the drugs they prescribed in 13 percent of cases.

Does this mean doctors don't know much about the drugs they are prescribing?

Yes, this does happen. In 13 percent of the total cases reviewed, the medication was used for an improper amount of time.

An inadequate medical history was taken in 13 percent of the cases. Inadequate hospital charting occurred in 10 percent of the cases as did a failure or delay to note an allergy previously listed. Failure or delay in ordering laboratory tests occurred in 8 percent of the cases and drugs were inappropriately administered in 8 percent of cases. In other words, the drug given was delivered the wrong way to the patient.

In 18 percent of cases an error occurred because of a communication failure between the physician and other providers—other physicians, the pharmacist or nurses. Errors in writing prescriptions occurred in 6 percent of the cases; and, patients failed to comply with their medications' instructions in 6 percent of all cases. Failure to read the medical record by physicians occurred in 6 percent of the cases. Medication was contradicted by other medication 4 percent of the cases.

As you can see, errors occur too commonly to be excused as a chance happening. The frequency of these errors or malpractice should not be so high. As a patient, you must take the responsibility to question what you are taking, what has been ordered for you and whether or not it is correct.

Remind yourself that medications are really poisons. Some of them are friendly poisons but nonetheless poisons. We certainly need antibiotics to kill bad bacteria and save lives. We certainly need pain medications to relieve the pain of injury, disease and surgery. We certainly need anesthetics to put us to sleep, but if we realize that these and all of the drugs are basically poisons, we will be more careful as to what we are getting and how to use them.

You don't have to question every prescription you get from your doctor to the point that he or she feels you don't trust him or her. But I'm telling you to be sure you get the proper medication, in the proper dose and for the proper amount of time.

A Guide to Getting the Right Drugs

As I said before, one of the most common mistakes in medicine today is in the dispensing of drugs. For this reason, drugs are usually dispensed in individual doses in the hospital. However, errors still occur. So many drugs sound and look alike these days, it's hard to make sense of it all. Generics are especially hard to distinguish because they don't usually come in fancy coats and colors. It's almost impossible to look at a white pill and ascertain what, specifically, is in that pill and how much (i.e., dosage).

> **If something does not seem correct, question it. After you have received one dose, the other doses should all be of the same type—same color, size, etc. and the timing should be the same—once, twice, three times, four times, six times, etc., per day. If you are aware that mistakes can happen, know that they do happen and decide that they will not happen to you, you can prevent being a victim of a cover-up.**

Be careful about over-the-counter medication as well. In 2002, a new government regulation required that a standardized Drug Facts label be placed on over-the-counter drugs. It's similar to the Nutrition Facts label you see on foods. Included on these labels are things like ingredients, uses, warnings and dosage instructions. Make sure you read these labels carefully. Just because a drug is over-the-counter doesn't mean it won't have side effects or counter interactions with other drugs.

What about patient mix-up? We have all read and know about new parents going home with the wrong baby. How can this happen? It is really quite easy. Two babies get to the nursery near the same time and the tags are mixed. Confusion and chaos in an overcrowded nursery result in confusion and a mixing up of tags or other important documents. These same kinds of mix-ups can occur with patients—with you when you are in the hospital. You could be taken for the wrong test, given the wrong food, given an IV when you do not need it, have the wrong blood test, taken to surgery for the wrong operation, receive the wrong medication. Avoid these kinds of errors by being aware of your treatment and care at all times. If in doubt, question. Ask why this is being done. Ask. You will not be a victim if you ask.

Adverse Reactions

Errors do occur when physicians prescribe medication and can't make a good judgment call as to which of the available medications are best for you. The complications, side effects, ill effects

and harmful effects of the medication that you are being prescribed should always be looked into—not only by your physician but by you, too. I know that most of the time medication is given for serious illnesses. The medication may even be lifesaving. However, you should know that there are many adverse reactions that do occur with various medications.

Many drugs can cause depression. You might have noticed that among the many side effects listed in some drugs today is depression. There are 128 drugs that can cause sexual dysfunction, and as of this printing, 36 drugs can cause parkinsonism, a neurological disorder (the most common form of parkinsonism is called Parkinson's Disease).

This is serious.

You must weigh the benefits versus the adverse reactions of the medication you are prescribed. Don't let your doctor prescribe something to you about which you know nothing. Search out the literature that your pharmacist gives you and search the Internet for a more detailed description of the ill effects, side effects and adverse reactions of anything you take.

Remember the horrific thalidomide stories. When doctors prescribed thalidomide in the late 1950s, early 1960s to pregnant women to help them sleep and treat morning sickness, it was later discovered that it caused serious birth defects. Children were born without properly formed limbs and many died within the first year. At the time it was prescribed, it was touted as a wonder drug; only later did doctors realize its ill effects.

Sometimes it can take years for the side effects of a new drug to manifest itself. Be careful. Be sure that you are getting the correct medication for the condition that you have. Read the side effects and weigh whether the side effects far outweigh the benefit. Only you can decide.

Ask Your Doctor About Medications

It's only recently that the pharmaceutical industry has begun to advertise to the public. Before this you would go to your physician and he or she would prescribe the medication you needed. As a result of the advertising, you go to the physician with the preconceived idea that Celebrex, Vioxx, Nexium, etc., is just for you. The ads will make you believe these are miracle drugs—they will cure all that ails you. Many of the ads don't even mention side effects; instead, they show people having fun, running through a field and laughing. At the end of watching healthy, happy people, a voice-over instructs you to "Ask your doctor about [the purple pill or some such]... ."

Don't forget that drug companies do this to entice you to ask your physician for this medication whether or not it's appropriate for your condition.

This is an advertising game, a ploy to make you ask for and get the medication advertised. Do you know what happens when a medication loses its patent and becomes generic? The drug companies come out with a new drug that is an isomer of the old

one—many times with a new name. The new ones are more expensive and may not even work as well as the old one.

An isomer is a mirror image, chemically, of an already existing drug. In some cases, they are better, but in many they are just more expensive, a new color pill, a lot of new advertising but the same effect. One example of this is Prilosec—the old medication—and Nexium—the new medication. In effect they both work the same but the new isomer, Nexium, is excreted from the body more safely—a small amount safer—and perhaps lasts longer. But, the cost difference between the new Nexium and the Prilosec when it goes generic will be substantial. The generic Prilosec will be a great deal cheaper to buy.

Yet, with all of the advertising you are enticed to ask for and use the new drug.

As a physician, I can dispense medication from my office. As such, I can purchase generic medications for pennies and sell them for dollars—making a good profit but still keeping the price way below that offered by the local pharmacies.

It's been estimated that when Prilosec becomes generic, the loss to the manufacturer (Astra Zeneca) will be in the neighborhood of $2 billion. That's a substantial loss.

For this reason the company has brought out Nexium.

> An isomer of a generic drug with a fancy new name and price tag doesn't necessarily mean it's a better drug. Ask your doctor to be honest with you about the drugs he or she prescribes. Ask for generics when they are available. Don't be fooled by the gimmicky advertising. Although there will be times when the only drug available to you is the most expensive one on the market, in most cases there are cheaper—and equally as effective—drugs to use for various conditions. When you buy the brand name, you buy the name and not the chemicals that make up that drug.

Be aware of isomers and get the best value for your money. You might not have a choice, but it doesn't hurt to ask.

Conclusion

I hope that you've gained an understanding of the kinds of things that can—and do—go wrong in hospitals, doctors' offices and pharmacies. It should get you to question every step of the way. Be sure you are receiving the quality of care that you expect and deserve. You can get the best care possible if you are involved and ask questions. Too often patients are wrongly intimidated and assume that the nurse or medical care provider knows best, but you need to question. Question everything so you will keep them from making a mistake—even an accidental mistake. Even the simplest question may set the quality of care in the correct direction.

This chapter took a specific look at drugs and the problems posed by their use. Hundreds of lawsuits involving medication errors occur every day, but these don't represent the true number of errors that occur and go unreported. There is no excuse for a large number of such errors. According to the Physicians Insurers Association of America, medication errors account for the second most frequent and second most expensive type of malpractice claims. The first most frequent and most expensive type of claim was error in office visits (i.e., errors in judgment and treatment). To put an end to this, you must take an interest and responsibility for your treatment and diagnosis. Then you'll never have to hire a lawyer...hopefully.

10 Things You Need to Know...

8. Women Have a Lot to Worry About

Women have special needs when it comes to their health. Generally, women visit the doctor more than men, have annual pelvic exams and have to manage more of their health care when it comes to pregnancy and menopause. In my opinion, too much malpractice occurs in the treatment of female diseases—specifically in the realm of gynecology.

In this chapter, I'll look into some of the more common diseases women face and give you the tools to handle these potential problems. Whether it's you or your significant other, you'll want to know about these diseases and how your doctor will treat them effectively.

The Pelvic Exam

Most women will—many times in their lives—visit the gynecologist for a pelvic exam. This is merely an examination of the area strictly unique to women. A patient is ushered into an examination room where she lies down with her feet in stirrups. The doctor will first examine the labia—the lips covering the vagina. The doctor will be sure there are no lesions such as cysts, tumors

or other abnormalities. The urethra—the opening from where a woman urinates—is also examined for abnormalities. Next, the patient receives a careful bimanual exam, which includes careful examination of the vagina, uterus and ovaries. The doctor will insert his or her hand to feel these areas and rule out any enlargements, abnormalities or irregularities. Finally, the doctor will insert a speculum into the vagina; most speculums used today are made of plastic so they are not as cold as the older, metal ones. A light on the speculum also warms the plastic.

With this device, the inner areas of the vagina are examined and a Pap smear is taken (i.e., the doctor swipes a sampling of cells from the cervix, the opening to the uterus) to look for abnormalities. If necessary, a doctor can take a culture if there is evidence of infection or yeast, which is not uncommon in women. When the instruments are removed, the pelvic exam is concluded.

When a woman goes in for her pelvic exam, she should also have her breasts checked for any abnormalities and a mammogram should be performed every one to two years. The general rule is that any sexually active woman or woman over 18 years of age should get a Pap smear (the test that screens for cervical cancer and precancerous lesions) every year.

I've seen many women in my office who, after being examined, say "That wasn't so bad or painful." I then ask, "Why did you say that?" Sometimes these women comment that previous exams had been painful and that their pain would last for hours or a few days. There is no reason for a pelvic examination to hurt. They can be uncomfortable, but they are far from causing true pain. While I was training as a medical specialist, and later in my

practice, I encountered other doctors who admitted to hurting women during pelvic exams. They aren't as gentle when performing the exams and don't take the extra time to avoid being harsh or hurtful. Although doctors don't try to inflict pain, approaching a pelvic exam without care and sensitivity toward the fact such a procedure is uncomfortable, is unnecessary and a form of malpractice.

> **There is absolutely no reason for great pain during a pelvic examination. If you experience pain, tell your doctor and ask what's causing it. And, if you feel something is not right when it comes to this examination, find another doctor.**

Finding the right gynecologist can be hard. Many general internists will perform basic pelvic exams—Pap smears and various cultures—so you don't have to find two different doctors to cover your every need. An internist who does Pap smears is often a good choice among young, healthy women who don't need prenatal care yet and don't want the hassle of dealing with more than one doctor. Today, with the training new doctors receive, a good internist, general practitioner, family doctor or ob/gyn can perform all the tasks related to a pelvic examination. Choose the one that suits you best.

Common Disease and Their Misdiagnoses

It is estimated that approximately five million women suffer from thyroid disease. This can be from an over production of thyroid hormone—*hyperthyroidism*—or an underproduction of thyroid hormone—*hypothyroidism*. There are many causes for the disorders and I will not go into them. The main reason thyroid disorders are missed in women is because they may create different symptoms, which are at times vague or disregarded as stress, nerves, etc. Symptoms can include fatigue and constipation, aches and pains and feelings of cold and/or warmth. All of these symptoms can be quickly dismissed by physicians as other things—nerves, PMS or menstrual problems, menopause, etc.

> **Skin problems and menstrual problems are often seen in thyroid disease. None of these symptoms should be disregarded, however. They should be investigated to rule out thyroid disease, which can be easily done through blood tests. Treatment is very simple if the diagnosis is established.**

Two other diseases often misdiagnosed—especially in women—is lupus and scleroderma. Lupus is seen in an estimated two million Americans, mostly women, while scleroderma is seen in 500,000 Americans. So, these diseases are not rare. Both are autoimmune diseases that affect mainly young women of childbearing age and can be potentially life-threatening.

If you have *lupus*, your joints, skin, blood and kidneys become inflamed; if you have *scleroderma*, your body's connective tissue and sometimes internal organs are hardened and destroyed. These diseases are missed by doctors because they cause subtle symptoms, which then get sloughed off as other minor problems. A doctor who doesn't investigate the subtle symptoms will rationalize that they are caused by nerves or stress. A diagnosis, however, can be easy for the careful doctor. The hard part is looking for the lupus or scleroderma.

Approximately 10 percent of all women of reproductive age suffer from *endometriosis*, a condition in which cells that look and act like the cells that line the uterus (endometrial cells) are found in other locations in the body—the ovaries, fallopian tubes, bowel, bladder or even in the abdominal wall. You can be born with these endometrial cells in the wrong place or they can develop later in life through migration, transplantation, etc. Every month, the endometrium bleeds and sloughs itself off in a normal menstrual cycle. When this occurs with endometriosis, a woman will experience pain because she will bleed in areas other than her uterus. Her body's response to the excess bleeding will be pain.

I once saw a young woman sent to me on referral. She complained of severe pain in her abdomen. She had had a C-section four months previously and given birth to a normal baby. Her pain now was happening at the same time as her menstrual period. After carefully considering all possibilities, and since her blood count was dropping, I assumed she was bleeding internally. After much consultation and deliberation, we decided to take the explo-

ration to the next step and open up her abdomen for a look at the source of the bleeding. This was 20 years ago—before the days of CT scans, MRIs and laparoscopes. I noticed during surgery that her abdominal wall was oozing blood from multiple areas. It was clearly evident she suffered from endometriosis, which was confirmed by a biopsy. The cells had been displaced during her C-section, leaving them in the abdominal wall and when her menstrual cycle began, they started to bleed.

As with some of the other diseases, the symptoms of endometriosis can be vague—from pain and cramps that mimic menstrual pain, to back pain, diarrhea and pain on urination. If you have a doctor who knows to look for endometriosis, he or she can definitively diagnose you by laparoscopic examination. But, it's key to get a doctor to take the most vague of symptoms seriously.

Pelvic inflammatory disease—PID—is frequently missed by doctors. PID is an infection of the female reproductive organs and is usually caused by various bacteria, organisms like chlamydia or gonorrhea. Untreated gonorrhea and chlamydia cause about 90 percent of all cases of PID. Other causes include an abortion, childbirth and pelvic procedures. More than one million women a year experience an episode of PID, while almost 15 percent of women experience PID at some point in their lives.

This disease is often overlooked because both the patient and the doctor loathe to bring up the subject of PID. The disease is inextricably linked to negative behaviors and risky lifestyles—promiscuity, sexually-transmitted diseases, drunkenness, personal recklessness with one's life, etc. So long as the stigmas remain tied to

STDs, talking openly about PID is a hurdle to clear. As a patient you should be honest about your symptoms and your sex life. You don't have to give details, but be willing to admit that you may have PID and need to treat it. Untreated PID can lead to other complications, including ectopic (tubal) pregnancies and infertility.

Sexually transmitted diseases (STDs) are still very prevalent. In the U.S., more than 65 million people are living with an incurable STD. An additional 15 million people become infected with one or more STDs each year, roughly half of whom contract lifelong infections. Of these 15 million new victims, one-fourth are teenagers.

Some of the most common STDs include: chlamydia, genital warts (HPV, or human papilloma virus), gonorrhea, hepatitis B, genital herpes, HIV/AIDS, syphilis and trichomoniasis. They can be hard to diagnose sometimes because they can be silent—they don't present themselves to their infected patients. It's a good idea to have your doctor test you for the various STDs when you have a comprehensive check-up or change sexual partners.

Irritable bowel syndrome is yet another common disease overlooked by doctors. This is missed for the same reason others are missed: the doctor and/or patient downplays the vague symptoms (pain, spasms, diarrhea or constipation) and chalks them up to stress, nerves and menstrual-related problems.

An estimated 450,000 women suffer from *interstitial cystitis*, an inflammation and irritation of the bladder that may be related to a collagen disease, an allergy or may even have begun as an infection. Typical symptoms include pain, pressure in the bladder area, an urge to empty the bladder—sometimes as much as 50 times per day—and problems with sex. Cystitis can completely devastate a woman's life, making it impossible for her to maintain an intimate sexual relationship, work and care for herself. It can leave her completely unable to cope. And yet it is often missed and misdiagnosed. Treatment for this disease is elusive. No single form of treatment has been successful in all cases. There's no need to go into the details of the various treatments available, but if you have interstitial cystitis, consult your physician and follow his or her advice.

Not the End

There are many more diseases that inflict women that are missed and misdiagnosed. I just wanted to touch on some of them in this chapter. Women are also prone to develop diseases such as ovarian and uterine cancer, too.

In addition, colorectal cancer inflicts just as many women as men. Women should have a rectal examination during an annual exam. This should include a sigmoidoscopy, or examination of the lower colon by an instrument; after age 50, women should have a colonoscopy to look for polyps that may become malignant. If this type of cancer runs in the family, a doctor may want to start screening before the patient reaches 50.

Women can also get lung cancer. If you're at risk (i.e., smoker, family history, etc.), you should ask your doctor about getting chest x-rays.

> **You can perform your own visual body scan to check for unusual skin abnormalities. Look for moles that are black and have irregular edges. Signs of skin cancer can present itself in a variety of brown to black. Stand in front of the mirror and look. Skin cancer does not differentiate between men and women.**

Strokes and heart disease must also be considered. No woman is immune to these diseases, which people often think target men only. This is when knowing your family medical history is key to your own health. If a blood relative died of cancer, heart disease, stroke, diabetes or some other illness, you should know to look out for it and alert your doctor.

Lastly, it's worth noting a few things about the latest information on hormone replacement therapy. For a long time, the medical community thought that women suffered fewer heart attacks and strokes if they received hormones after menopause. The latest studies indicate that there is no benefit from hormone replacement therapy, or HRT, in the prevention of heart disease and stroke. However, there is still a benefit from hormones in the prevention of osteoporosis, or the wearing down of bone tissue.

Estrogen is currently the best way to prevent osteoporosis. For the latest on this topic, I advise you to contact your physician or get several opinions from several physicians and follow the advice that makes the most sense to you. As of yet, there is no conclusion about whether HRT is worth the risk of side-effects that it poses. The final analysis on the effects of estrogen is not complete.

But, you can keep up with the news, the recent findings and read articles as they come out. Discuss the topic and your concerns with your physician.

> **There's an enormous volume of material to read regarding all the diseases that can inflict you. Don't rely solely on your doctor for all the information. Seek out the information and gather as much as you can before you accept whatever your doctor tells you. It's up to you to mill through the findings and choose those that apply to you.**

I hope this gives you some insight into the frequency with which a diagnosis is often missed and malpractice occurs. My intention is not for you to go away from this chapter thinking that your doctor is doing a bad job or that all doctors are committing daily malpractices. To the contrary, I am merely trying to inform you about some of the more common diseases in women so that you can take a greater interest in your treatment and prevent any malpractice from occurring.

Diseases of the Breast

Diseases of the breast have been extensively covered in the news and by popular women's magazines. But that still doesn't trump the fact that diseases of the breast go unnoticed for a long time. Except for skin cancer, breast cancer is the most commonly diagnosed cancer among American women—and it's second to lung cancer as the leading cause of cancer-related death. If detected early, however, the five-year survival rate for localized breast cancer is 96 percent.

> **Mammography is the best available method to detect breast cancer in its earliest, most treatable stage—an average of 1 to three years before the woman can feel the lump. Women aged 40 years of age and older should have routine mammograms every one to two years.**

The best way to consider the anatomy of a breast is to think of a large stem of grapes. The stem is the nipple and the grapes are the ducts that produce the milk. The milk flows through the smaller stems toward the large stem. This is basically the ductal system and around all of this is fat. When it comes to breast cancer, it's about the ductal system—not the fat.

Let's say a woman notices a small irregularity in her breast. It's not necessarily a lump, but she notices an irregularity—something doesn't seem right to her. She visits her physician and learns that

there's nothing wrong and she should forget it. Although the doctor may not feel anything wrong does not mean everything is okay. But the patient is satisfied with the statement and time passes. Finally a real lump does appear and again she visits her physician. Now he does feel something and orders a mammogram but the mammogram and/or the reading of the mammogram does not reveal any abnormality. She is once again reassured with the words, "I don't see anything wrong on the mammogram, so we'll just watch it."

This continues and eventually a lump—abnormality—does show up on subsequent mammograms, a biopsy is done and cancer is discovered. The biopsy should have been done in the beginning when the woman felt something wrong. She should have demanded a more intense examination...or sought a second opinion. This proves that you should always follow your instincts. If you think something is wrong, ask your doctor to investigate to your satisfaction.

No one knows your body better than you. You must follow your natural instincts or intuitions and if something seems wrong to you, perhaps something *is* wrong.

Let's look at another scenario. Let's say a woman notices a definite lump in her breast. She visits her physician, who says, "Yes, I do feel the lump but it is nothing. We'll just watch it." As a surgeon, I've heard countless stories like this from patients who,

after years of letting their lumps grow, had to resort to more invasive procedures to rid the cancer. In some cases, it was too late and the cancer had spread.

Drainage from the breast is another condition that should be investigated, but often doesn't get enough attention. If a woman has bloody or milky fluids leaking from her nipples, she might have a simple abrasion around the nipple...or she might have an abnormality that goes beneath the nipple. She could have a tumor in the ductal system of her breast, which, as mentioned above, is the part of the breast that controls milk production.

In fact, the site of origin for most breast cancers is in the milk ducts, and for high-risk women (or for women who have had cancer in one breast and want to monitor the other), they can get a ductal lavage, whereby the doctor collects cells that line these milk ducts and analyzes them for abnormalities. This new method can detect cancerous cells far more in advance than mammography. By repeatedly "lavaging" (washing) the duct system, thousands of cells can be collected for analysis.

The American Cancer Society recommends the following guidelines for finding breast cancer early in women without symptoms:

- **Mammogram: Yearly for women 40 and over.**

- **Clinical Breast Exam (CBE): Between the ages of 20 and 39, women should have a clinical breast exam every three years. After age 40, women should have a breast**

exam by a health professional every year. The CBE should be done close to, or preferably before, the mammogram.

- **Breast Self-Examination (BSE): All women age 20 and over should do BSE every month.**

Any woman who does not know how to at least perform a breast self-examination should ask her doctor to show her the next time she visits him or her. The doctor can perform a BSE on the woman to demonstrate the motions so she can repeat it for herself once a month in the shower or other convenient place.

Conclusion

As a final note to this chapter, it's worth adding the importance of finding a good, trustworthy and reliable doctor. Women who have a problem going to a male doctor for a pelvic examination can opt for a female physician. If you *ever* feel uncomfortable with your doctor, get yourself a new one.

You need to be able to find a doctor with whom you can share intimate details and receive objective, honest opinions. You're probably shy to begin with and don't like talking about your sex life, odd behaviors and quirky lifestyle to others (particularly a doctor you see maybe once a year), but when you compound your general reluctance to talk about yourself with the sterility of your doctor's office, it becomes all the more difficult to open up and find a comfort zone.

Doctors must adhere to codes of ethics, but that doesn't mean unscrupulous doctors don't exist. As a patient, you also bear the responsibility of acting in an appropriate, respectful manner. The field of psychotherapy, for example, is rife with stories of patients who fall in love with their therapists. There is never an appropriate time to make advances on your treating physician under any circumstances.

Likewise, it's always wrong for your doctor to act in any way romantic toward you. If you visit your podiatrist and he decides to perform a breast examination, bring it to his attention that such an exam is unnecessary. Then never go see that doctor again.

It may sound odd to mention this subject in an age when the threat of litigation seems to prevent these situations, but they do still happen. Most go unreported.

It might take you time and energy to find a good doctor, but your efforts will be rewarded over the long haul. You'll lessen the chance of fearing those doctor visits and best be able to manage your overall health.

10 Things You Need to Know...

9. Children and Elderly Need Extra Attention

As with women's health, pediatrics and geriatrics deserve special attention because each field raises particular doctor/patient issues. With pediatrics, you're dealing with children whose systems need quicker attention when hit by an illness. A child with a high fever cannot be neglected. If a sick child does not get treatment, permanent brain damage and even death can result. The waiting time for treatment is not as long for children as for adults.

Geriatrics deals with elderly people and their health issues. As people live longer, they live to experience more disease—particularly those affiliated with advanced aging. Doctors who specialize in geriatrics treat more dementia, Alzheimer's and cancer, for example, because these are the diseases that affect the elderly. It is not odd today to see a man in his 90s with an acute gall bladder disease who comes through the surgery well. Similarly, heart transplantation is being performed on people in their 80s since the life expectancy has been extended.

So, whether you're talking about an infant or someone at the other end of the lifeline, you're talking about specific sets of health issues that require specific sets of knowledge.

Pediatrics

Malpractice in pediatrics is tricky because it concerns children. And children are usually unable to express themselves well. If you have a very young child, he or she might not be able to even tell you verbally that something is wrong or that something hurts. Older children might be able to talk, but they might not be able to explain what they are feeling...or they might avoid telling you things for fear of going to the doctor.

Pediatricians are at a disadvantage to other doctors in this regard; it's more of a challenge for a pediatrician to reach a diagnosis and determine what course of action to take.

When it comes to children, doctors have to deal with smaller doses of medicines and be careful about giving a child something that will cause an allergic reaction. Children are more fragile individuals and the interval between "normal" and "serious" with regard to an illness is much shorter than it is for adults. In other words, a problem that would normally be a small matter for an adult could be a very serious problem for a child. The younger the child, the larger the problem. A good example of this is simple dehydration.

For an adult, dehydration is not a very serious problem unless it is prolonged. An adult can fast—abstain from drinking any liquids for 24 hours—without any serious complications. However,

a child has less reserves because of smaller body weight, so dehydration can be a serious complication. You've probably heard stories of athletes who have gotten seriously ill and even died because they became grossly dehydrated and went into cardiac arrest. This is more likely to happen in a child—especially if the child has diarrhea and/or vomiting and is losing fluids.

A child is very fragile. You and your treating physician should know this fact. Severe diarrhea and vomiting should not be ignored. Adults can accommodate some degree of vomiting and diarrhea but a child will dehydrate very fast and should be treated promptly.

Because children are more fragile than adults when it comes to their health, certain things should be treated quickly. An infection in a child can spread rapidly, so it should be treated at once. Strep throat, caused by an invading bacteria, can be lethal in a child whereas it's not such a serious infection in an adult. There are many other situations that can be serious and even lethal in children, which do not affect adults to the same degree.

If your child has any kind of infection accompanied by a fever, you should seek treatment at once.

On the other hand, you need to know when not to run to the doctor's office for every little thing. You must use good judgment and common sense. There has to be a balance between the disease

process and good judgment. For most, if you follow your instinct, you'll know when to get your child help.

Both parents and children can exaggerate or play down symptoms, making it harder for the doctor to make decisions. As a parent, you might exaggerate one symptom but in truth your child is suffering from another—more revealing—symptom that your child fails to explain to you. A pediatrician must consider all these factors when dealing with children.

As children become older, some may be fearful of talking about symptoms for fear of retaliation from the parent. For example, your son may have broken a treasured piece of glassware and gotten some glass into his hand or foot. He might avoid telling you about the accident because he knows that you cherished that piece of glass. He manages to clean the area of broken skin, but an infection sets in because he doesn't get all the glass out and by the time you find out about the incident, the infection is so bad that your son needs minor surgery. If you had known about the accident in the beginning, you could have removed the glass and avoided the doctor altogether.

Another example is a child who is playing outside. She gets into trouble by going into an area you've made off-limits, where a bee stings her. The symptoms that follow are bizarre: she's dizzy, light-headed, has shortness of breath and maybe even a stiff neck. But she fails to tell you about the bee because she doesn't want anyone to know where she had been. After an extensive examination, a doctor might find the bite and make sense out of the symptoms. Or the doctor might not find the bite nor learn of it quickly enough to make a smart conclusion.

Diagnosing children can be tough in these situations. The point of these two stories: As a parent, always make your child feel safe and comfortable when it comes to talking about his or her health. If your child fears punishment for something he or she did that led to an accident, you need to assuage their fears.

Whenever your child comes to you feeling sick with vague symptoms, make sure you recall what he or she had been doing the last 24 hours. You'll want to aid your pediatrician with these things—including what he or she ate—when and if you take your child to the doctor.

You can also perform your own mini-examination of your child. Survey the skin, take a temperature, think about what he or she ate and ask questions. Just like you know your own body better than anyone else does, you probably know your child better than your doctor, so the more you prepare for a visit to the pediatrician, the better your pediatrician will be able to diagnose your child.

Remember: It's very difficult for a small and even a larger child to express what is wrong. Children often will vomit if they are not feeling well. This does not mean that there is something wrong with their GI tract (i.e., stomach, etc.) but the vomiting is a symptom of something being wrong. If you establish a good relationship with your child, he or she will be better able to communicate the problem to you.

Also realize that language skills are not fully developed in children. They often know that something is wrong, even know what it is, but are unable to communicate the wrongs to you. Ask simple questions. Try to find out what the problem is before calling the doctor. The doctor will also ask simple questions and try in the same way that you can. A fever—even one that is not too high—can cloud the mind.

Children with a fever often cannot communicate. Instead, they will begin to cry or vomit. Have patience. Be compassionate and show your love and you will be able to get to the problem. If you can point to the problem before reaching the pediatrician's office, your child will be able to receive the best and most effective treatment. If you cannot figure out what's wrong, then seek the advice and care of your doctor and together, you will come to the right solution.

Gaining a child's confidence is a challenge for both the parent and treating physician. We tend to tell children "This will not hurt," when in reality we should say, "It will only hurt for a short period of time." If we tell children the truth they will believe us, have confidence in us and let a doctor treat them properly. Through my own practice, I have learned that if you tell children the absolute truth you can immediately gain their confidence and do whatever is necessary for that particular child with minimum effort. One of the worst things you can do as a parent is say something like "If you're not good, you're going to the doctor." This programs the child to fear the doctor, which will probably stay with your child for a long time. Part of your job as a parent is teaching your child

how to establish a good relationship with doctors and not to fear them.

Missed Diagnoses

As a surgeon, I encountered cases whereby the pediatrician missed a diagnosis and landed the child in the operating room. Some of these missed diagnoses included hernia and *hydroceles*, or fluid filled sacs around the testicle of a male. Hydroceles can easily be diagnosed by a physician but sometimes a doctor will fail to look or look when the child is lying down and the fluid is pushed into the abdominal cavity.

Undescended testicles are yet another problem encountered in male children. In boys, their testicles descend into the scrotum. But in some children, this does not occur. If caught early, there are treatments available to get the testicle into the scrotum. And if medical treatment is unsuccessful then surgery may be necessary.

If a boy's testicles don't descend into the scrotum, they remain undescended in the abdominal area where the temperature is warmer and causes the testicle to atrophy. If left untreated, the boy might grow into a sterile adult.

There are many other problems that can arise that I will not go into. The point here is to suggest that you look at your child and speak with him or her. The more you can understand what's going on in your child's body, the more you can get the most out of your pediatrician for your child.

If ever your pediatrician questions a concern of yours, get a second opinion. You know your child best, and if you feel your pediatrician is not making thorough examinations or coming to any decisive conclusions, ask for a second opinion.

> **Just because we are dealing with children doesn't mean we can ignore what they say. It's hard enough for children to express themselves when it comes to their health; the best we can do as adults is take whatever they say seriously. Listen to your child and ensure that your treating pediatrician also listens.**

Geriatrics

At the opposite end of the age scale there's geriatrics—treatment of the elderly. As the population ages, geriatrics becomes a hot topic because more (aging) people seek more information about how to deal with age-related health problems. It's been said that there's a shortage of geriatricians, or physicians who specialize in treating the elderly. And yet, by 2030, the number of older Americans will have more than doubled to 70 million, or one in every five Americans.

The public's definition of "elderly" is also changing. Medical advances, technology and pharmaceuticals keep people healthier longer...and people stay in the work force for longer than the usual retirement age. The result is an ever-changing social concept of

who constitutes the elderly. As people's idea of "middle-aged" moves from the 40s to the 50s, people's idea of "elderly" gets pushed older as well. There is a growing number of people who are 100 years old and older today.

Consider this: The average life expectancy for an American woman turning 65 in 2002 was age 84; for a man, age 81.

One of the things that happens when you age is you lose some of your mental sharpness. This also means that as you age it's harder for you to remember symptoms; the elderly are more likely to misinterpret symptoms and even misunderstand proper treatment. They also forget to tell their physician all of the medications they are taking, and the doses.

For these reasons, I believe that malpractice frequently occurs in the elderly. Whenever I had elderly patients, I asked them to bring in all of their medications so I could read the labels and check doses. If a doctor fails to thoroughly question elderly patients about their medications, when they take them and how much, a doctor is committing a malpractice.

At times, the symptoms of a problem are given to the physician by a relative—a son, daughter, niece, nephew, etc. But even then, every symptom might not be relayed to the physician.

Under-Treatment

Most situations of malpractice among the elderly have to do with under-treating even a correct diagnosis. Because the elderly are more fragile than young and middle-aged adults, their symptoms are often dismissed as "old age." But they could have physical problems unrelated to old age.

I don't know why, exactly, but when it comes to symptoms of the elderly, the symptoms are often disregarded. My best theory about why this happens isn't flattering for doctors: There's less an inclination to believe in the symptoms that the elderly describe. A busy physician will sometimes not have the patience to listen to all of the symptoms given by an elderly patient—thus running the risk of missing the correct diagnosis. Being too busy is no excuse for not listening to the symptoms or problems of the patient.

In an attempt to save time, sometimes the physician will get only a part of the patient's story and miss some of the most pertinent parts or symptoms. In this situation, the physician will treat part of the problem and miss the more serious part completely. While there's no excuse for this, it will go undetected probably because there will be no way to discover the error until another visit. Also, the elderly, if given medication to take for the problem, will believe they are being treated properly, while in reality the real problem is being missed.

Often, the elderly feel that because of their age, some treatments are not available to them. Generally speaking, this is not true; most treatments are available to patients re-

**gardless of age. Of course, some procedures are contrain-
dicated on the basis of age, but this is because the proce-
dure poses more risk than no procedure. So, if there is a
greater chance that you will lose your life with a certain
procedure, the doctor will advise against it.**

However, as I have stated, the elderly are taken advantage of
in the field of medical treatment. They are under-treated in many
situations. Why? Sometimes it's for financial gain for the physician
and other times it's simply a gross malpractice. When malpractice
happens, no one places blame because either the elderly don't know
about the malpractice or the family does not want to pursue a
legal claim.

I've seen several such cases where a critical diagnosis was
missed but the family avoided making a claim for the sake of their
sick, elderly family member. I have also seen several cases of gross
malpractice in the elderly where the patient has died prior to the
doctor discovering the error, and the evidence gets buried with
the patient.

Easy Targets

The elderly are vulnerable and easy targets for many unscru-
pulous sorts, doctors included. If you have elderly parents, it's a
good idea to accompany them to the doctor to ensure they get the
proper treatment and care. Check their medications and doses.

Keep in mind that just because they are elderly doesn't mean they are not entitled to the same kinds of treatment you'd receive. If they can't speak up for themselves, it's up to you to insist on their health care.

The Merck Institute plans to provide information to seniors on health promotion and disease prevention. This information will cover behavioral changes that can affect the health of older adults, such as smoking, drinking, exercising and getting the right nutrition, as well as describe conditions they should consider being screened for, such as breast cancer and osteoporosis.

You may want to look for a geriatrician for your parents if they currently don't have one and are elderly. Because diseases can manifest differently in older adults than in young people, it's a good idea to consider a geriatrician when you think the time is right. When is the time right? The answer usually has more to do with the condition of someone's health than his or her age.

Many issues related to seniors in their old age need to be addressed by a physician who knows about these issues and how to treat them. Examples include osteoporosis, rheumatoid arthritis, chronic pain and cataracts. The older you get, the more brittle and fracture-prone your bones become, and combined with osteoporosis (or thinning of the bone), you might fall and hurt yourself more than a young person would.

A good physician will perform a bone density test on an older adult to check how brittle his or her bones are. If the patient's bones are brittle, it's time to see a gerontologist.

Memory also becomes a problem the older you get. For this reason, I recommend to the elderly that they write down all of the complaints and facts that they wish to discuss with their physician so that nothing will be overlooked. It is so easy to make a list of the problems that you want to discuss with your physician and go through the list.

If your physician does not have enough time for your list then you do not have a caring and good physician in my opinion. I never rushed my patients through their lists of complaints and things they wished to discuss with me. There are plenty of good doctors who will take the time to listen to you; it's up to you to find one. Keep looking if you haven't found one.

With a list of the complaints, the next thing that I advise is to take a pen and pad of paper with you to your visit and write down the advice you get from your physician. It's too easy to forget what is said and discussed.

Bringing pen and paper with you to the doctor's office shouldn't be a habit of the elderly only. Even young people forget what the doctor says and suggests. Information might fly by your mind and you might later forget what you need to know. If you write things down you can refresh your memory. If you still forget, then you can call your physician.

In these days of busy physicians, this is a good test for your doctor. Something as important as refreshing your memory will always deserve a return phone call. (And if your doctor can't handle a simple phone call like that, then he or she isn't getting the job done right.) And, if nothing else, keeping in contact with your doctor will refresh *his or her* memory about you.

Other common ailments to consider as an elderly patient include skin cancers, especially those related to overexposure to the sun (e.g., basal cell cancers or carcinomas), skin ulcers that are not related to "aging spots" and incontinence of the bladder or bowel.

As you age, your brain ages. Older people are more likely to get confused. This may be due to either aging of the brain or not enough blood reaching parts of the brain—both of which are signs of the normal aging process and there is very little you can do about it. Just realize that it will occur and try to keep lists to remind you of tasks you wish to do. I am not talking about dementia or Alzheimer's, which are separate diseases that I will not discuss. Some studies say it is good to keep your brain active to prevent deterioration, so you might try that.

Keeping a brain active the older it gets is a good way to slow down the brain's natural deterioration. You can keep a brain active by engaging in activities—reading, playing cards, doing crossword puzzles and by having an active social life.

If you come across any indications of skin ulcers, they should be examined by a doctor immediately. This could be the early indication of insufficient blood supply to this area or even the beginning of diabetes. Do not try to treat the ulcer yourself; seek professional advice.

Incontinence of the bladder or the bowel is another common ailment to the elderly. Many diseases can cause incontinence, which is simply one's inability to control urination or bowel movements. Besides disease that can cause it, as you age you develop a weakness in the muscles that hold in urine or stool. Straining can therefore cause a loss of stool or urine. Although this is not normal, it does occur. Seek professional advice if you have this problem.

> **There are several products on the market to help the elderly contain incontinence. These may be very useful for them but first I advise an elderly person to seek professional help to be sure he or she does not have a condition that can be treated, such as a cystocele—a fallen bladder—or a weak muscle in the rectum or even a tumor that is causing leakage. Once the serious possibilities are ruled out, an elderly person may wish to use some of the various pads available to treat the condition.**

As I mentioned before, one of the most serious problems in dealing with the elderly is that they are often victims of under-treatment or over-treatment. Enlargement of the prostate gland

in men, for example, occurs in the normal aging process. The condition may cause you to urinate frequently and have to get up several times during the night. If the condition is not serious, it can be left alone. If it causes blockage or stoppage of urine then it must be treated surgically.

However, I know of a urologist who made a good living by going to nursing homes and examining male patients. After finding enlarged prostates in them, he operated on all of them. In many cases their quality of life was no better than before. This was unnecessary surgery; their lives were no better after surgery than before.

Likewise, I knew an ophthalmologist who also went to nursing homes to examine the eyes of the elderly. He found cataracts in almost all of the patients there and advised surgery. This procedure is simple and relatively easy, causing little pain. But the doctor can make a lot of money. These elderly patients were no better off after their surgery than before. True, they now could read better but few of them read. Many just vegetated all day.

Be aware of scams. They exist out there in all fields. The elderly are especially vulnerable and must be cautious. If a procedure is recommended to you, seek a second opinion and if that does not seem correct, go for a third opinion. Be aware.

And, if you are a caregiver of someone in a nursing institution, you need to question how a surgical procedure will really improve the quality of life of your loved one.

Diabetes

Seventeen million Americans suffer from diabetes, a disease of the pancreas whereby your body fails to either produce or respond to insulin, a hormone that helps your body store and use the sugar and fat from the food you eat. Diabetes is a lifelong disease with no known cure; if you have diabetes, you have to manage it carefully. There are two types of diabetes. Type 1 occurs because the insulin-producing cells of the pancreas (called beta cells) are damaged and they produce little or no insulin. So people with type 1 diabetes must use insulin injections to control their blood glucose.

Type 2 diabetes is the most common form of diabetes mellitus, and while over 91 percent of these cases can be prevented, it remains the leading cause of related complications such as blindness, non-traumatic amputations and chronic kidney failure requiring dialysis in adults. Type 2 diabetes, sometimes called "adult-onset diabetes," usually starts in people over age 40 who are overweight but it can occur in people who are not overweight.

Because diabetes can be particularly pernicious in the elderly, any elderly person should be tested for diabetes on every annual visit to the doctor. The disease can lead to very serious complications and is often overlooked in the elderly until complications arise.

The symptoms of type 1 diabetes often occur suddenly and can be severe.

They include:

Increased thirst;

Increased hunger (especially after eating);

Dry mouth;

Frequent urination;

Unexplained weight loss (despite regular diet);

Fatigue (weak, tired feeling);

Blurred vision;

Numbness or tingling of the hands or feet; and

Loss of consciousness (rare).

The symptoms of type 2 diabetes may be the same as those listed above. Onset of type 2 is usually gradual. Other symptoms may include:

Slow-healing sores or cuts;

Itching of the skin (usually in the vaginal or groin area);

Yeast infections; and

Recent weight gain.

Diabetes is a serious disease that requires daily management. Preventing adult-onset diabetes is more about maintaining a healthy lifestyle—eating the right foods and exercising regularly—than anything else. You can't do much about your age, genetic history and ethnicity (African-Americans, Hispanics and Asians are more likely to develop diabetes) but you can do something about your diet, alcohol and nicotine intake. Talk to your doctor

about diabetes if you have any questions about it and how you can prevent its onset. Once you're diabetic, it's impossible to go back.

Hypertension, or high blood pressure, is also very common in the elderly and should be monitored frequently. If untreated it can lead to a stroke.

If your physician does not carefully examine you for both diabetes and hypertension by a blood test and examination, insist on it.

I cannot emphasize strongly enough the importance of checking, especially in the elderly, the dosage of drugs you are given. As mentioned in the chapter on drugs, the plethora of drugs in today's world leads to mistakes. Two very different drugs can sound the same but have very different effects. Celexa, for example, is an antidepressant; Celebrex is an antiarthritic drug.

The elderly need to be extra careful about checking their prescriptions. Be sure you are getting what you need. You can buy a reference book similar to the ones nurses use and check names, or go on the Internet, call your pharmacy, talk to your pharmacist and be sure you are getting the medicine that you need.

If you take this message to heart I am sure you will have a healthy and fruitful life in your senior years.

Conclusion

Even if you're not a child or an elderly person, chances are you're having to take care of one or both kinds of people. Forty-four million American adults care for both elderly parents and minor children. So most Americans know a little about pediatrics and geriatrics. According to a study by the U.S. House of Representatives, the average woman spends 17 years caring for a child and 18 years caring for her elderly parents.

And that latter number is getting larger every year.

10. Know Yourself and Your Body

The point of this book has been to show you how—and why—you need to take charge of your health care. There are things you need to know and things you need to ask your provider if you expect to receive the best care. Many things mentioned here you have already learned from previous chapters, but it's useful to reiterate the essentials so you won't forget. Some essentials to keep in mind are discussed in this final chapter.

Remember, you are the communicator to the health professional. No one can guess what is wrong unless you describe it to your physician. It is important to go into every detail of your symptoms and what ails you. No detail is unimportant. The following is everything you should keep in mind.

The Wrong Direction

One of the first things to know when it comes to medicine, is that it's not an exact science and a doctor's approach and treat-

ment will change. Sometimes a treatment will go in the wrong direction. In other words, a doctor will miss the right diagnosis, and take the problem in another direction—treating something that isn't wrong. On one level, doctors can make human mistakes and miss important diagnoses. On another, they can lack the training and experience to make certain diagnoses.

Some years ago I heard a very good lecture on adrenal tumors. Adrenal tumors—tumors of the adrenal glad the usually causes an excess of adrenal hormones—are rare. But after the lecture, all of the sudden four of these tumors were operated on at the hospital where the lecture occurred. How could this happen? Because of the lecture, everyone was looking for such a tumor—the symptoms were in everyone's mind. Normally the symptoms would be overlooked and the treatment would go in another direction first, but because of the lecture everyone was looking for these symptoms. It made sense out of the symptoms for those who were suffering from adrenal tumors.

I once saw a young child who came in with symptoms of arthritis and weakness. To me the symptoms pointed to Lymes disease, a disease with arthritic complaints, among other things. The disease is carried by ticks so if you're bitten by one of these infected ticks, you'll develop the disease. The cause of Lymes, however, is a spirochete, a parasite-like organism that gets transmitted by the tick bite. An infected person might have skin lesions in the beginning, and later develop neurological, cardiac or joint abnormalities.

After questioning, I learned that the boy had been to an area endemic for the disease and was riding in a train with the windows open. His mother had noticed a black bug on his hand and had swatted it away. Obviously, the boy had been bitten by a tick. Three of my colleagues had missed the diagnosis; the only reason I was able to quickly diagnose the child was that I had recently read about Lymes disease.

The child tested positive for the disease and started treatment. He made a full recovery.

Many correct diagnoses are missed because the treatment is directed in the wrong direction to start. The expertise of the physician plays a big role in this regard.

Physicians are always students. They never stop learning. Having to diagnose a rare illness that they've never seen before in their experience is a challenge.

Once a physician stops learning, he or she is practicing medicine of another era. Especially now, with the fast changing and advancing technology, your provider must keep up with the newer trends and changes in medicine. A doctor cannot treat something he or she thinks may be correct and ignore other modalities of treatment, diagnosis and testing. In other words, all bases must be covered. There are specialists for almost every field. Medicine has become so vast that no one can keep abreast of all of the diseases and conditions that exist.

If your doctor has a hard time diagnosing you, he or she should seek the advice of others in the field (and you should get a second opinion!) If you don't respond to a certain treatment and your symptoms continue, you should seek a second opinion. Don't ever think that your doctor is the last word. There are experts out there in every field—you just have to seek them out and use them.

Here's a classic example of the wrong direction. When I was a resident, doctors were spending years proving that peptic ulcers were due to too much acid in the stomach and that there was an automatic turnoff of acid in the stomach itself. We tried to find the automatic turnoff but could not. At that time they got government grants to fund our research.

At the end of my residency we thought we had conclusive evidence of this automatic turnoff, so we published a paper to prove it. It was not until the mid-1980's that researchers in Australia proved that peptic ulcers in many cases were caused by a bacteria.

Our research was rendered fallacious since the bacteria could be isolated and cultured. We had been going in the wrong direction.

You want your diagnosis and treatment to be in the right direction. You can help in your own treatment by guiding your provider in your care. Keep asking questions. Ask for results. Ask if this is the way he or she would go and then decide for yourself. Get all the help you can from reading,

> **research on the Internet, going to the library, etc. You can
> help guide your treatment and you must. Then you will get
> the best advice possible.**

Why the Wrong Direction?

There are many things that can lead your medical adviser to go in the wrong direction. Let's examine some important problems that can go wrong in the realm of cardiac conditions.

> **If you are taking a beta blocker for hypertension—high
> blood pressure—and get stung by a bee, the reactions can
> be severe. And these reactions may seem like an acute ill-
> ness to a doctor who doesn't know what medicine you're
> taking.**

If you have any food allergies, a bee's sting can also be severe. This is why you need to tell your doctor about any allergies you might have. Being allergic to strawberries and melons might not sound so serious to you, but it's key to let your doctor know.

Many Americans have a problem with high blood pressure, or hypertension. Although how doctors manage hypertension and set standards for hypertension have changed over the years, most physicians believe that if your blood pressure is over 140/85-90, you

have hypertension. It is no longer considered your age plus 100 for the top level as previously thought.

However, many people suffer from what is called *white coat syndrome*. This is a condition whereby a medical professional in a white coat (it could be any colored coat, actually) comes in to examine you and you get excited or nervous. This reaction elevates your blood pressure. Sound familiar? Your doctor should be aware of this and not treat a slightly elevated blood pressure reading just because you get nervous being in the doctor's office.

Other things besides the anxiety you feel about being in the doctor's office, can cause an elevated blood pressure. You may have just eaten, or have rushed over to your doctor after a late morning.

If you feel rushed, anxious or excited, explain this to your medical professional and try to have your pressure checked when you are relaxed. Otherwise you will get the wrong diagnosis and treatment. Do not accept a diagnosis of hypertension made by the nurse when you are nervous or excited. If you feel your doctor is treating you for hypertension and you feel you've been misdiagnosed, seek another opinion.

Also remember that the interactions between blood pressure medications and other medications do occur. It is common, for example, to develop impotence after taking blood pressure medications. Certain nasal decongestants and anti-inflammatory agents

like Motrin and aspirin may promote fluid retention and thus raise blood pressure. There are many other complications that can arise with blood pressure medications. You should read carefully any informational material supplied by your pharmacist. If you have any questions, be sure to ask your doctor or pharmacist.

On the other hand, many older patients are not treated for high blood pressure when they should be. Ask what your blood pressure is and if it fits into an acceptable range. Don't accept the answer, "It's okay."

If your blood pressure numbers are over 140/90, ask why you are not being treated. If you do not get an answer, seek care elsewhere.

I went to a seminar once on hypertension where the speaker, a well-known national expert, asked the audience, "How many of you use diuretics, beta blockers and Ace inhibitors on the same patient?"

Almost no one did. He then explained that in some recalcitrant patients a doctor must use these medications. My point of bringing this up is to show you that you may be treated in the wrong direction. If so, seek aid that will bring you to the right direction.

Going to the Doctor

When you visit your health care provider, remember you are going because of a symptom. In your opinion, something is wrong and you need your doctor's good judgment. You hope that you will leave your doctor's office with a diagnosis. You also expect to get a correct diagnosis.

This all depends on the experience and expertise of the physician. Many times the symptom can be misleading. A typical example of this is the pain that one gets from an impending heart attack. The pain may not at all be in the chest. It may be in the jaw, running down the arm or even in the back. All of these pains may actually be the pain of an impending heart attack. It is up to the health professional to put these symptoms together and make a correct diagnosis; then and only then can you be properly treated.

One of the basic rules to remember is that the human body wants to heal itself. It does not like to be ill. It will give you symptoms so that you can aid it in its ability to heal. It wants to be well. With the proper treatment it can heal and be well most of the time.

I've mentioned in previous chapters that medicine is not an exact science and that we must accept a certain level of mistakes to naturally happen. Errors do occur. But those errors are greatly reduced if you help your health care professional. Part of a doctor's ability to arrive at correct diagnoses and suggest proper treatments

is your ability to convey thorough and honest information. You must tell all of the symptoms—no matter how trivial—to your doctor. Don't leave anything out.

Do not misunderstand me: There are some bad doctors out there. There are doctors who are interested in only making money. There are some doctors who order unnecessary tests only for monetary gain. However, I think that most of the doctors will try to arrive at the correct diagnosis if presented with the proper symptoms.

Sometimes a malpractice is the result of a patient not giving the right information—not enough information. For example, you might present some of the symptoms and forget others. Therefore, the doctor will look in the wrong direction.

Most of your vital organs are hidden. They lie deep within the body. They cannot be touched or looked at directly— except during surgery. As such, a doctor can only visually see vital organs through images like x-rays, CT scans, MRIs or ultrasounds. Doctors manage to do pretty well when you realize that they are only looking at an image. They can do a great deal of complex diagnosing without invasive surgery.

There are any number of books and Internet sites available for you to research your condition—no matter how trivial it may seem

to you. Refer to the appendices for lists of good reference books and sites.

Because medicine is so complex, understand that there are many things that a physician may not be aware of. Why? Because no one can know it all. Physicians get their knowledge from their reading, studies, recent experiences or from the experiences of their colleagues. If you do not have an astute physician, find another.

Misinterpretation of Pain

Another way your doctor may take a wrong direction is in the interpretation of your pain. Many patients who have gall bladder disease initially visit their doctor with pain in their right shoulder. I already have discussed referred pain—pain from one area that is referred to another. These patients may actually have pain in the shoulder and will be treated for shoulder abnormalities while the real problem lies within the abdomen in the gall bladder. Years ago, before some of the newer technological advances, people died of a ruptured appendix because the pain was referred elsewhere and the abdomen was not carefully examined. By the time the correct diagnosis was made, the patient had died. This actually happened to my grandfather.

When you think that a woman can have the same symptoms for appendicitis, food poisoning, intestinal obstruction (i.e., blockage of the bowels), ruptured ovarian cysts or even the release of an egg—so called Mittelschmerz or ovulation—there's a lot for a doctor to consider when presented with a complaint. Any of these

problems needs immediate attention. Delay in treatment can be fatal if complication occur. If you've landed in the emergency room, it's probably busy and there's little time for personal attention. This is when demanding attention and knowing how to convey exactly to the doctors what you are feeling, is critical.

Two other things demand special attention: rectal and pelvic examinations. Having a rectal exam will rule out diseases of the rectum and additionally in males, the prostate. Because such an exam requires time, people often forget to schedule one. Don't wait until your doctor suggests it; ask for one.

For females, pelvic examinations should be an annual examination. Even if a woman has nothing to complain about with regard to this area, she should have regular pelvic exams and ask for a Pap smear.

The Things You Should Know

The following is an abbreviated list of things that you should know and be aware of:

✔ **Your weight.** Know what your weight is. Monitor it periodically. Remember that the Department of Agriculture (USDA) and the United States Department of Health and Human Services (DHHS) have a food guide for daily health. These include:

1) bread, cereal, rice and pasta;

2) vegetables;

3) fruits;

4) meats, poultry, fish, beans, eggs and nuts;

5) milk, yogurt and cheeses;

6) fats and sugars; and

7) fluids (water, tea, coffee, beverages, soft drinks).

These are the basic foods. I will not tell you what or how much to eat. There are all kinds of diets but they all basically boil down to the same concept. It's all in the calories. Diets change but they still rely on the idea that the more calories you consume than burn in energy, the more you'll gain. You must decide for yourself how much and what to eat, making sure you get the daily allowance of vegetables and fruits. Limit fat.

On the following page is a graphic of the USDA's Food Guide Pyramid. Trendy diets might try to change the looks of this pyramid (and some will even inverse the pyramid), but this has become the accepted standard for nutritional guidelines.

The USDA suggests that each food group provides most—not all—of the nutrients a person needs each day to remain in good health.

Food Guide Pyramid

A Guide to Daily Food Choices

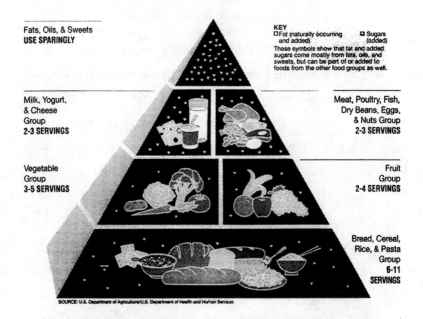

Fats, Oils, & Sweets
USE SPARINGLY

KEY
☐ Fat (naturally occurring and added) ☐ Sugars (added)
These symbols show that fat and added sugars come mostly from fats, oils, and sweets, but can be part of or added to foods from the other food groups as well.

Milk, Yogurt, & Cheese Group
2-3 SERVINGS

Meat, Poultry, Fish, Dry Beans, Eggs, & Nuts Group
2-3 SERVINGS

Vegetable Group
3-5 SERVINGS

Fruit Group
2-4 SERVINGS

Bread, Cereal, Rice, & Pasta Group
6-11 SERVINGS

SOURCE: U.S. Department of Agriculture/U.S. Department of Health and Human Services

Use the Food Guide Pyramid to help you eat better every day. . .the Dietary Guidelines way. Start with plenty of Breads, Cereals, Rice, and Pasta; Vegetables; and Fruits. Add two to three servings from the Milk group and two to three servings from the Meat group.

Each of these food groups provides some, but not all, of the nutrients you need. No one food group is more important than another — for good health you need them all. Go easy on fats, oils, and sweets, the foods in the small tip of the Pyramid.

Do what you think is best for you but maintain your weight. If you have a weight problem ask your health care professional for advice. Read the newest books on diet that are available and change your intake. Remember portion control is more important than avoidance of some foods. If you restrict certain foods, you will only crave them and binge on them unhealthily. Everything in moderation is the best piece of advice.

✔ **Blood pressure**. Know your blood pressure figures. If necessary, buy a blood pressure monitor (from any health instrument store or even your local drug store) and monitor it yourself. If it's high, demand treatment. Remember, untreated hypertension may result in severe cardiac disease and stroke.

✔ **Personal medical history**. You must relate to your physician your previous medical history. This includes telling you doctor about any procedures you've had done, surgeries, emergencies, etc. All of this information is valuable in making a correct diagnosis. You should keep a written record of this information, as well as a record of your immunizations, past prescriptions, past tests and their results, etc. Keep up your tetanus inoculation. Did you have any serious illnesses? Were you hospitalized? If so, for what? All of this should be on your medical record.

✔ **Cholesterol and blood tests**. Today it is important to have your blood tested for cholesterol, symptoms of diabetes and other diseases that can be detected by blood. A general blood test can detect leukemia, for example. This should be a normal part of an annual examination. Men over 50 should also request a special PSA (prostate-specific antigen) test to check their prostate, as elevated PSA levels are a possible indicator of cancer. If you are taking any medication for hypertension, a doctor should test your blood for potassium.

✔ **Medications that you take and have taken.** It's very important to keep a record of the medications you take. If you have any questions about your medications and their contraindications, you should consult your pharmacist or doctor.

If you are seeing several physicians for the same infection, you might get prescriptions for several different antibiotics. Your primary physician may not know that you are already being treated by someone else and that you might be duplicating or even triplicating the type and dosage of these drugs. Inform your health care professional of what and how much medication you are taking.

Never take someone else's prescription. The dosage and type may not be the same. This is dangerous.

✔ **Family history.** Giving your doctor an idea of what your family health history is like, is key to his or her ability to keep you healthy. If some diseases have been prevalent in your family, notify your doctor. Most diseases have a lot to do with genes, so if you have cancer, heart disease or stroke, for example, in your family history, tell your doctor. At the end of this chapter there is a sample family health pedigree. You should construct a similar one using your family's information. Going back three generations is probably sufficient. Another copy of this pedigree is also included in Appendix E.

✔ **Allergens and toxic materials**. There is a preponderance of allergens today—pollens, dust, mites and food allergies, to name a few. All of these things cause allergies. Toxic mold hit the headlines in the early 2000s. If you ever worked with asbestos, it could have deleterious effects on you and cause cancer of the lung. Chemicals like benzene and some of the phenols, etc. can also have toxic effects on the body. Notify your physician if you are concerned.

✔ **Blood type**. You should know your blood type. This is very important should you need blood. It is very simple to be tested and everyone should know this fact. Your blood type is probably already noted in your doctor's record of you, so all you have to do is ask.

✔ **X-rays, CT Scans, MRIs and Mammograms, etc.** Document any special tests that you have had. Even if they don't seem important to you, they should be documented. Try to recall when and where you had these done. Unfortunately, in some case the hospital or physicians' offices where these were done may be long gone but do the best you can. Ask relatives or your loved ones if you do not remember.

✔ **Special tests**. Did you have a cardiogram? If so, when and why. Have you had any special cardiac test such as a stress test or any cardiac procedures such as a stent put in? For what reason? All of these facts are very important and should be documented.

Conclusion

In this chapter I have tried to explain how the proper diagnosis may go wrong or be incomplete. I have showed you how you can best steer your health professional in the right direction. Without your help, it cannot be done. Only by your awareness and involvement will you receive the care that you deserve.

Use the sample health pedigree on the following page to think about your family's health history. Call your family members and ask questions to help you fill in the blanks. It might be hard to get the facts about when and how people died when it comes to relatives that go way back, but do the best you can. You and your doctor will be happy that you did.

Sample Family Health Pedigree

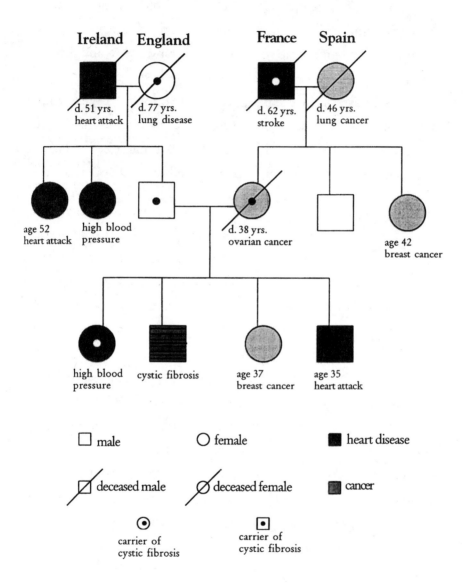

"Doctor, Before We Begin…"

I cannot reiterate enough: Medicine is forever changing. Treatments and methods of diagnosis are always changing. New methods come and sometimes go. The old must give way for the new. Sometimes treatments come into popularity that are nothing more than snake oil. Years ago, so-called traveling medicine men would try to sell treatments called snake oil. It was supposed to be a cure-all for all ailments, but it didn't work. If it did, it was more a case of mind over matter—the same way placebos manage to work on some people.

Modern versions of snake oil come out today, but some do harm people. Medications can come onto the market as fast as they are removed. Remember the thalidomide story or the more recent Fen-Phen story that duped a lot of innocent people looking for a quick fix weight loss solution.

The lesson: Don't jump at the chance to try new drugs the moment they hit the market. No matter how much a drug goes through various levels of pre-clinical and pre-market trials, drugs still do emerge that have unknown, long-term side consequences. The public is the ultimate guinea pig for new drugs.

Of course there are many exceptions to this advice. If someone has a life threatening disease he will be desperate and want to try a new and unproven form of treatment. Anyone grasping for anything that can help alleviate pain, relieve suffering and better his or her quality of life should consider new drugs.

However, if there is a known treatment that is proven to work, why try something new just for the sake that it is new? Why not use the treatment that has been known to work. Stick with the winners and you will be better off. Surveys are often asked of physicians when they would change to new drugs—as soon as it is released, after a few weeks or when they have been tried and are known to work. Those surveys reveal that most doctors are anxious to try new medications, to be the first to use a drug they think will work. Some doctors want to use medications that others do not use just to be different.

It's up to you whether you opt for the new or old drugs. Understand that you take on a different kind of risk when you choose to try a new drug that hasn't been tested by the general public for a long period of time. In general, the longer the period of time that a new drug is on the market, the more it is being used and has become more reliable. If the patients have little success with the new drug or deleterious results surface, it may be taken off of the market.

Conclusion: "Doctor, Before We Begin..."

I talked a lot about *malpractice* in this book. I got to thinking about what malpractice really means. Malpractice actually means bad practice—no more or no less. It may include some of the obvious bad things that happen in the practice of medicine. However, in our litigious society it has come to mean money. Malpractice has come to mean injury—injury from birth, brain injuries, bad or misdiagnosis, surgical errors, medical errors, medication errors, negligence of the hospitals, nurses, doctors, HMOs, neglected treatment, delayed treatment, over-treatment, and under-treatment...and even improper treatment.

People are often looking for the way to make the easy money and one of the best ways is to sue. It seems to be a way of life. When I first went into practice, the cost of malpractice insurance for physicians was about $35 per year. Now the average can range to $100,000 or more. Everyone seems to be looking for the deep pockets to sue and collect a sizeable amount of money. If people will play the odds of the lotteries, people will play the odds for winning big sums of money in a medical malpractice lawsuit.

According to medical dictionaries, malpractice is "improper or injurious practice; unskillful or faulty medical or surgical practice." This covers a large amount of territory. After talking to several attorneys, malpractice today implies that harm has been done. This harm can be either physical or emotional.

Some years ago I was asked to be a medical expert witness at a trial of a professor at one of the medical schools in my area. I was a witness for the defense—in other words, I was to defend the doctor in a malpractice suit against him. The facts of the case were as follows: A surgical procedure was done in which the stomach was stapled in part to help the patient lose weight. Inadvertently some of the small intestine was also stapled. This prevented any material from going through the intestine. In post-operative condition, the patient was not given anything by way of her mouth, so little was traveling through the bowel, making it harder to easily discover the problem. However, the patient had developed a small infection in this area from spillage during the procedure, which required another operation.

At the time of the second surgery, the stapling of the small intestine was noted and corrected. After the patient left the hospital, she sued the physician for malpractice. The defense was based on the premise of "no harm, no damage." The patient required another operation anyway so no harm was done when the small bowel was unstapled. Because of the testimony in this case, the doctor actually won the case and no malpractice judgment was made against him.

Malpractice is not always evident. As I mentioned, to collect any money there has to be damages. However, bad practice—malpractice—occurs more frequently then doctors like to admit. Sometimes there are cover-ups. The health care provider will sweet talk to you about something and make you think that you are really friends. You would not sue your friends. Certainly you would not sue your doctor!

I once knew a doctor who had a friend who was also a patient. The patient brought his son in to see the physician with a stomachache. At the time, the doctor didn't find anything wrong with his friend's son, so he sent them on their way and told them to return if anything became worse or if other symptoms developed.

After about three days, the patient returned with his sick son, this time with severe pain, nausea and vomiting. I was called to see the patient and made a diagnosis of a perforated appendicitis. The boy's appendix had ruptured and there was pus in the abdomen.

We had to perform surgery to remove the perforated appendix and clean the abdomen. The father, realizing that too much time had passed since the onset of symptoms, sued the physician, his friend.

In this case, a sizeable amount of money was paid by the insurance company to the family of the boy for this misadventure—a real case of malpractice. Closer observation of the patient would have resulted in earlier surgery and the avoidance of a perforated appendix with all of the postoperative complications. This was a classic case of malpractice.

Many times the error is not so obvious. Common errors that occur are those during surgery. It is obvious that leaving an instrument in the abdomen, leaving a sponge or needle in the abdomen,

removing the wrong body part or forgetting to do something obvious will result in obvious malpractice. But there are many instances of not-so-obvious malpractice. Prescribing the wrong drug; prescribing the wrong dosage of a drug; prescribing the wrong timing of the drug (i.e., telling a patient to take a drug three times a day instead of six times a day); not informing the patient of the complications of a drug, etc.

In another case, a physician prescribed a drug to a patient for high blood pressure (hypertension). The physician failed to tell the patient that there was a small possibility that this drug could result in *priapism*, a condition in which a man experiences a constant and painful erection. This patient developed the complication and because he had not been informed of the complication, he sued the physician and won.

An Art, Not a Science

There are very few black and white conditions in medicine...but there are many gray areas. Most of the time things are not so obvious. For this reason, in my opinion, lawyers are able to work the system to their advantage and sue physicians for sizeable amounts of money for errors that occur in the gray areas.

At times, physicians will try to cover up their errors that happen and avoid a malpractice suit. Just because something went wrong does not mean that a malpractice has occurred. The human body is a very complex bit of chemistry. Much of its running properly depends on chemistry and this can be very complex. Things

do happen that go wrong. Various organs do not always function the way that we expect them to. Just like in any other machinery, things do not always go according to plan. People must adjust for this and not assume that just because things do not go as planned, that malpractice has occurred.

In many instances it is not the doctor's fault. Things happen that don't amount to a cover-up. But a crafty lawyer may make it out to be malpractice. And, in my opinion, this is why a health care provider will run many extra tests—blood tests, x-rays, cultures, etc.—just to protect himself from the hassle of a malpractice suit. More tests ensure that something small and insignificant isn't missed. Of course this raises the cost of medical care tremendously but it routinely does occur.

Remember one very important fact: Just because the result is not always what you expected does not mean that a malpractice has occurred. Sometimes things just go wrong and it's nobody's fault.

If, for example, sutures are removed at the proper time, sometimes the wound will open up and it's not due to the physician's lack of care or expertise. It may be the patient's fault or some other factor that has nothing to do with either the patient or the doctor. Do not blame your physician for all the things that can go wrong.

Also remember that in the true definition of the word malpractice, "damage" doesn't come into play. The word refers to "bad practice," and this can occur in every field of medicine.

In this book, I tried to teach you a few things about how to be a patient in today's complex and, at times, crazy medical world. In the following appendices, you'll find some good resources for health-related topics both in book form and on the Web. Just as your doctor should be the constant student, so should you. Keep reading. Keep abreast of the latest changes and developments in medicine.

One of the first things taught in medical school in my time was *do no damage*. If this were completely practiced and true there would be no malpractice. There might still be some errors occurring but nothing of a serious nature.

Medicine has become very complex. There are a multitude of drugs all treating the same disease. The drug companies are out there competing for your dollar—that is what they are supposed to do. That is why there are so many drugs out there. With such a multitude of drugs, which one is correct for you? Which antibiotic will do the best job? Which one should you take? You have to leave that decision up to your health care provider. It is up to him or her to be aware of all of the drugs on the market and to decide which one is best for you. Sometimes he may pick the wrong one—not by an error but by a bad guess. There's an element of trial and error in medicine.

Sometimes it is in the patient's best interest to cover up the facts. Let me give you an example of what I mean. Some years ago I saw a woman who had pain in her abdomen. She told me that she

had had ovarian cancer and that a colleague of mine had removed one ovary. However, an x-ray revealed a mark consistent with a sponge left within the abdomen.

The sponges, which are either 2 x 2 inches or 4 x 4 inches in size, all have an opaque marker on them so that they will show up on x-rays. Larger sponges also have a marker on them that are visible on x-rays. Before each procedure the sponges, needles and instruments are all counted. They are counted as the procedure progresses and again at the end. A final sponge count is declared and indicated on the final report.

I read the report for this woman's operation and noted that sponges and needles were reported as correct. But obviously one sponge had been miscounted or something had happened to mix-up the count because a sponge still remained in her abdomen.

At the time of this case, it was customary to perform second operations to check for more cancer. The woman underwent another operation, at which point the sponge was removed, and her abdomen was observed for more cancer. No further cancer was noted. After the surgery, the patient asked me if she should sue the physician who had left the sponge. I told her that the first physician had done a good job because there was no evidence of recurrent cancer, so the doctor had successfully removed all of it. I advised her not to sue. She accepted what I said and did not sue. (Note: her insurance covered the second procedure entirely, so there was no expense to her out-of-pocket.) I felt this was good advice. The woman was cleared of cancer and no damage was actually done. There was no cover-up.

In my lifetime I've seen some of the most dramatic changes occur in medicine. Within the last century we have found the causes of malaria, with the development of some prevention. We have developed a whole armamentarium of drugs to treat all types of diseases. We have developed new cures for previously untreatable diseases. However, with all of the advances made we have found new devastating diseases such as AIDS.

Because of modern medicine's complexity, we live in a time of great specialization. There are specialists for almost everything. In Russia, there are specialists of the right and left eye. So if you have a problem with your right eye, you go see a specialist for right eye.

My advice to you is always seek the advice of others if you don't feel you're getting the right treatment. You may be a victim of bad practice—malpractice. Malpractice does not always have to be a mistake, an error or a missed diagnosis. It can be as simple as not pursuing the correct diagnosis or not using the best kind of treatment.

> **If you have a life-threatening disease such as cancer, you're going to want access to the best treatments. In most hospitals, there are what's called tumor clinics. These are mini-conferences where various tumor cases are discussed and the best types of treatments are proposed by a panel of experts and anyone else in the audience who is present. This is a free service offered to the doctors at that hospital. So, the doctors have insight into various methods of treatment and how they've worked on other doctors' patients.**

Discussion groups like this aren't necessarily available only to physicians. There are many forms of this type of experience exchanges on the Internet, for example, where you can surf various medical school libraries, read important articles and even chat with various physicians.

Some of these research tools are not available to the public but your physician can access them and get the information for you. Ask your doctor for references regarding your condition. You should have knowledge of your condition, knowledge of your disease, knowledge of your diagnosis and knowledge of the available treatments. With all of this knowledge and information you will be able to seek the best and proper care available and avoid any bad practice and errors of treatment, judgment and care. In all, you will avoid any malpractice.

I hope that by now you've gained a little more knowledge and insight about medicine and how to help yourself receive the best possible medical care. I have tried to show you how you must take an interest and active part in your treatment and the treatment of your loved ones. And, when errors occur, they will be errors of over-treatment rather than under-treatment.

If you will take the responsibility for overseeing your medical treatment everything will go well. Take the same responsibility for your care that you take in the repair of your automobile. Be responsible. After almost 50 years in the medical field I know you can. To you, the patient, I dedicate these chapters of this book and hope that you enjoyed it and found it helpful and can benefit and learn from it. Thank you. I hope this information allows you to lead a better, happier...and healthier life.

10 Things You Need to Know...

Appendix A

The following is a list of books you may find useful for expanding your library at home and having good reference tools.

Books

Mayo Clinic Family Health Book: The Ultimate Illustrated Home Medical Reference (Second Edition), by The Mayo Clinic and Howard Gallagher; William Morrow, 1996.

Mayo Clinic Guide to Self-Care: Answers for Everyday Health Problems, by Philip T. Hagen and the Mayo Clinic; Kensington Publishing Corp., 1999.

Mayo Clinic on Healthy Aging: Answers to Help You Make the Most of the Rest of Your Life, by Edward T. Creagan; Kensginton Publishing Corp., 2001.

Johns Hopkins Symptoms and Remedies: The Complete Home Medical Reference, by Simeon Margois, Johns Hopkins Medical Institutions and Marjorie Schwarzer; Rebus, Inc., 2003.

The Johns Hopkins Guide to Medical Tests: What You Can Expect, How You Should Prepare, What Your Results Mean, by Simeon Margolis; Rebus, Inc., 2001.

The Merck Manual of Medical Information: Home Edition, by Robert Berkow; Pocket Books, 1999.

The PDR Family Guide to Prescription Drugs, by Physicians' Desk Reference; Three Rivers Press; Eighth Edition, 2001.

The PDR Family Guide to Over-the-Counter Drugs, by David W. Sifton and Physicians' Desk Reference; Ballantine Books, 1998.

The PDR Family Guide to Nutritional Supplements: An Authoritative A-to-Z Guide to the 100 Most Popular Nutritional Therapies and Nutraceuticals, by Physicians' Desk Reference; Ballantine Books, 2001.

The PDR Pocket Guide to Prescription Drugs, by Medical Economics Company; Pocket Books; Fifth Edition, 2002.

The PDR Family Guide to Natural Medicines and Healing Therapies, by David W. Sifton and Physicians' Desk Reference; Ballantine Books, 2000.

The Physicians' Desk Reference Family Guide Encyclopedia of Medical Care, by The Physicians' Desk Reference; Ballantine Books, 1999.

American College of Physicians Complete Home Medical Guide, by David R. Goldmann and the American College of Physicians; DK Publishing, 1999.

The American Medical Association Encyclopedia of Medicine, by Charles B. Clayman, The American Medical Association and Sam Vaughn; Random House, 1989.

Merck Manual Diagnosis and Therapy, by Mark H. Beers, Robert Berkow and Mark Burs; Merck & Co.; Seventeenth Edition, 1999.

Stedman's Medical Dictionary, by Thomas Lathrop Stedman; Lippincott, Williams & Wilkins, 2000.

The Pill Book, by Harold M. Silverman; Bantam Books; Tenth Edition, 2002.

Complete Guide to Prescription and Nonprescription Drugs, by H. Winter Griffith and Stephen W. Moore; Perigee, 2002.

The Cornell Illustrated Encyclopedia of Health: The Definitive Home Medical Reference, by Antonio M. Gotto; Lifeline Press, 2002.

Complete Guide to Symptoms, Illness and Surgery for People Over 50, by H. Winter Griffith and Mark Pederson; Perigee, 1992.

Harvard Medical School Family Health Guide, by Harvard Medical School and Anthony Komaroff; Simon & Schuster, 1999.

The Children's Hospital Guide to Your Child's Health and Development, by T. Berry Brazelton, Children's Hospital Boston, et al.; Perseus Publishing, 2001.

American Academy of Pediatrics Guide to Your Child's Symptoms: The Official, Complete Home Reference, Birth Through Adolescence, by Donald Schiff, Steven P. Shelov and The American Academy of Pediatrics; Villard Books, 1999.

What to Expect When You're Expecting, by Heidi E. Murkoff, Arlene Eisenberg and Sandee Hathaway; Workman Publishing Company, 2002.

Caring for Your Baby and Young Child: Birth to Age 5, by The American Academy of Pediatrics, Stephen P. Shelov, et al.; Bantom Books, 1991.

Smart Medicine for a Healthier Child: A Practical A-to-Z Reference to Natural and Conventional Treatmetns for Infants and Children, by Janet Zand, Robert Rountree, Rachel Walton and Bob Rountree; Avery Penguin Putnam; Second Edition, 2003.

A Parent's Guide to Medical Emergencies: First Aid for Your Child, by Janet Zand, Rachel Walton, Bob Rountree and Robert Rountree; Avery Penguin Putman, 1997.

How to Raise a Healthy Child: In Spite of Your Doctor, by Robert S. Mendelsohn; Ballantine Books, 1985.

10 Things You Need to Know...

Appendix B

The following is a list of medical licensing boards by state. For more information, contact the Federation of State Medical Boards of the United States, Inc. at P.O. Box 619850; Dallas, TX 75261-9850; phone: (817) 868-4000 / Fax: (817) 868-4099; www.fsmb.org.

State Medical Licensing Boards

Alabama State Board of Medical Examiners
Larry D. Dixon, Executive Administrator
P.O. Box 946
Montgomery, AL 36101-0946
(street address: 848 Washington Ave.)
(334) 242-4116 / (800) 227-2606 / Fax: (334) 242-4155
www.albme.org

Alaska State Medical Board
Leslie A. Gallant, Executive Administrator
550 West Seventh Ave., Suite 1500
Anchorage, AK 99501
(907) 269-8163 / Fax: (907) 269-8196
www.dced.state.ak.us/occ/pmed.htm

Arizona Medical Board
Barry A. Cassidy, PhD, PA-C, Executive Director
9545 East Doubletree Ranch Road
Scottsdale, AZ 85258-5514

(480) 551-2700 / Fax: (480) 551-2704
www.azmdboard.org

Arizona Board of Osteopathic Examiners in Medicine and Surgery
Elaine LeTarte, Acting Executive Director
9535 East Doubletree Ranch Road
Scottsdale, AZ 85258-5539
(480) 657-7703 / Fax: (480) 657-7715
www.azosteoboard.org

Arkansas State Medical Board
Peggy P. Cryer, Executive Secretary
2100 Riverfront Dr.
Little Rock, AR 72202-1793
(501) 296-1802 / Fax: (501) 603-3555
www.armedicalboard.org

Medical Board of California
Ronald Joseph, Executive Director
1426 Howe Ave., Suite 54
Sacramento, CA 95825-3236
(916) 263-2389 / (800) 633-2322 / Fax: (916) 263-2387
www.medbd.ca.gov

Osteopathic Medical Board of California
Linda J. Bergmann, Executive Director
2720 Gateway Oaks Dr., Suite 350
Sacramento, CA 95833-3500
(916) 263-3100 / Fax: (916) 263-3117
www.dca.ca.gov/osteopathic

Colorado Board of Medical Examiners
Susan Miller, Program Administrator
1560 Broadway, Suite 1300
Denver, CO 80202-5140
(303) 894-7690 / Fax: (303) 894-7692
www.dora.state.co.us/medical

Connecticut Medical Examining Board
Jeff Kardys, Board Liaison
P.O. Box 340308
Hartford, CT 06134-0308
(street address 410 Capitol Ave., MS13PHO)
(860) 509-7648 / Fax: (860) 509-7553
Licensing Information: (860) 509-7563
www.dph.state.ct.us

Delaware Board of Medical Practice
Gayle Franzolino, Interim Executive Director
P.O. Box 1401
Dover, DE 19903
(street address: 861 Silver Lake Blvd., Cannon Building,
Suite 203, 19904)
(302) 739-4522 / Fax: (302) 739-2711
www.professionallicensing.state.de.us

District of Columbia Board of Medicine
James R. Granger, Jr., Executive Director
825 North Capital Street, NE, 2nd Floor
Washington, DC 20002
(202) 442-9200 / Fax: (202) 442-9431
dchealth.dc.gov

Florida Board of Medicine
Larry McPherson, Esq., Executive Director
Department of Health
4052 Bald Cypress Way, BIN #C03
Tallahassee, FL 32399-3253
(850) 245-4131 / Fax: (850) 488-9325
www.doh.state.fl.us

Florida Board of Osteopathic Medicine
Pamela King, Executive Director
4052 Bald Cypress Way, BIN C06
Tallahassee, FL 32399-1753
(850) 245-4161 / Fax: (850) 487-9874
www.doh.state.fl.us

Georgia Composite State Board of Medical Examiners
Karen Mason, Executive Director
2 Peachtree Street, NW, 36th Floor
Atlanta, GA 30303
(404) 656-3913 / Fax: (404) 656-9723
www.medicalboard.state.ga.us

Guam Board of Medical Examiners
Teresita L.G. Villagomez, Acting Administrator
Health Professionals Licensing
1304 East Sunset Blvd.
Hagatna, GU 96913
(011) 671-475-0251 / Fax: (011) 671-477-4733

Hawaii Board of Medical Examiners
Constance Cabral, Executive Officer
Dept. of Commerce & Consumer Affairs

P.O. Box 3469
Honolulu, HI 96813
(street address: 1010 Richards St., 96813)
(808) 586-3000 / Fax: (808) 586-2874
www.state.hi.us

Idaho State Board of Medicine
Nancy Kerr, Executive Director
1755 Westgate Drive, Suite 140,
Boise, ID 83704
(street address: 83704)
(208) 327-7000 / Fax: (208) 327-7005
www.bom.state.id.us

Illinois Department of Professional Regulation
Robert E. Hewson Jr., Director (Discipline)
James R. Thompson Center
100 W. Randolph St., Suite 9-300
Chicago, IL 60601
(312) 814-4500 / Fax: (312) 814-1837
www.dpr.state.il.us

Alicia Purchase, Board Liaison (Licensure)
320 W. Washington St., 3rd Floor
Springfield, IL 62786
(217) 785-0800 / Fax: (217) 524-2169
www.dpr.state.il.us

Indiana Health Professions Bureau
Lisa R. Hayes, J.D., Executive Director
402 W. Washington St., Room 041
Indianapolis, IN 46204

(317) 232-2960 / Fax: (317) 233-4236
www.ai.org/hpb

Iowa State Board of Medical Examiners
Ann Mowery, Ph.D., Executive Director
400 Southwest Eighth Street, Suite C
Des Moines, IA 50309-4686
(515) 281-5171 / Fax: (515) 242-5908
www.docboard.org/ia/ia_home.htm

Kansas Board of Healing Arts
Lawrence Buening Jr., J.D., Executive Director
235 South Topeka Blvd.
Topeka, KS 66603-3068
(785) 296-7413 / Fax: (785) 296-0852
www.ksbha.org

Kentucky Board of Medical Licensure
C. William Schmidt, Executive Director
Hurstbourne Office Park
310 Whittington Parkway, Suite 1B
Louisville, KY 40222-4916
(502) 429-8046 / Fax: (502) 429-9923
www.state.ky.us/agencies/kbml

Louisiana State Board of Medical Examiners
John B. Bobear M.D., Executive Director
P.O. Box 30250
New Orleans, LA 70190-0250
(street address: 630 Camp St., 70130)
(504) 568-6820 / Fax: (504) 568-8893
www.lsbme.org

Maine Board of Licensure in Medicine
Randal C. Manning, Executive Director
137 State House Station (U.S. mail)
2 Bangor Street, 2nd Floor (delivery service)
Augusta, ME 04333
(207) 287-3601 / Fax: (207) 287-6590
www.docboard.org/me/me_home.htm

Maine Board of Osteopathic Licensure
Susan E. Strout, Executive Secretary
142 State House Station
Augusta, ME 04333-0142
(207) 287-2480 / (207) 287-3015
www.docboard.org/me-osteo

Maryland Board of Physician Quality Assurance
C. Irving Pinder, Executive Director
P.O. Box 2571
Baltimore, MD 21215-0095
(street address: 4201 Patterson Ave., 3rd floor, 21215)
(410) 764-4777 / (800) 492-6836 / Fax: (410) 358-2252
www.bpqa.state.md.us

Massachusetts Board of Registration in Medicine
Nancy Achin Audesse, Executive Director
560 Harrison Ave., Suite G-4
Boston, MA 02118
(617) 654-9800 / Fax: (617) 451-9568
(800) 377-0550
www.massmedboard.org

Michigan Board of Medicine

Ann Marie Pischea, Licensing Director
P.O. Box 30670
Lansing, MI 48909-8170
(street address: 611 W. Ottawa St, 1st floor, 48933)
(517) 373-6873 / Fax: (517) 373-2179
www.michigan.gov/cis

Michigan Board of Osteopathic Medicine and Surgery

Ann Marie Pischea, Licensing Director
P.O. Box 30670
Lansing, MI 48909-8170
(street address: 611 W. Ottawa St, 1st floor, 48933)
(517) 373-6873 / Fax: (517) 373-2179
www.michigan.gov/cis

Minnesota Board of Medical Practice

Robert A. Leach, J.D., Executive Director
University Park Plaza
2829 University Ave. SE, Suite 400
Minneapolis, MN 55414-3246
(612) 617-2130 / Fax: (612) 617-2166
Hearing impaired: (800) 627-3529
www.bmp.state.mn.us

Mississippi State Board of Medical Licensure

W. Joseph Burnett, M.D., Director
1867 Crane Ridge Drive, Suite 200B
Jackson, MS 39216
(601) 987-3079 / Fax: (601) 987-4159
www.msbml.state.ms.us

Missouri State Board of Registration for the Healing Arts

Tina M. Steinman, Executive Director
3605 Missouri Blvd.
Jefferson City, MO 65109
(street address: 3605 Missouri Blvd., 65109)
(573) 751-0098 / Fax: (573) 751-3166
www.ecodev.state.mo.us/pr/healarts

Montana Board of Medical Examiners

Jeannie Worsech, Executive Director
P.O. Box 200513
Helena, MT 59620-0513
(406) 841-2300 / Fax: (406) 841-2363
www.discoveringmontana.com/dli/bsd/license/hc.index.htm

Nebraska Board of Medicine and Surgery

Health and Human Services
Regulation and Licensure Credentialing Division
Becky Wisell, Section Administrator
P.O. Box 94986
Lincoln, NE 68509-4986
(402) 471-2118 / Fax: (402) 471-3577
www.hhs.state.ne.us

Nevada State Board of Medical Examiners

Larry D. Lessly, J.D., Executive Director
1105 terminal Way, Suite 301
Reno, NV 89502
(775) 688-2559 / Fax: (775) 688-2321
www.medboard.nv.gov

Nevada State Board of Osteopathic Medicine
Larry J. Tarno, D.O., Executive Director
2860 E. Flamingo Rd., Suite G
Las Vegas, NV 89121
(702) 732-2147 / Fax: (702) 732-2079
www.osteo.state.nv.us

New Hampshire Board of Medicine
Penny Taylor, Administrator
2 Industrial Park Drive, Suite 8
Concord, NH 03301-8520
(603) 271-1203 / Fax: (603) 271-6702
complaints (800) 780-4757
www.state.nh.us/medicine

New Jersey State Board of Medical Examiners
William V. Roeder, Executive Director
P.O. Box 183
Trenton, NJ 08625-0183
(609) 826-7100 / Fax: (609) 826-7117
www.state.nj.us/lps/ca/medical.htm#bme5

New Mexico State Board of Medical Examiners
Charlotte Kinney, Executive Director
491 Old Santa Fe Trail, Lamy Building, 2nd Floor
Santa Fe, NM 87501
(505) 827-5022 / Fax: (505) 827-7377
www.state.nm.us/nmbme

New Mexico Board of Osteopathic Medical Examiners
Liz Z. Montoya, Executive Director
2055 S. Pacheco, Suite 400

Santa Fe, NM 87504
(505) 476-7120 / Fax: (505) 476-7095
www.rld.state.nm.us

New York State Board for Medicine (Licensure)
Thomas J. Monahan, Executive Secretary
89 Washington Avenue, 2nd Floor, West Wing
Albany, NY 12234
(518) 474-3817 Ext. 560 / Fax: (518) 486-4846
www.op.nysed.gov

New York State Board for Professional Medical Conduct (Discipline)
Dennis J. Graziano, Executive Director
Department of Health
Office of Professional Medical Conduct
433 River St., Suite 303
Troy, NY 12180-2299
(518) 402-0855 / Fax: (518) 402-0866
www.health.state.ny.us

North Carolina Medical Board
R. David Henderson, J.D., Executive Director
P.O. Box 20007
Raleigh, NC 27619
(919) 326-1100 / Fax: (919) 326-1130
www.ncmedboard.org

North Dakota State Board of Medical Examiners
Rolf P. Sletten, JD, Executive Secretary/Treasurer
City Center Plaza
418 E. Broadway, Suite 12

Bismarck, ND 58501
(701) 328-6500 / Fax: (701) 328-6505
www.ndbomex.com

Northern Mariana Islands
Medical Profession Licensing Board
Juanet S. Crisostomo, Office Manager
P.O. Box 501458, CK
Saipan, MP 96950
(670) 664-4811 / Fax: (670) 664-4813
www.saipan.com/gov

State Medical Board of Ohio
Thomas A. Dilling, J.D., Executive Director
77 S. High St., 17th Floor
Columbus, OH 43215-6127
(614) 466-3934 / Fax: (614) 728-5946
(800) 554-7717
www.state.oh.us/med

Oklahoma State Board of Medical Licensure and Supervision
Lyle Kelsey, C.A.E., Executive Director
P.O. Box 18256
Oklahoma City, OK 73118
(405) 848-6841 / Fax: (405) 848-8240
(800) 381-4519
www.osbmls.state.ok.us

Oklahoma State Board of Osteopathic Examiners
Gary R. Clark, Executive Director
4848 N. Lincoln Blvd, Suite 100
Oklahoma City, OK 73105-3321

(405) 528-8625 / Fax: (405) 557-0653
www.docboard.org

Oregon Board of Medical Examiners
Kathleen Haley, J.D., Executive Director
1500 SW First Avenue, 620 Crown Plaza
Portland, OR 97201-5826
(503) 229-5770 / Fax: (503) 229-6543
www.bme.state.or.us

Pennsylvania State Board of Medicine
Joanne Troutman, Administrator
P.O. Box 2649
Harrisburg, PA 17105-7769
(717) 787-2381 / Fax: (717) 787-7769
www.dos.state.pa.us

Pennsylvania State Board of Osteopathic Medicine
Gina K. Bittner, Administrator
P.O. Box 2649
Harrisburg, PA 17105-2649
(street address: 124 Pine St., 17101)
(717) 783-4858 / Fax: (717) 787-7769
www.dos.state.pa.us

Board of Medical Examiners of Puerto Rico
Pablo Valentin-Torres, Esq, Executive Director
P.O. Box 13969
San Juan, PR 00908
(787) 782-8949 / Fax: (787) 792-4436

Rhode Island Board of Medical Licensure and Discipline
Bruce W. McIntyre, J.D., Interim Chief Administrator
Department of Health
Cannon Building, Room 205
Three Capitol Hill
Providence, RI 02908-5097
(401) 222-3855 / Fax: (401) 222-2158
www.docboard.org/ri/main.htm

South Carolina Board of Medical Examiners
Department of Labor, Licensing and Regulation
John D. Volmer, Board Administrator
110 Centerview Drive, Suite 202
Columbia, SC 29210-1289
(803) 896-4500 / Fax: (803) 896-4515
www.llr.state.sc.us/pol/medical

South Dakota State Board of Medical and Osteopathic Examiners
L. Paul Jensen, Executive Secretary
1323 S. Minnesota Ave.
Sioux Falls, SD 57105
(605) 334-8343 / Fax: (605) 336-0270
www.state.sd.us/dcr/medical

Tennessee Board of Medical Examiners
Rosemarie Otto, Executive Director
425 5th Ave. North, 1st Floor, Cordell Hull Building
Nashville, TN 37247-1010
(615) 532-3202 / Fax: (615) 253-4484
www.state.tn.us/health

Tennessee Board of Osteopathic Examiners
Rosemarie Otto, Executive Director
425 5th Ave. North, 1st Floor, Cordell Hull Building
Nashville, TN 37247-1010
(615) 532-3202/ (888) 310-4650 / Fax: (615) 253-4484
www.state.tn.us/health

Texas State Board of Medical Examiners
Donald W. Patrick, M.D., J.D., Executive Director
P.O. Box 2018
Austin, TX 78768-2018
(512) 305-7010/Fax: (512) 305-7008
Disciplinary Hotline (800) 248-4062
Consumer Complaint Hotline (800) 201-9353
www.tsbme.state.tx.us

Utah Department of Commerce
Div. of Occupational & Professional Licensure
Physicians Licensing Board
Craig J. Jackson, R.Ph.
160 E 300 South, 84102, Heber M. Wells Building, 4th Floor
Salt Lake City, UT 84114
(801) 530-6628 / Fax: (801) 530-6511
www.dopl.utah.gov

Utah Department of Commerce
Div. of Occupational & Professional Licensure
Board of Osteopathic Medicine
Diana T. Baker, Bureau Manager
160 E 300 South, 84102, Heber M. Wells Building, 4th Floor
Salt Lake City, UT 84114
(801) 530-6628 / Fax: (801) 530-6511
www.dopl.utah.gov

Vermont Board of Medical Practice
John Howland, Interim Executive Director
108 Cherry Street
Burlington, VT 05402-0070
(802) 657-4220 / Fax: (802) 657-4227
www.healthyvermonters.info

Vermont Board of Osteopathic Physicians and Surgeons
Jessica Porter, Director, Office of Professional Regulation
26 Terrace Street, Drawer 09
Montpelier, VT 05609-1106
(802) 828-2373 / Fax: (802) 828-2465
vtprofessionals.org

Virgin Islands Board of Medical Examiners
Lydia Scott, Executive Assistant
Department of Health
48 Sugar Estate
St. Thomas, VI 00802
(340) 774-0117 / Fax: (340) 777-4001

Virginia Board of Medicine
William L. Harp, M.D., Executive Director
6603 W. Broad St., 5th Floor
Richmond, VA 23230-1717
(804) 662-9908 / Fax: (804) 662-9517
www.dhp.state.va.us

Washington Medical Quality Assurance Commission
Doron N. Maniece, Executive Director
Department of Health
P.O. Box 47866
Olympia, WA 98504-7866
(360) 236-4788 / Fax: (360) 586-4573
www.doh.wa.gov

Washington State Board of Osteopathic Medicine and Surgery
Robert Nicoloff, Executive Director
Department of Health
P.O Box 47869
Olympia, WA 98504-7869
(360) 236-4945 / Fax: (360) 236-2406
www.doh.wa.gov

West Virginia Board of Medicine
Ronald D. Walton, Executive Director
101 Dee Drive
Charleston, WV 25311
(304) 558-2921 / Fax: (304) 558-2084
www.wvdhhr.org/wvbom

West Virginia Board of Osteopathy
Cheryl Schreiber, Executive Secretary
334 Penco Rd.
Weirton, WV 26062
(304) 723-4638 / Fax: (304) 723-2877
www.state.wv.us/bdosteo

10 Things You Need to Know...

Wisconsin Medical Examining Board
Department of Regulation and Licensing
Deanna Zychomski, Bureau Director
1400 E. Washington Ave.
Madison, WI 53703
(608) 266-2112 / Fax: (608) 261-7083
www.drl.state.wi.us

Wyoming Board of Medicine
Carole Shotwell, J.D., Executive Secretary
211 W. 19th St., Colony Bldg., 2nd floor
Cheyenne, WY 82002
(307) 778-7053 / Fax: (307) 778-2069
wyomedboard.state.wy.us

Disciplinary Files

For a long time, the records to physician disciplinary actions were only available to state medical boards and health care organizations. But now the public can access the most comprehensive nationally consolidated data bank of disciplinary histories on U.S. licensed physicians.

If you want to access any disciplinary action on file, you can do so through the Federation of State Medical Boards' DocInfo site at *www.docinfo.org*. You can order disciplinary histories online with a credit card (for roughly $10) or mail in your request with a cashier's check or money order. If you do the request by mail, you

have to download the Disciplinary Search Request Form over the Web site and mail it to:

> The Federation of State Medical Boards
> Attn: Physician Profiles
> P.O. Box 972507
> Dallas, Texas 75397-2507

Mail-in requests take five to seven days to process. If you get a report back that says "No Reported Actions Found," your physician has a clean record and has not been disciplined by a state medical board. Receiving a clean report gives you peace of mind.

For access to services designed specifically for credentials verification of physician disciplinary history, refer to the Federation's Board Action Data Bank site at *www.drdata.org* or call (817) 868-4072.

Appendix C

The following is a list of useful Web sites (and related addresses) for various kinds of research related to your health. These sites are good for gathering information about your doctor, your state health department and organizations that target consumers of health care.

Agencies and Organizations on the Web

National Association of Insurance Commissioners
2301 McGee Street, Suite 800
Kansas City, MO 64108-2662
phone: (816) 842-3600; fax: (816) 783.8175
www.naic.org
*Through the NAIC, you can obtain contact information for your state's department of insurance and a link to your state's insurance department Web site directly from the NAIC's site.

Administrators in Medicine
National Organization for State Medical & Osteopathic Board Executive Directors (affiliated with the Federation of State Medical Boards)
www.docboard.org

American Academy of Physician Assistants
950 North Washington Street
Alexandria, Virginia 22314-1552
phone: (703) 836-2272; fax: (703) 684-1924
E-mail: aapa@aapa.org
www.aapa.org

American Board of Medical Specialties
1007 Church Street, Suite 404
Evanston, IL 60201-5913
Phone Verification (866) ASK-ABMS
phone: (847) 491-9091; fax: (847) 328-3596
www.abms.org

American Medical Association
American Medical Association
515 N. State Street
Chicago, IL 60610
(312) 464-5000
www.ama-assn.org

American Osteopathic Association
American Osteopathic Association
142 East Ontario Street, Chicago, IL 60611
phone: (800) 621-1773; (312) 202-8000; fax: (312) 202-8200
www.aoa-net.org

U.S. Department of Health and Human Services
Food and Drug Administration (FDA)
5600 Fishers Lane
Rockville, MD 20857-0001
1-888-INFO-FDA / (888) 463-6332
www.fda.gov; www.hhs.gov

U.S. Department of Health and Human Services
200 Independence Avenue, S.W.
Washington, D.C. 20201
phone: (202) 619-0257; (877) 696-6775
www.hhs.gov

*A list, by subject, of Web sites and public inquiry and publication of phone numbers for popular topics is available at: *www.hhs.gov/about/referlst.html*

U.S. Department of Health and Human Services
Health Resources and Services Administration
Parklawn Building
5600 Fishers Lane
Rockville, Maryland 20857
www.hrsa.gov

National Association of Boards of Pharmacy
700 Busse Highway
Park Ridge, IL 60068
phone: (847) 698-6227 fax: (847) 698-0124
www.nabp.net

Centers for Disease Control and Prevention
1600 Clifton Rd.
Atlanta, GA 30333
phone: (404) 639-3311; (800) 311-3435
Hotlines:
National AIDS Hotline (800) 342-2437
National HIV/AIDS Hotline (Spanish) (800) 344-7432
National Immunization Hotline (English) (800) 232-2522
National Immunization Hotline (Spanish) (800) 232-0233
National STD Hotline (800) 227-8922
Traveler's Health (877) 394-8747
www.cdc.gov
*A great resource on the CDC's Web site is Health Topics A to Z at: *www.cdc.gov/health/diseases.htm*
**Access to your state and local health departments can be found through CDC's site at *www.cdc.gov/other/htm*

National Institutes of Health
9000 Rockville Pike
Bethesda, Maryland 20892
You can contact the NIH via e-mail at:
NIHInfo@OD.NIH.GOV.
The main telephone number is (301) 496-4000. Other toll-free NIH telephone numbers can be found at *www.nih.gov/health/ infoline.htm*.

World Health Organization
Avenue Appia 20
1211 Geneva 27
Switzerland
phone:(+ 41 22) 791 21 11 fax: (+ 41 22) 791 3111
telex: 415 416
telegraph: UNISANTE GENEVA
www.who.int
To request general information about WHO or current WHO events, e-mail them at info@who.int.

UC Berkeley Public Health Library
42 Warren Hall #7360
Berkeley, CA 94720-7360
circulation/reference: (510) 642-2511; fax: (510) 642-7623
www.lib.berkeley.edu/PUBL/internet.html

National Cancer Institute
NCI Public Inquiries Office
Suite 3036A
6116 Executive Boulevard, MSC8322
Bethesda, MD 20892-8322
(800) 4-CANCER
www.cancer.gov; www.cancernet.nci.nih.gov

Healthfinder®

P.O. Box 1133
Washington, DC 20013-1133
E-mail: healthfinder@nhic.org
www.healthfinder.gov
Go to *www.health.gov* to access all links to other government-related and multi-institutional health-related agencies.

National Women's Health Information Center

8550 Arlington Blvd., Suite 300, Fairfax, VA 22031
phone: (800) 994-WOMAN (800-994-9662)
TDD: (888) 220-5446
www.4women.gov

Centers for Medicare & Medicaid Services

7500 Security Boulevard
Baltimore, MD 21244-1850
phone: (877) 267-2323; local: (410) 786-3000
TTY: (866) 226-1819; TTY Local: (410) 786-0727
*The Centers for Medicare & Medicaid Services (CMS) is a federal agency within the U.S. Department of Health and Human Services. CMS runs the Medicare program, Medicaid program and State Children's Health Insurance Program (SCHIP).
www.cms.hhs.gov
Medicare's 800 number: (800) 633-4227
www.medicare.gov

Office of Disease Prevention and Health Promotion

Office of Public Health and Science, Office of the Secretary
Hubert H. Humphrey Building
200 Independence Avenue SW., Room 738G
Washington, DC 20201

phone: (202) 205-8611; fax: (202) 205-947

E-mail: hp2010@osophs.dhhs.gov; fax: (202) 205-9478

odphp.osophs.dhhs.gov

Intercultural Cancer Council

6655 Travis, Suite 322

Houston, TX 77030-1312

phone: (713) 798-4617; fax: (713) 798-6222

E-mail: info@iccnetwork.org

iccnetwork.org/who

National Asian Women's Health Organization

250 Montgomery Street, Suite 900

San Francisco, CA 94104

phone: (415) 989-9747; fax: (415) 989-9758

E-mail: nawho@nawho.org

www.nawho.org

Office of Minority Health Resource Center

P.O. Box 37337

Washington, D.C. 20013-7337

phone: (800) 444-6472; fax: (301) 251-2160

www.omhrc.gov

The American Lung Association

61 Broadway, 6th Floor

NY, NY 10006

phone: (212) 315-8700

www2.lungusa.org/

The New England Journal of Medicine
860 Winter Street
Waltham, MA 02451-1413
phone: (781) 893-3800 x5515; (800) 843-6356
fax: (781) 893-0413
content.nejm.org/

The Mayo Clinic
200 First St. S.W.
Rochester, MN 55905
phone: (507) 284-2511; fax: (507) 284-0161
TDD: (507) 284-9786
Appointment Office: (507) 284-2111
*There are Mayo Clinics in Arizona, Florida and Minnesota.
Got to the Web site for other addresses.
www.mayoclinic.org

Appendix D

The following is a list of useful Web sites that provide health-related information. Some of these organizations and agencies are not affiliated with federal or state-run agencies, so it's important to check company sponsorship. A few are national non-profit organizations. Be careful about seeking medical advice over the Internet, as consumer protection issues continue to surface.

Popular Health Web Sites

AccentHeath (by Axolotl Corp.)
www.accenthealth.com

drkoop.com (*not* related to C. Everett Koop, M.D., former Surgeon General of the United States)
www.drkoop.com

HealthCentral
www.healthcentral.com

InteliHealth (provided by Aetna, Inc.)
*This site features Harvard Medical School's Consumer Health Information
www.intelihealth.com

HealthAtoZ (by Medical Network, Inc.)
www.healthatoz.com

WebMD
www.webmd.com

Foundation for Informed Medical Decision Making
www.fimdm.org
*Also check out an affiliated link: *www.collaborativecare.net*, an online service that provides decision support to individuals making choices about their health care.

American Diabetes Association
www.diabetes.org/main/application/commercewf

American Foundation for Urologic Disease
www.afud.org

American Heart Association
www.americanheart.org

Arthritis Foundation
www.arthritis.org

National Breast Cancer Coalition
www.natlbcc.org/nbccf/index.html

National Comprehensive Cancer Network
www.nccn.org/index.html

Susan G. Komen Breast Cancer Foundation
www.breastcancerinfo.com/bhealth

National Heart, Lung and Blood Institute
www.nhlbi.nih.gov/health/public/heart/index.htm

National Institute of Diabetes & Digestive & Kidney Diseases
www.niddk.nih.gov/health/health.htm

National Institute of Child Health & Human Development
www.nichd.nih.gov/publications/pubs/fibroids/index.htm

National Institute of Arthritis and Musculoskeletal and Skin
Diseases
www.niams.nih.gov/hi/index.htm#ip

National Cholesterol Education Program
www.nhlbi.nih.gov/chd

U.S. Preventive Services Task Force
www.ahcpr.gov/clinic/uspstfix.htm

Agency for Healthcare Research and Quality
www.ahcpr.gov
*This agency examines what works and does not work in health
care.
www.ahrq.gov/consumer/uterine1.htm (for information
about uterine fibroids, chronic pelvic pain, dysfunctional uter-
ine bleeding, and other common uterine conditions)
www.ahcpr.gov/clinic/epcsums/utersumm.htm (for a
comprehensive summary of the available evidence on the ben-
efits and risks of common medical and surgical treatments for
uterine fibroids)

Appendix E

Sample Family Health Pedigree

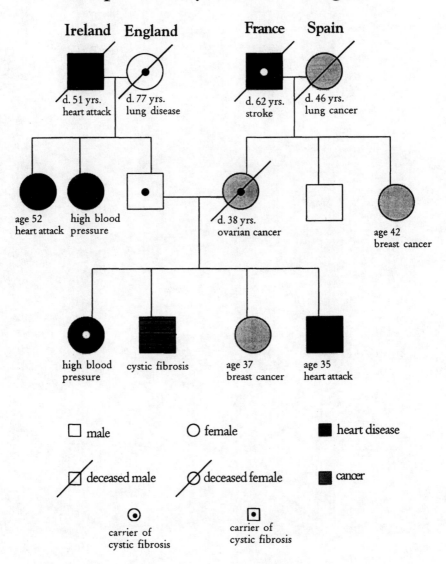

Ireland England France Spain

d. 51 yrs. d. 77 yrs. d. 62 yrs. d. 46 yrs.
heart attack lung disease stroke lung cancer

age 52 high blood d. 38 yrs.
heart attack pressure ovarian cancer age 42
 breast cancer

high blood cystic fibrosis age 37 age 35
pressure breast cancer heart attack

☐ male ◯ female ■ heart disease

▨ deceased male ⊘ deceased female ▩ cancer

⊙ ▣
carrier of carrier of
cystic fibrosis cystic fibrosis

Index

abdominal surgery 82
acute or chronic pain 54
adverse reactions 168-169
aging 7, 16, 21-22
alternative therapies 16
Alzheimer's 41, 191, 204
angiogram 40
antacids 29, 75
antibiotics 23, 29-31, 42, 132-133, 139, 150, 162-163, 166, 225
appendicitis 74, 100, 104, 220, 233
arthritis 16, 70, 202, 212
asthma 16, 39
autopsies 8-9, 38
average life expectancy 199

bad doctors 124-125, 128, 135, 219
bad medicine 12-13, 50
bad practice 49-50, 59, 69, 126, 232, 236, 239
biopsy 14, 76, 180, 186
blood pressure 21, 41, 56, 209, 215-217, 224
blood type 41, 66, 226
board certification 86
body scan 22, 151-152, 183
bone doctor 26
breast cancer 98, 185, 187, 202
 breast self-examination (BSE) 188
 clinical breast exam (CBE) 187-188

cancer 14, 27, 41, 47-49, 54, 58, 61, 66, 74-76, 98, 143, 176, 182-183, 185-187,
 191, 202, 204, 237, 224-226
cardiologist 26, 110

10 Things You Need to Know...

cataracts 89, 202, 206
catastrophic insurance policy 119
chemotherapy 14
choice of provider 110
cholesterol level 41
choosing a doctor 58, 122
choosing a health plan 109
chronic conditions 16
chronic pain 54
colonoscopy 21, 182
common cold 42, 144, 150
copayment 111-113, 117-118
cover-up 9, 65, 67, 99, 167, 232, 235, 237
CT (computed tomography) scan 116, 180, 219, 226

deductible 111-112, 117-119, 129
dehydration 163, 192-193
dermatologist 26
diabetes 16, 21, 41, 61-62, 89, 183, 205, 207-209, 224
diagnostic error 39
disability 11, 53, 65, 110, 121
drug side effects 165

EENT (ear, eye, nose and throat) 26
elderly 90, 131, 137, 191, 198-207, 209-210
electrocardiogram 40, 56
employer-sponsored plan 110
endometriosis 179-180
estrogen 184
euthanasia 44
experimental procedure 11, 131
exploratory surgery 82

family medical history 183
fever 143-144, 146

gastroenterologist 26
gatekeeper 134-135
general practitioner (or family doctor) 26, 86, 106-107, 137, 141, 177
generic drug 141, 158, 160, 172
geriatrics 191, 198, 210
germs 34, 95-96, 143, 150
getting referrals 124

groin pain 57
group policies 113-114
gynecologist 175, 177

health care provider 16, 25, 111, 138, 140, 218, 232, 235-236
health history 21, 121, 225, 227
health insurance 25, 109-110, 113-115, 117, 120, 128, 131
health maintenance organization (HMO) 31, 33-34, 50, 93, 102, 112-113, 124, 128, 131-135, 137, 139-141, 153
heart attack 39-42, 54, 56-57, 62, 65, 74, 133, 183, 218
heart disease 29, 40-41, 55, 183, 225
hernia 83-85, 100-101, 134, 197
high blood pressure 209, 215, 217, 234
HIV/AIDS 45, 181, 238
hospital hygiene 97
hypertension 209, 215-217, 224, 234
hysterectomy 92

iatrogenic disease 94-95, 97-98
indemnity plan 111-113, 124
individual policies 114
infection 29, 81, 94-95, 102-104, 132, 139, 143, 150, 162-163, 176, 180-182, 193-194, 208, 225, 232
influenza 42
insurance
 applying for insurance 120
internal medicine 26-27
irritable bowel syndrome 181

lupus 178-179

malpractice litigation 38, 51, 77, 83
mammography 13, 47, 185, 187
managed care 25, 43, 110-113, 115, 117, 122, 124
mastectomy 67
Medicaid 110, 114-115
medical jargon 37
medical standards 47
Medicare 89, 110, 114, 128, 131
medication 14, 20-21, 24, 45, 54, 64, 69-71, 74-75, 88, 95, 97-98, 102, 133, 136, 139, 143-144, 148, 150, 152, 158-171, 173, 216-217, 224-225, 199-201, 229-231
misdiagnosis 76, 146, 178, 213

missed diagnosis 145, 197
MRIs (magnetic resonance imaging) 22, 31, 116, 133, 151, 180, 219, 226

nausea 31, 143-144, 146, 162, 233
negligence 40-41, 51, 77
neurologist 31, 132

ob/gyn specialist 92
orthopedist 26, 135
osteoporosis 183-184, 202
over-diagnosis 148
over-the-counter medication 53, 74, 144, 150, 160, 162-163, 168

pain
 definition of pain 63
 pain in the chest 54-55, 68
pain reliever 53
painkiller 64, 69, 71-73, 75
pathologist 38, 47-48, 66, 80-82
pediatrics 191-192, 210
pelvic exam 175-177, 188, 221
pelvic inflammatory disease (PID) 180-181
personal negligence 41
PET (positron emission tomography) scans 22
pharmaceuticals 24, 33-34, 198
 pharmaceutical campaigns 37
physician-patient relationship 51
physiology 38
point-of-service (POS) plans 112-113
postmortem diagnosis 8
pre-existing condition 115, 121
preferred provider organization (PPO) 112, 141
prescriptions 24, 37, 54, 71, 112, 116, 119, 139, 148, 159, 164, 166, 209, 224-225
preventive care 112, 117
primary care physician 16
private insurance 32, 135
private physician 34, 134
public health care 10

radiation 14, 136
referred pain 55, 220
right to die 43-44
risky behavior 16

saturated fat 21
scar 12, 19-20, 50, 96, 103-107, 113
scleroderma 178-179
second opinion 11, 43, 49-50, 59, 82, 91-93, 136, 147, 154, 186, 198, 206, 214
sexually transmitted disease (STDs) 181
Social Security disability benefits 110
specialist 90, 92, 110, 113, 116, 122, 127, 132, 134, 177, 141, 213, 238
specialization 26
standard of care 46, 51, 78
stress test 40, 226
stroke 39, 41, 90, 183, 209, 224-225
sudden cardiac deaths 39
surgeons 26, 58, 86, 93, 101, 105, 110, 186
surgery 12-13, 18-20, 27, 29-30, 32, 161, 166, 168, 180
 surgical error 85, 231
 surgical procedure 27, 78, 80, 85, 88, 95, 161, 206, 232

transplant 66, 77, 93, 179, 191
trauma 18, 39, 62, 71, 74, 207

ulcers 29, 55, 115, 204-205, 214
under-diagnosis 152-154
under-treatment 200, 205, 231, 239
undescended testicles 197
unnecessary procedures 58, 89, 92
urologist 31, 90, 132, 206

weight 41, 193, 207-208, 221, 223, 232
workers' compensation 110
work-related benefits 110
wrong dosage 164
wrong medication 159-162, 168

x-rays 54, 79, 94, 104, 116, 131-132, 145, 148-149, 151, 183, 219, 226, 235, 237